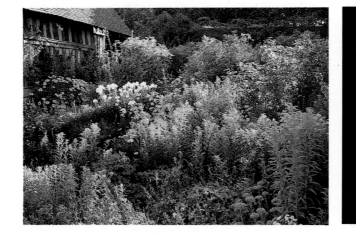

The Gardens of Russell Page

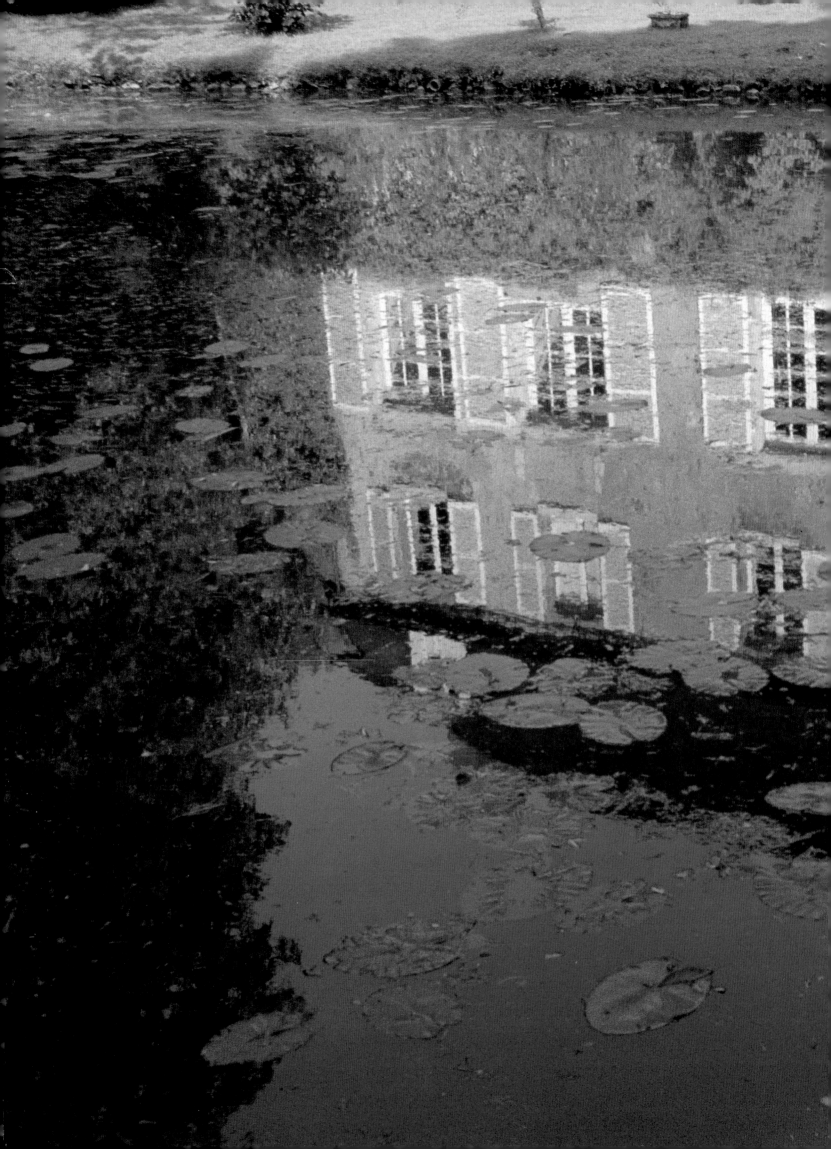

The Gardens
of Russell Page

Photographs by Marina Schinz

Text by Gabrielle van Zuylen

Stewart, Tabori & Chang ❀ New York

Photographs copyright © 1991 Marina Schinz
Text copyright © 1991 Gabrielle van Zuylen

Originally published in hardcover in 1991.
Paperback edition published in 1995 by Stewart, Tabori & Chang,
a division of U.S. Media Holdings, Inc. 575 Broadway, New York, NY 10012

LIBRARY OF CONGRESS CATALOGING-IN-PUBLICATION DATA
Van Zuylen, Gabrielle.
 The gardens of Russell Page /
photographs by Marina Schinz : text by Gabrielle van Zuylen.
 p. cm.
 Includes index.
 ISBN 1-55670-170-5
 1. Page, Russell, 1906–1985. 2. Gardens—Europe.
 3. Gardens—United States. 4. Gardens—Europe—Pictorial
 works. 5. Gardens—United States—Pictorial works.
 6. Landscape architects—England—Biography. I. Schinz,
 Marina. II. Page, Russell, 1906–1985. III. Title.
 SB470.P34A2 1991 91-12570
 712'.092—dc20 CIP

Published and distributed in the United States by
Stewart, Tabori & Chang, 575 Broadway, New York, NY 10012.
Distributed in Canada by General Publishing Company Limited,
30 Lesmill Road, Don Mills, Ontario, Canada, M3B 2T6.
Distributed in the U.K. by Hi Marketing, 38 Carver Road,
London, SE24 9LT, England.
Distributed in Europe by Onslow Books Limited, Tyler's Court,
111A Wardour Street, London, W1V 3TD, England.
Distributed in Australia and New Zealand by Peribo Pty Limited,
58 Beaumont Road, Mount Kuring-gai, NSW, 2080, Australia.

Printed in Japan
10 9 8 7 6 5 4 3 2 1

Gigantic arcaded yew hedges form a ballroom-sized green enclosure at the château de la Hulpe near Brussels, where Russell Page was active in the 1930s. Much of his early work was done on a grand scale in elegant surroundings.

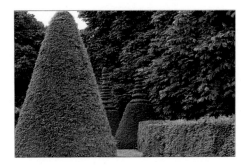

After the war Page turned his attention to smaller formal gardens of distinction. A cone-shaped yew and a pair of topiaries mark a corner of the eighteenth-century estate the Creux de Genthod, in Switzerland, which Russell Page adapted with an eye toward reduced maintenance.

Contents

In the South of France Russell Page had the freedom to execute new architectural and horticultural ideas that were inappropriate or impossible farther north. In this garden near Grasse, Page installed a body of water next to the house in place of a lawn; an interesting feature in a sunny climate.

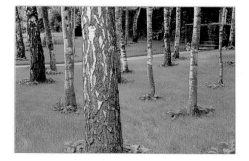

Russell Page aimed at creating an illusion of tranquility when designing town gardens. A stand of birches on a slope between a highway and the house lends the residence of Prince Aly Khan near Geneva a rustic air.

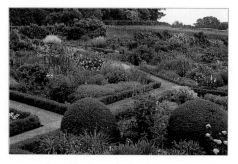

Upon returning to his native country in 1962, Russell Page found renewed inspiration in England's riches of cultivated plants. The abundance of flowers nevertheless required a firm underlying structure, which Page was only too happy to provide, as at Leeds Castle, in Kent.

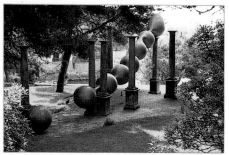

The culture and flora of Spain, as well as a commission to create a sculpture garden for a prominent banker, Don Bartolomeo March, opened up new possibilities for Page. Xavier Corbero's construction of golden spheres stands near the seashore at March's estate in Majorca.

Chapter 7
Trees and Water 167

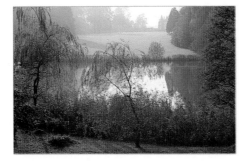

Water and trees were Russell Page's inspirations when he was designing a naturalized landscape. The pond at the château de la Hulpe provides a setting for such moisture-loving trees as willows and swamp cypresses.

Chapter 8
Southern Italy 195

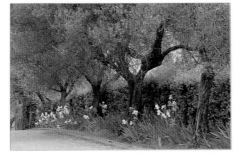

The pleasant climate and enthusiastic gardeners of southern Italy stimulated Russell Page's talent for horticultural experimentation and daring plant association. Bearded irises grow underneath olive trees along the driveway at San Liberato, near Rome.

Chapter 9
The Last Years 223

Russell Page's creative talent was appreciated in the United States, by private clients and public institutions alike. The culmination of his career was the reorganization and expansion of the Donald M. Kendall Sculpture Gardens at the PepsiCo headquarters. Arnaldo Pomodoro's Triad *sits on an expanse of lawn with the lake visible in the distance.*

Preface

In January 1980 I went to London to photograph Russell Page in his flat in Cadogan Gardens. At home in New York I had regularly passed by the garden he had designed for the Frick Collection and had long been curious about the creator of that tranquil spot and so had decided to photograph him. The sitting was a very pleasant one, and we had long and leisurely chats. We talked about mutual acquaintances and about music and literature, which he called "part of one's equipment." When I departed he took a small roundish object from a shelf and gave it to me as a gift. It was a piece of rubble from the Parthenon.

A few months later Page came to visit me at my studio in New York. We became friends, and soon after I approached him about producing a volume of photographs of his gardens with his own commentary. This proved to be a project with rather more than the ordinary problems of a photography book. Added to the usual unpredictability of the weather and seasons was Russell's skepticism about the changes that had been made in some of the gardens he had designed and his acute discouragement about the number of those that had disappeared altogether. Rather than add to his dismay I decided not to pursue what I considered a worthwhile documentation of his oeuvre. Luckily, however, I had already begun to photograph the gardens and thus had been able to record some before they vanished.

When Russell Page died I met Gabrielle van Zuylen, and it became clear to both of us that something had to be done to preserve and document what remained of his work. Many of Page's gardens had disappeared completely, while others were teetering on the brink of extinction. If at that point I had any misgivings about the number and the quality of those still intact, my doubts were dispelled when I saw Gabrielle's own garden at Varaville, which not only epitomizes many aspects of Page's work but is also most lovingly kept.

Though he labeled himself a gardener, Russell Page really comes across as a landscape architect with a firm grip on what is the most permanent feature of a garden: its overall plan. Long views, bodies of water, hedges and compartments, steps and paths, transitions from one area to the next were his first and foremost concern. He never lost sight of the framework that was needed to house his or his clients' choice of plants—and he was also, of course, a gardener with an excellent knowledge of horticulture.

Page's biggest passion was water, and when it did not occur naturally on a site he tried to introduce it. Potential clients had a better chance of interesting him in a commission when there was a prospect of water. The myriad lakes, pools, ponds, streams, canals, fountains, and brooks he installed testify that he was a hydromaniac of the first order. He also

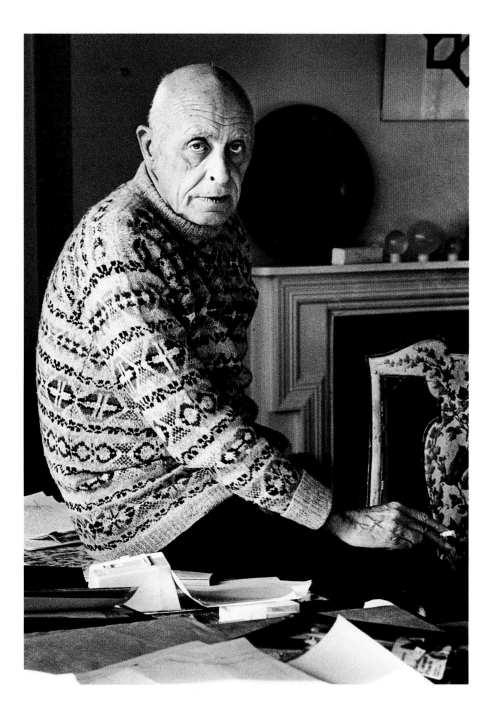

had a great liking for trees, almost an affinity for them, as if they were personal acquaintances. I could not help thinking that this had to do with his own height; he was an impressively tall man.

Page was a remarkable garden architect on several accounts. The gardens he designed were often very large, certainly by today's standards, and he excelled at handling such spaces. He was also one of the few people of his time who designed in the grand manner, adapting the vernacular of past centuries to modern times. He designed formal gardens in an informal age and knew how to make them work visually as well as practically. A well-defined underlying structure and perfect proportions were essential to his art, but creating a harmonious picture was only part of his goal with each garden. He understood the requirements of his clients as well as the needs of his plants and knew that even the most breathtaking design could not survive if its maintenance demands were beyond the owner's reach.

Every garden designer is faced with one of two situations when he starts out on a project: He is commissioned to create a garden from scratch; or, more often, he is called upon to change an existing situation. The degree to which he alters a site varies. He can make an addition or a subtraction, an elaboration or a simplification. Much of Russell Page's work involved simplifications, which he often regarded as necessary (these simplifications, of course, were harder to photograph). I remember a number of garden owners who were somewhat appalled when his very first recommendation was to eliminate certain trees and shrubs, some of which had been planted too recently to make such a suggestion welcome. Page's style was on the austere side. He disliked fussiness. When it came to flowers, however, he would have them in generous quantity or not at all. By and large he was a descendant of Le Nôtre rather than of Gertrude Jekyll; the French tradition suited him better than the English.

Water and trees, scale and proportion are what these photographs try to render. They illustrate what I regard as the essence of Page's work as it survives the passing of time. I photographed not only those parts of the gardens Page actually designed but occasionally included some existing feature, such as a view or a clump of trees, that I felt had provided a crystallizing point around which his design had arranged itself. Views of the residence and the surrounding countryside too are shown where appropriate, as they often play a role in dictating the tone or setting the scale.

I realize that this book cannot encompass Page's complete oeuvre nor do justice to his gardens as they must have looked when they were at their peak. Not surprisingly, the gardens that have survived best are those that represent a collaboration between Russell and his clients,

wherein the owners actively participated in the conception and continue to do so, even if they have changed some of the plants. Change is, after all, the very nature of gardens, and few gardeners have the gift of leaving a recognizable trace. Russell Page, to my mind, is certainly among them.

I dedicate my work on this book to Tessa Traeger.

MARINA SCHINZ
New York, March 1991

Russell Page is buried in a small graveyard in Badminton, England, at the estate of his friends the Duke and Duchess of Beaufort. He wished his grave to be unmarked.

Whenever the renowned English garden architect Russell Page was asked his occupation he always answered "gardener." Although he had spent a lifetime designing landscapes for other people, had received private praise and public honors for his work in many countries, and had written a classic book, *The Education of a Gardener,* this extraordinary and complex man considered himself, at heart, a gardener.

In his youth he had wanted to be a painter, but acquaintances in Paris intent on making gardens helped change his direction. In later years when asked whether he was more of a plantsman or a designer, his answer was understated: "I know more about plants than most designers, and more about design than most plantsmen."[1] In fact, he had an exceptional understanding, knowledge and feel for plants allied to a strong sense of architecture.

Few other garden designers have ever had a larger number of different cultures, climates, trees, and plants to learn and assimilate

nor a vaster canvas on which to work than Russell Page. His gardening itinerary began in England and France in the 1930s. The war years found him in the United States, the Near East, India, and Ceylon (now Sri Lanka). Soon after the liberation of France in 1946, he based himself in Paris. Over the years the ever-expanding geographical scope of his work took him to Belgium, Switzerland, northern Italy, and throughout France, with occasional expeditions to Egypt, Iran, and the United States, and later, southern Italy and Spain. During the sixteen years he resided in Paris, he addressed more than four hundred projects, ranging from small private gardens to such larger schemes as the layout and planting of the Festival Gardens in Battersea Park in London in 1952, for which he was awarded the OBE. In 1962 he returned to live in England but continued to work throughout Europe, Australia, and the Americas.

Page enjoyed the creative process as much as he did surveying his finished work. "Processes have always given me more satisfaction than results,"[2] he once said. Pleasure colored Page's work, whether it was the discovery of a "new" plant or tree, a happy combination of shape and texture in a well-planted border, or the scent of an old-fashioned rose warmed by the sun. He often stopped to touch a leaf, smell a flower, or write down the name of an unknown species so as to fix it in his memory. At times he would make a quick pencil sketch of an architectural detail. The artist in him was subsidiary to the plantsman, but dominated when he was studying a site for the first time to extract its true character, its *genius loci*.

Russell Page described gardening as an ever-changing pursuit, a partnership between nature and artifice. It is a relationship dependent on time, the gardener's fourth dimension, whose yearly passage plays out the life cycle of growth, maturity, decay, and rebirth, and adds a terrible fragility to life. Neglect, indifference, a client's death, or the sale of a property correspondingly accelerate the possibility of loss. "A few years of neglect and only the skeleton of a garden can be traced,"[3] he wrote. Toward the end of his life he, to whom clarity of design and simplification were the essence of his art, grew increasingly concerned that his plans were too complicated. He calculated that he had designed or worked on hundreds of gardens, many of which had disappeared. A sense of loss and failure shadowed his gratitude for the privilege of spending his life doing what he loved most.

Marina Schinz and I have tried to retrace, photograph, and describe what remains of Russell Page's legacy of gardens. With the invaluable

and amazingly generous help of his clients and friends, often one and the same, we have found and photographed much of Page's best work, early and late. The search for many gardens involved deciphering discreet references in his book to clients and places, identifying unmarked photographs from his files, even checking out chance remarks and locating the sites on untitled architectural plans. Sadly, some of his work we found too altered to photograph; other work, for a variety of reasons, was impossible to render justice to. We therefore decided to concentrate on the best and most representative gardens of the different periods of his life.

This book is not a biography, but we have endeavored to trace a brief chronology of Page's life and achievements, so as to indicate work no longer in existence as well as to clarify the sequence and logic of our choice of gardens.

Russell Page's gardening education began in the grand manner at Longleat in England in the 1930s and culminated in the United States in the 1980s with the 140-acre PepsiCo sculpture park in Purchase, New York. Knowledge can, in part, be transmitted, style imitated, and design adapted, but the sensitivity, intelligence, and flash of intuition that were the heart of his creation, the essence of his genius, can never be learned. We hope that this book will help present and preserve the clarity and beauty of his work and serve as an inspiration for all who love gardens.

I dedicate my work on this book to the memory of Russell Page.

GABRIELLE VAN ZUYLEN
Paris, March 1991

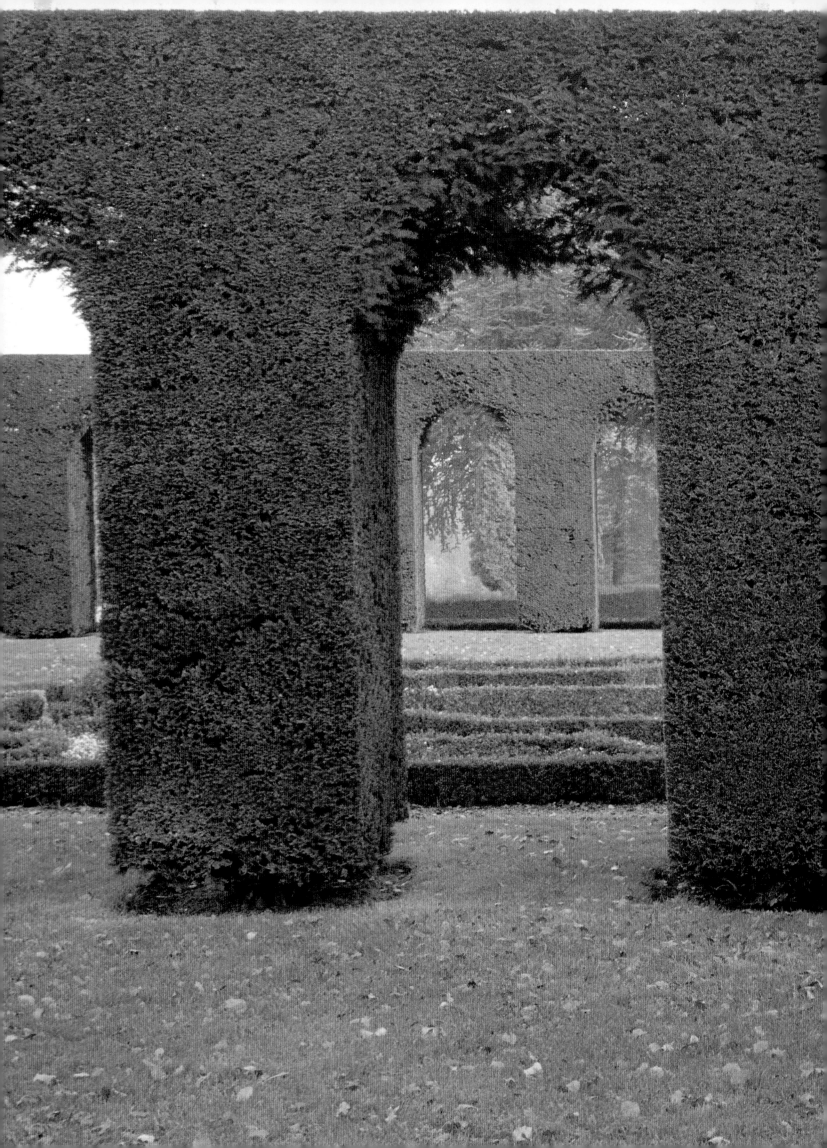

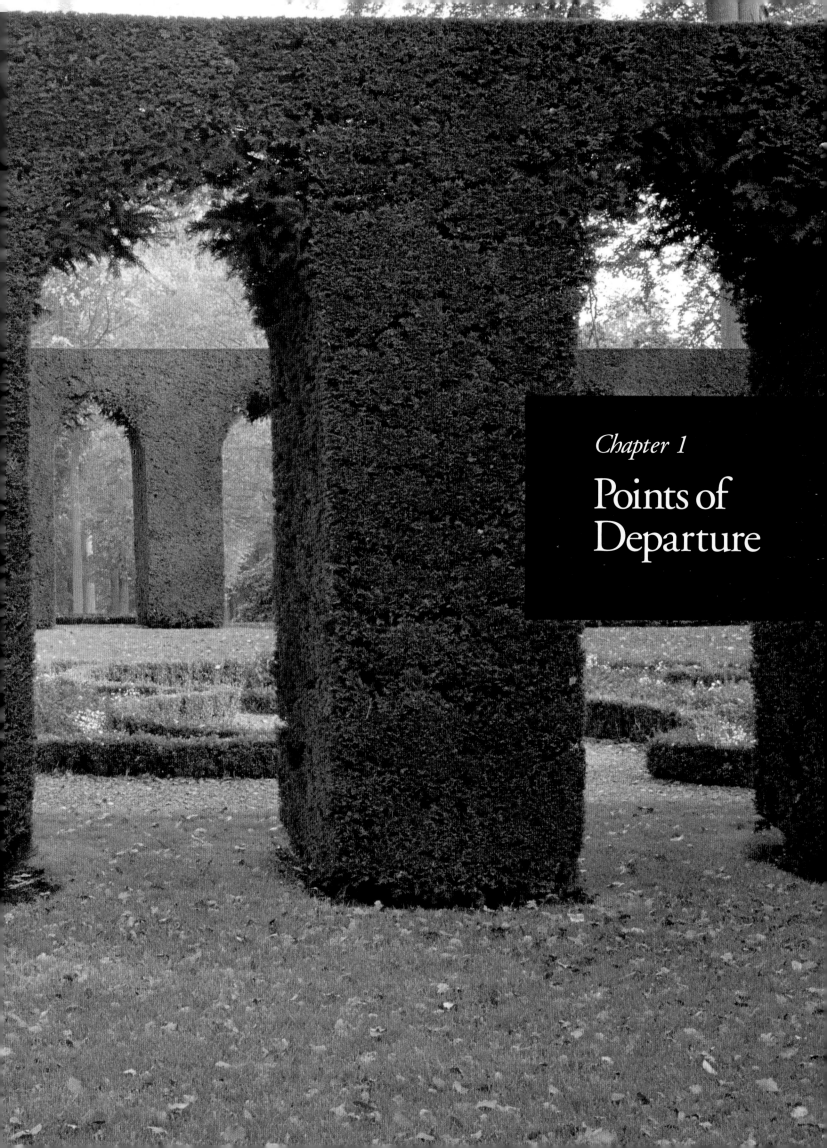

Chapter 1

Points of
Departure

Even as a boy, Russell Page showed a passionate interest in nature. Although schooling bored him, it was during those impressionable years that he was first exposed to, and stimulated by, the arts. It was this love of nature and the arts, in particular, that led him to a lifetime built around the making of gardens. ❧ "As a boy raised in the English countryside," he wrote, "I took for granted the fields and woods and streams where I spent most of my time. I knew every hedgerow in detail, the texture of leaves and twigs, the visual effects of changing skies, the varying scents of leaf and flower, the nature of soils and of stones to the point that all were part of me and I of them. ❧ "School, my formal education, was a hardship since for nine months of the year I had to clatter about in formal clothes on hard surfaces and flowers and plants only seemed to exist behind other people's walls. Desperate I would write home and occasionally shoe boxes of primroses or michaelmas daisies would come by post to the contemptuous surprise of my fellows. Much helped by a sympathetic art-master I took to drawing and painting for which I showed some aptitude and so sitting in front of a stuffed owl, a plaster cast, a couple of flowers in a glass or a still life of pots and pans I became interested in the depiction of objects in space and so in painters and sculptors and their problems. The range of cultural interests widened. Fortunately a good voice opened the world of music to me and the study of painters and sculptors led to an interest in architecture. Incapable of making any use of a formal education I saw no future except to continue to study painting and drawing."[1] ❧ Montague Russell Page was born in Lincolnshire on November 1, 1906. His paternal family, who came from farming stock, had settled in this county around 1700. In 1921 his mother and father moved to the town of Wragby, eleven miles east of Lincoln, where they converted some farm buildings into a country cottage. ❧ Page wrote that his gardening education began with a pot of campanula bought for one shilling at a country fair when he was about fourteen years old. In handling the plant he began to understand its nature and requirements. Desiring to learn more, he borrowed books from the local public library that opened up to him a trove of horticultural information

*A*BOVE *Longleat House in Wiltshire was the site of Russell Page's first professional landscaping engagement. He carried out work there in many phases from 1932 to 1955. Page reintroduced a formal seventeenth-century aesthetic to Longleat with such features as this intricately patterned band of low box hedges dotted with clipped trees.*

*O*PPOSITE *The view from the ornate roof of the Elizabethan mansion takes in the allée of tulip trees.*

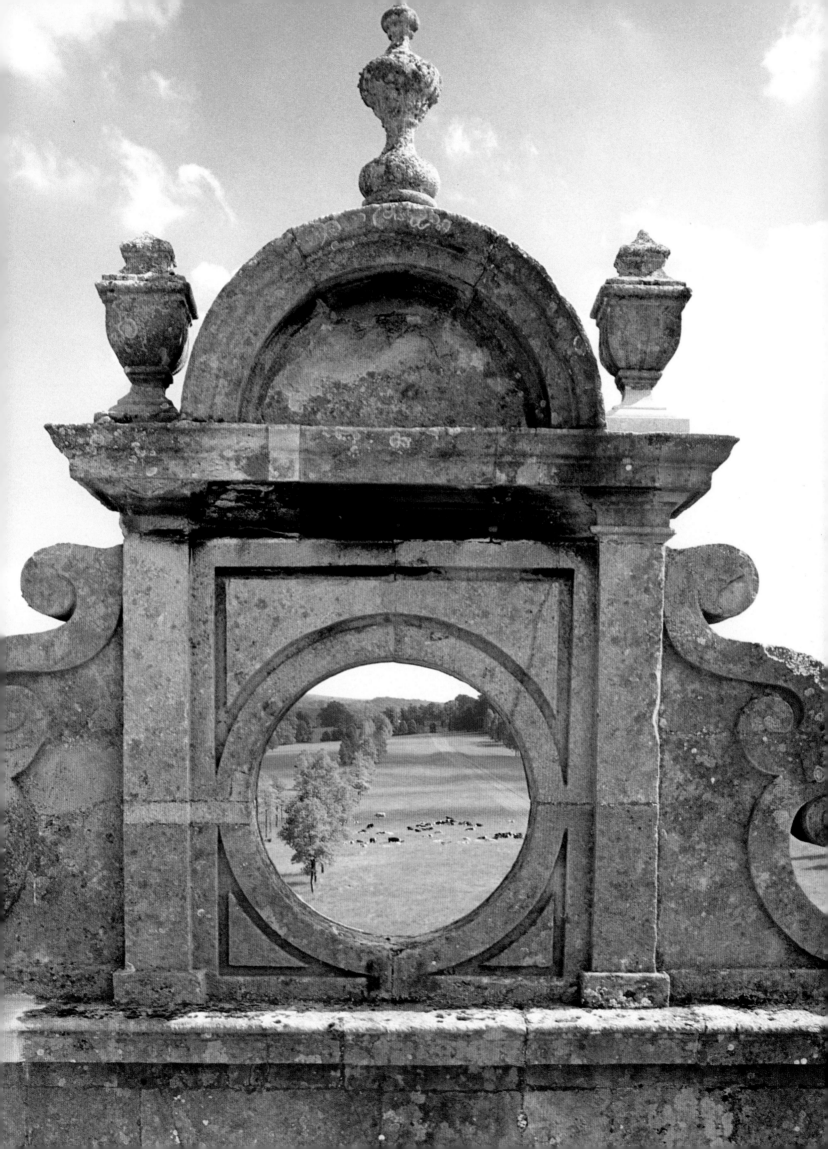

and introduced him to garden designer and writer Gertrude Jekyll and Reginald Farrer, author of *English Rock Garden.* Page's education continued as he worked with his parents in the new garden at Wragby and had his first physical contact with a world he soon would make his own.

Page's sister, Mrs. Bey Corbally Stourton, well remembers that garden. "Our parents bought and enlarged a labourer's cottage down a small lane on the outskirts of the village. They proceeded then to make a remarkable garden of the field in which the cottage was situated. This field had in it at the south end a fairly large pool with banks on the far side and then undulating rough uneven ground which ultimately became a wild garden and bird sanctuary. On the far side of the cottage our parents made an enchanting garden which was called the Dutch Garden. It was of formal paths made of old red bricks in symmetrical lines, paths edged with clipped box and planted in each square different coloured iris."[2]

If Russell Page's feel for plants was hereditary, it came from his mother, whose intuitive knowledge was the inspiration for the garden at Wragby. She went to local flower shows, visited nurseries and other people's gardens, and bought or begged any plant that attracted her. It was she who consoled her son's unhappy school days with brown-paper parcels of flowers and gave him his own corner of the garden in which to indulge his early love of rock plants.

Page spent school holidays making his first rock garden. He often bicycled for miles to find plants and materials especially for it. A local head gardener, Johnny Johnson, who later became director of the school of architecture at Dartington Hall in Devon, shared knowledge of his craft with the young Page. At seventeen Page served an apprenticeship to the art of garden composition that involved making a small stream and rock garden at Flete. He also worked on a rock garden in Rutland for a brother of Mark Fenwick, whose well-known hillside garden is home to an extraordinary collection of plants. Friends began to recommend the young enthusiast to other friends, a pattern that would continue throughout Page's lifetime. The practical back-bending work that these early jobs entailed taught Page that "one cannot be taught to design gardens academically or theoretically. You have to learn the ways and nature of plants and stone, of water and soil at least as much through the hands as through the head."[3]

On a visit to Gloucestershire, Page became acquainted with Mark Fenwick and his famous thirty-year-old garden at Abbotswood, near Stow-on-the-Wold, in the Cotswold Hills. The elderly man was delighted to share his love and knowledge of gardening with Page. Together they visited Lawrence Johnston's Hidcote, which Page acknowledged as the best modern garden he knew and the one that

Preceding pages In the 1930s Russell Page renovated the venerable but somewhat neglected park surrounding Longleat House, thinning out some trees and adding others, in order to enlarge the ancient stands of beeches and lindens.

Opposite When the Marquess of Bath decided to open Longleat House to the public, Page simplified many features near the orangerie; he replaced the Victorian flower beds with a lawn, widened the paths, and repositioned the hedges to suit the new requirements.

Following pages The grounds of Longleat were shaped by some of England's most prestigious landscape architects. Capability Brown was the first to "modernize" them in 1757. Page in turn overhauled some of Brown's alterations in the 1950s when he straightened the approach avenue from the South Lodge and installed the forecourt pools.

most influenced his work. By this time Page understood the importance of the site in garden design, but Hidcote, a self-contained garden existing independently of house and countryside, was a revelation. The green garden rooms that led off from the thickly hedged central walk were a perfect frame for the rich variety of plants. Page saw in them just how important living material was to the foundation of a strong architectural composition.

After completing studies at Charterhouse, a public school, and making rock gardens in his free time, Page began formal art training at the Slade School, University of London. He had always wanted to

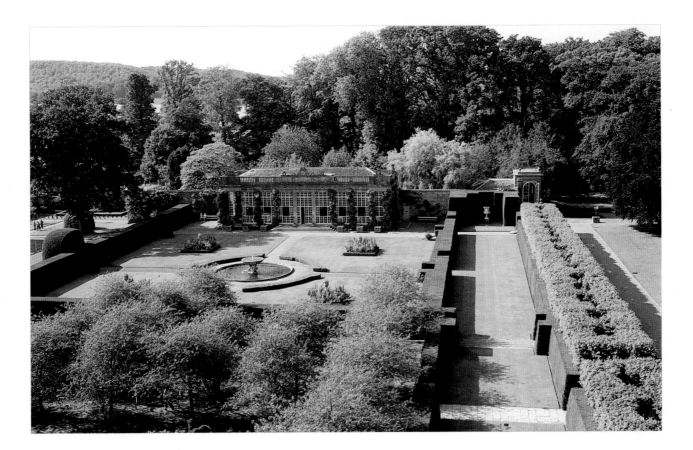

be a painter, but institutions never agreed with him. At the end of three years he coaxed his father into giving him a small allowance and left England to be an art student in Paris. There was still a leisured class in the late twenties and early thirties, and it was a good time for a young man without a fixed ambition to make friends, follow his curiosity and travel, and, in Page's case, garden where and when he could.

Page met many people in France, including André de Vilmorin, whose family had been horticulturists and seed merchants for 200 years, and who would become a friend for life. Another friend, Amos Laurence, a rich, eccentric American who owned Boussy Saint-Antoine, a small château near Paris, found Page odd gardening jobs and introduced him to numerous French gardens.

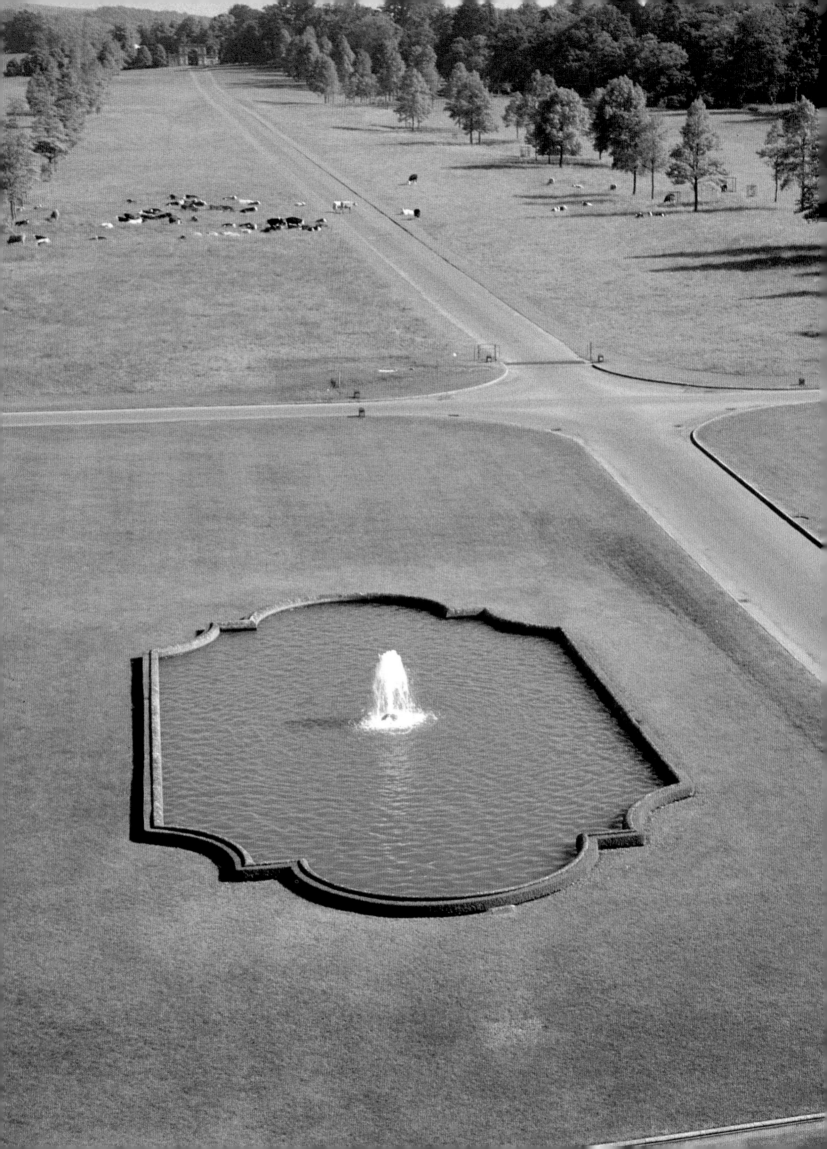

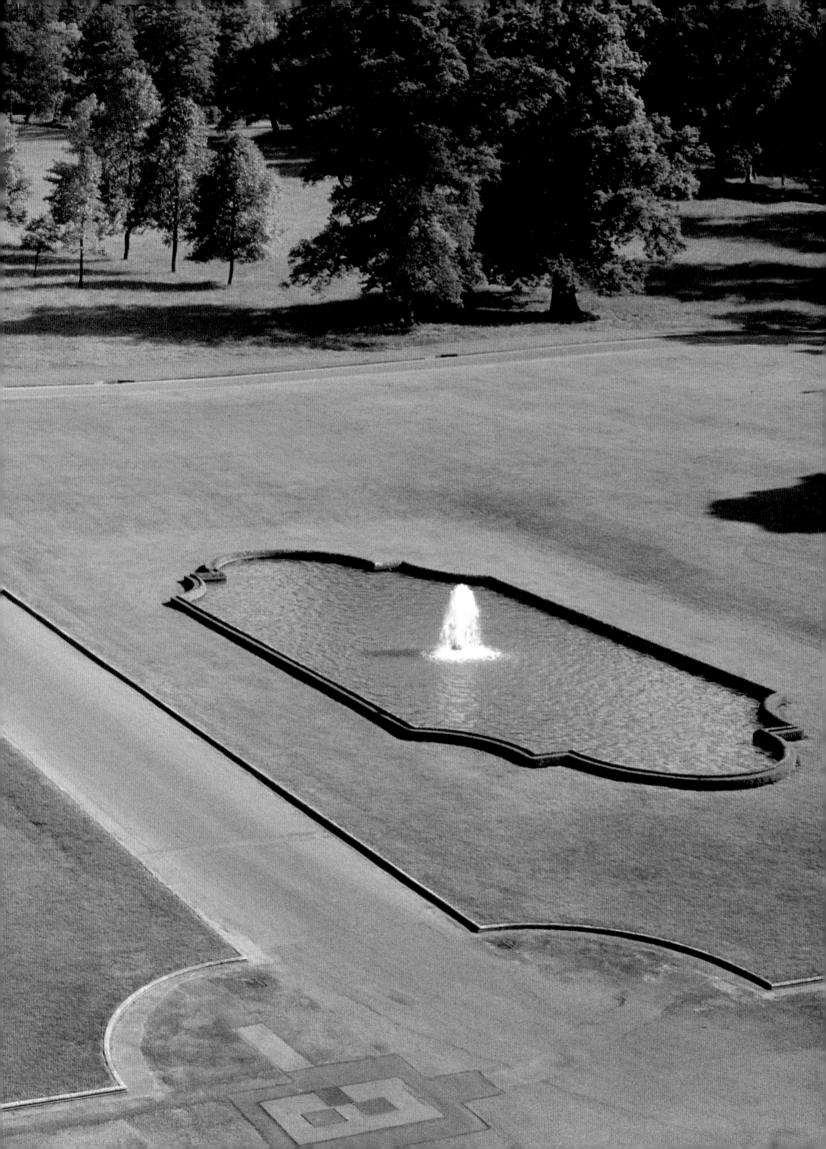

The young Englishman often spent his weekends and vacations at Boussy, which had a fine library of old garden books. Years later Page wrote that he served his apprenticeship to the art of garden design in that library, studying the history and tracing the themes of garden designs from the sixteenth to the nineteenth centuries. He passed part of the summer of 1932 alone at Boussy, trying to draw and measure the gardens he had actually viewed, training his eye and hand to see and remember. He contemplated the clarity of formal French garden design and learned to integrate it with his own ideas. The French logic of line combined with the knowledge, feel, and love of plants that he had developed in England became the base of all his future work.

The pressing need to earn a living soon forced Page to return to London. He found work selling furniture, then held a very minor

Russell Page designed this smaller, separate garden at the back of the orangerie, adjacent to the rose garden, to provide an intimate, secluded area. The columnar yew trees, which give strength and permanence to this green compartment, bear Page's unmistakable imprint.

position drawing planting plans for urban developments in the office of a landscape architect. He was still unsure of the direction his life would take when he had a meeting with Henry Bath in 1932 that proved decisive. As heir to the vast estate and parklands of Longleat House, a magnificent Elizabethan mansion in Wiltshire, Bath asked Page to help him improve the neglected park. Their main tasks were to replant the deer park and one of the main roads to the mansion, Longcombe Drive. Side by side, Bath and Page walked the open parkland, which had been designed by eighteenth-century landscape gardener Capability Brown, marking old trees to be eliminated and staking out new plantings. It was hard work, but both men relished it. Page always did his own staking and got infinite satisfaction from fieldwork.

Longleat was a forerunner of many of the commissions Page would undertake in the future. The project was on the grandest of scales, a park rather than a garden, and Page carried out the work in various

phases over a long period of time. It was not uncommon for him to return to his worksites years or even decades later and turn his attention to new areas.

After successfully tackling the woods and drive of Longleat with Bath, Page was offered the job of reorganizing one of the caves at Cheddar Gorge, a part of the Longleat estate that was open to the public, so that it could be run more efficiently. Here Page was faced with both landscape and architectural challenges. Unsure of his ability to design and build a museum and restaurant or how to resolve the problem of handling large crowds in a limited area, he joined forces with Geoffrey Jellicoe, the founder of the Institute of Landscape Architects. This venture led to a number of other collaborations: the formal gardens at Ditchley Park, an eighteenth-century house; a

Page felt that the Longcombe Drive, lying in a sheltered valley enclosed by beech groves, was the perfect area to grow azaleas and rhododendrons, nonnative shrubs that he had eliminated from the deer park, where he thought them ill matched to the old English landscape.

planting guide of the village of Broadway in the Cotswolds; a terrace and gardens at the Royal Lodge in Windsor Great Park; and plans for harmonizing the circulation of people around the school buildings and open areas at Charterhouse. This partnership, Page's only one, lasted until the outbreak of war in 1939.

At Ditchley Park Page met Stephane Boudin, a world-famous French decorator (who made the reputation of La Maison Jansen in Paris); it was another meeting of great consequence in Page's career. Page admired Boudin's work and suggested him to a London client, and after this recommendation, Boudin never decorated another house in Europe that needed a garden without bringing in Page as the landscape designer.

Page and Boudin were a study in contrasts. Boudin was a small, rotund Frenchman who spoke in a rapid, concise manner. Page was tall, thin, tentative, and shy, ill equipped to perform the role of a

professional with clients. He could be either brutally outspoken or taciturn. The more diplomatic Boudin taught him to explain his ideas with more clarity. Each man valued the other's talents and expertise. "Knowing his own field so well," wrote Page of Boudin, "when he turned his attention out of doors, he could understand the complications and possibilities of garden design without any specialised knowledge."[4]

Boudin lured Page from his work with Jellicoe whenever his own projects called for a garden designer. But it did not take too many working trips in Boudin's wake to bring the Englishman to the realization that most of the projects required imitation, or at least adaptation, of the classical French garden style. Boudin's clients owned restored châteaux or large houses that were often surrounded

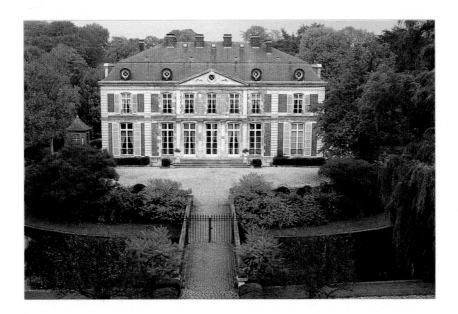

by or near landscapes and gardens designed in the grand manner. Page considered these copies "borrowings" and "fashions rather than styles,"[5] and thus, like all fashions, rapidly dated and dull. Unfortunately, they were the usual frame he was given to work within when not asked to create new formal gardens.

In 1937 Page crossed the Channel to join Boudin and a young architect named Jacques Regnault, with whom he would continue to work over the years, on a project for Albert Prouvost at Le Vert Bois, a château in northern France near the Belgian border. Boudin was commissioned to redecorate the late-eighteenth-century-style house; Regnault to add a basement room to the building; and Page to design a garden to disguise the transformations and create a link between the château and its seventeenth-century Flemish-style brick gatehouse. He solved the problem by creating a rise in the ground and tracing a curving brick-walled moat between the château and the older brick

LEFT *The château Le Vert Bois, in northern France, was Russell Page's opportunity to execute a grand design from scratch. He rerouted a nearby stream to form a moat and built a bridge to connect the château with the gatehouse, accentuating it with clumps of sumac trees.*

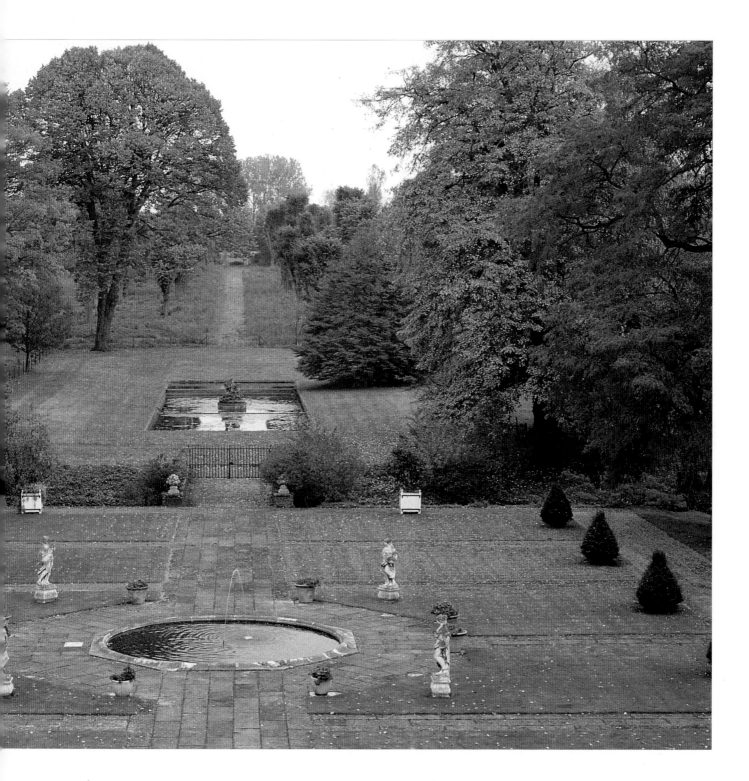

ABOVE A parterre on the north side of the château evokes the grand manner of a previous century with the simplest of means: paving stones, circular and rectangular pools, and a handful of clipped yews.

building. He diverted water from a distant stream to encircle the château and then loop around a meadow before rejoining its source. Page placed two weeping willows on the far corners of the moat to mark the boundary between the French formality of the château and the rustic gatehouse. The water, a mirror often ruffled by the wind, reflects the hanging branches and brings the wide sky down into the composition. It was here at Le Vert Bois that Page began to find the balance between creative improvisation and interpretation that he was to master with measure and clarity later that same year at Mivoisin.

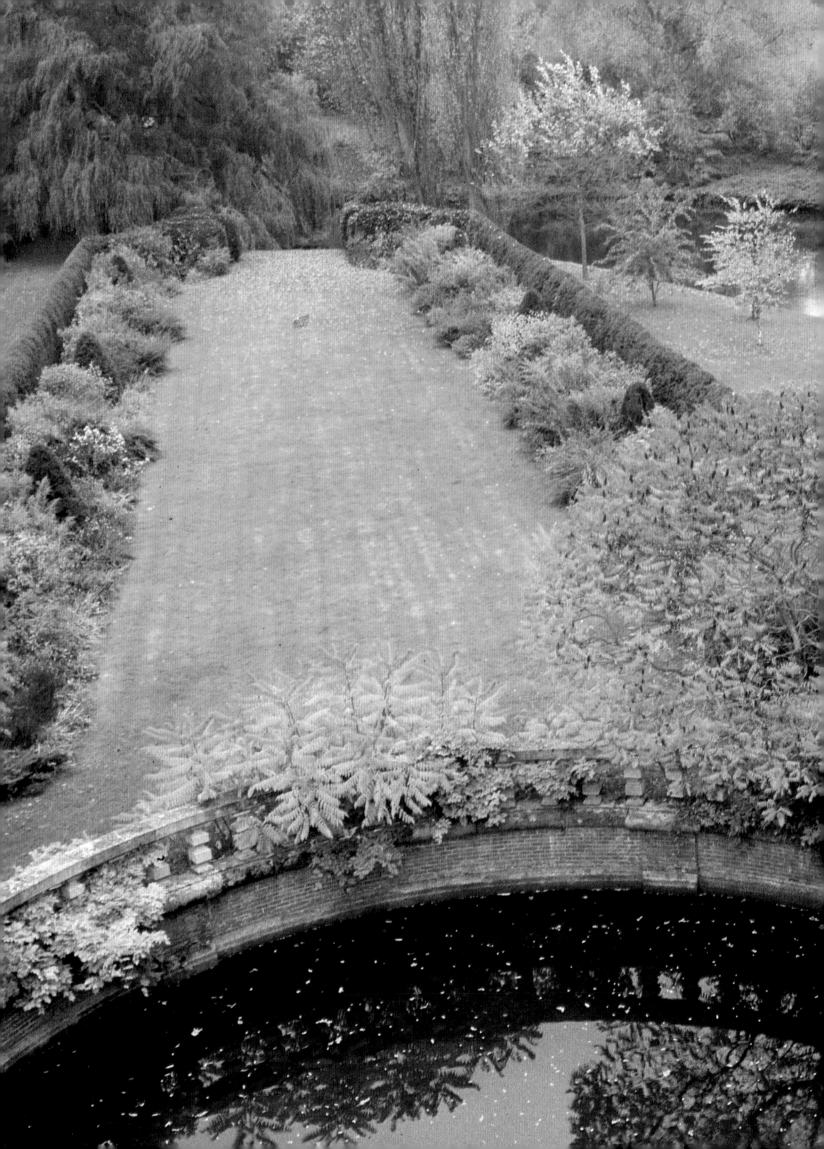

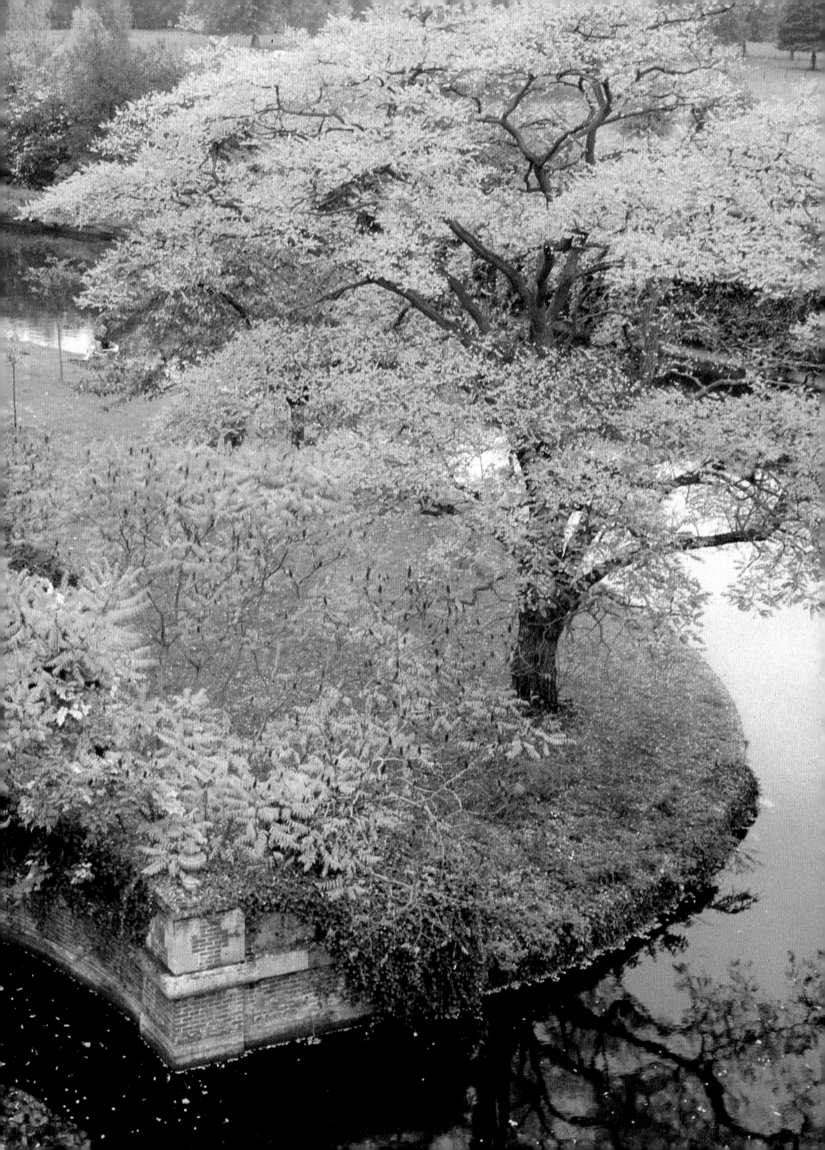

Boudin was redecorating the château of Mivoisin, a lovely six-teenth-century hunting lodge on the river Loing 100 miles south of Paris. Page was asked to collaborate again with Regnault in designing, situating, and building a new courtyard with stables, garages, and a gun room, in addition to redesigning the estate's late-nineteenth-century formal gardens. The huge property belonged to Marcel Boussac, a textile magnate who subsequently became the founder and owner of the House of Dior. A conventional man, he was, neverthe-less, quick to appreciate and retain men of exceptional quality in their particular field. His alliance with Page, in fact, continued after World War II, when the garden designer returned to Mivoisin in 1946.

In many respects, the task Page faced at Mivoisin was comparable to that at Longleat: Both were grand and ambitious undertakings that

Preceding pages At Le Vert Bois a double shrub and flower border is appropriately tucked away between hedges on the east side of the moat. Water adds depth and interest to the monotony of the Flemish landscape.

Left Always as interested in the details as in the overall planning, Russell Page designed this charming "théâtre de verdure" at some distance from the château de Mivoisin, where it catches one by surprise.

Opposite At the château de Mivoisin, Page was inspired to alter the course of the river Loing in order to create a pond in the château's main view. It was an ambitious scheme, since permission had to be sought from the notoriously slow French authorities.

took marked departures from the past and required many phases of alterations. They demanded a person with not only the daring and talent to conceive new plans but also the conviction and authority necessary to persuade the owners that he was doing the correct thing. Surely, it must have been as difficult to push Boussac into horticultural change as it had been to overrule Capability Brown's designs at Longleat. The success of these two mammoth projects attests to Russell Page's creative mind and the authority with which he worked.

The slender river Loing, bordered by tall poplars that were a favorite subject of the Impressionist Alfred Sisley, ran through the grounds at Mivoisin near, but unseen from, the house. Page chose to alter the river's course to bring life to the rather dull landscape in the central axis of the château. This meant not only resolving the technical problems of ground levels and water power but also tackling the traditionally stagnant French bureaucracy whose permission was needed to alter

the course of any river, even by just a few feet. Page succeeded, however, and on its new course the Loing curved through the park before it became a canal en route to a water mill. He further widened the loop near the château to form a small lake bordered on the far side with clumps of weeping willows and accented by a few poplars placed to enliven the flat skyline at the end of the perspective. Years later, still unsatisfied with the view, Page added a long, shallow basin in the rectangular lawn, flanked by two miniature brick pavilions. Growing up in the level countryside of Lincolnshire, he had learned that a sky reflected in water adds depth and movement to a scene.

Page changed many other features at Mivoisin over the years. Referring to the high wrought-iron grille work that enclosed the château, he told Boussac, "You've put your house in a prison."[6] He

replaced the fencing with hornbeam hedges backed by pink horse chestnuts. Nor did Page like the French municipal-type garden of formal beds and flaming red salvia on one side of the château. Forbidden by the owners to get rid of what he considered a horror, he framed it with a strong hedge of clipped yew topped by a rhythmic play of topiary domes, which were echoed by fat balls of boxwood set in curved beds of flat clipped box and clumps of lavender. He took great pleasure in designing a miniature *théâtre de verdure,* a homage to the gardens at the Villa Marlia in Italy, with backdrop and wings shaped in yew. He set it off to the side, an unexpected surprise, barely visible from the château.

All the unforeseen landscape problems at Mivoisin kept Page challenged while he continued the routine jobs of planting new hedges and trees, cutting allées through the park, and "finiking" (as Page referred to the dull tasks) the planting in the formal gardens. Since

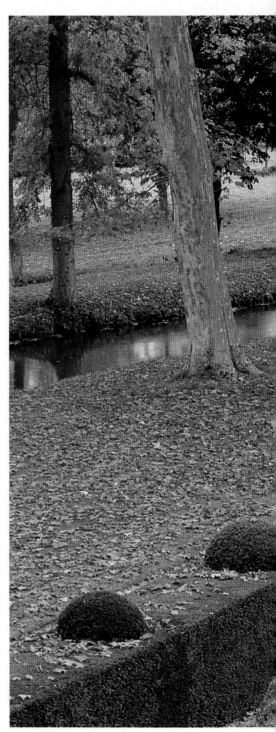

LEFT For the west side of the château de Mivoisin, Page designed a small parterre around an Italian stone well.

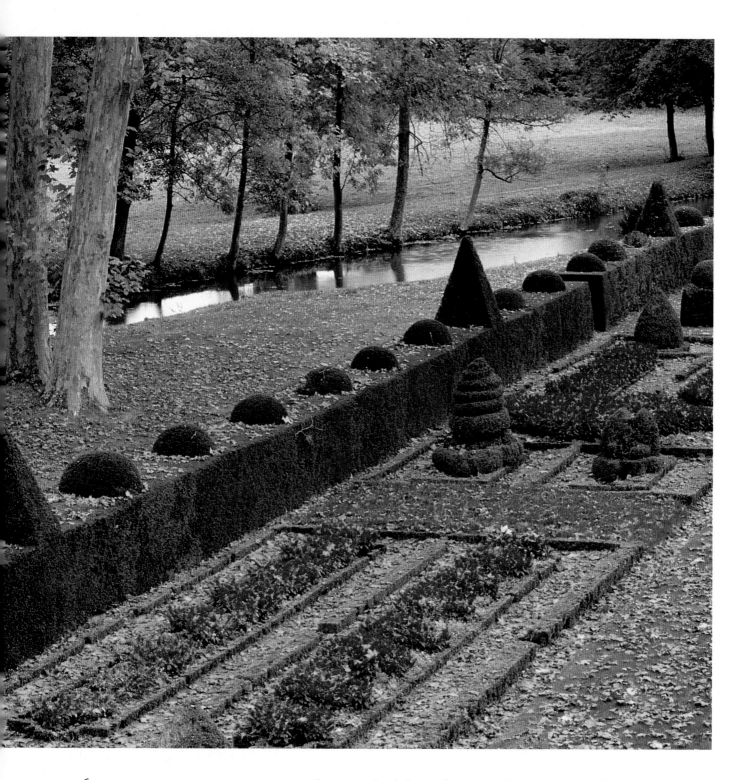

Above The view from the château's first floor reveals the stream in the back, separated from the main parterre by a hedge planted by Page, who as a rule preferred parterres to be in an enclosed space.

architecture had always fascinated Page, he enjoyed helping to design all the buildings and stonework that Regnault had been commissioned to build on the estate. The question of "linkage" further stimulated him, as he sought the key to such problems as anchoring the château to the landscape and planning new stables between the house and the vast complex of formal and kitchen gardens. But he seemed to have found guiding principles for such situations: "Carefully studied proportions and changes in level and an asymmetrical composition weld . . . disparate elements,"[7] he explained.

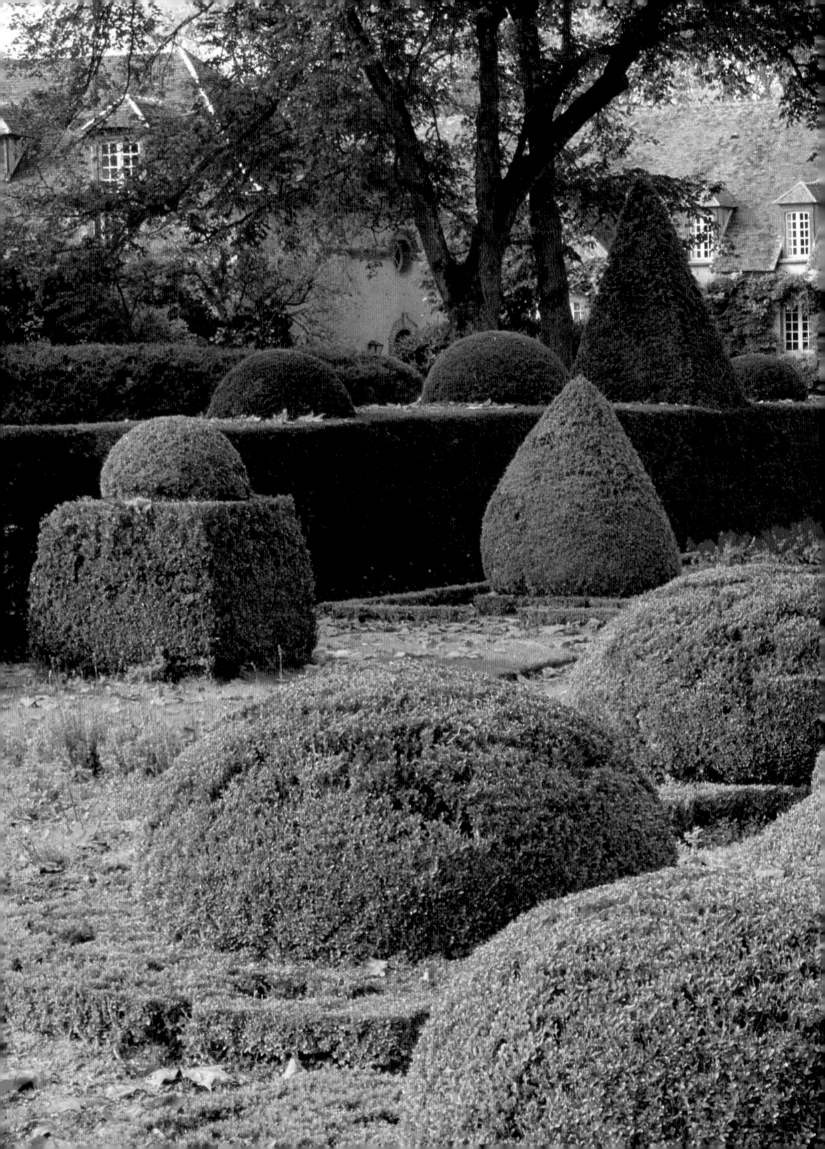

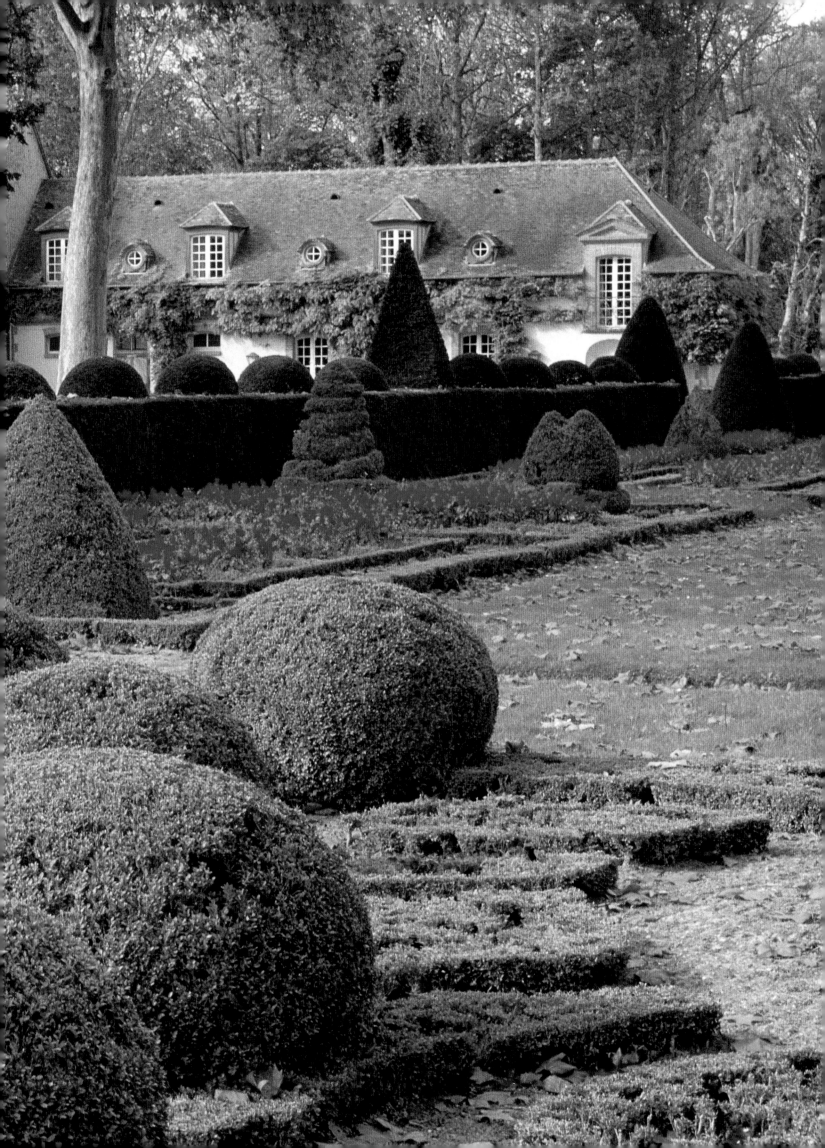

In 1948 the particular problem of uniting distinct components into an integrated whole brought Page back to England. After World War II Henry Bath, now the sixth marquess of Bath, faced massive death duties on run-down lands and a house in shambles. "The Mad Marquess," as the press forthwith dubbed him, made the unconventional, imaginative decision to open his inheritance to the public.

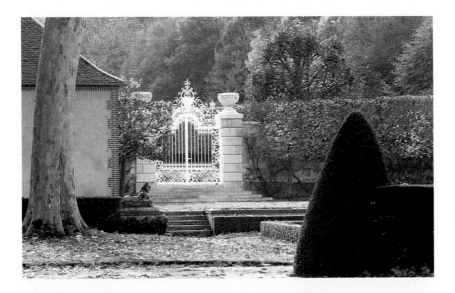

Preceding pages Page emphasized Mivoisin's existing parterre by planting fat box balls that echo the motif of the surrounding hedge, thus tying them together and creating a harmonious whole.

Left, above At Mivoisin well-defined changes in level, correctly scaled hedges, and generously proportioned gates were keys to Page's work. The white gate leads to a walled garden.

Left, below Page gave even these steps leading to a utility area a formal treatment. The ramps in the center of the steps are for wheelbarrows.

Opposite Page designed this small parterre, planted with begonias in two different shades of red, to fill the space between the stables and the château.

He asked his friend Russell Page for assistance in linking Longleat's stately past to a future of visitors and tourism.

Page was as enthusiastic as ever about trying something new. He had had time to rethink the relationship between the magnificent High Elizabethan architecture of Longleat House and the Romantic pastoral park landscaped by Capability Brown. Brown had suppressed the estate's original seventeenth-century French- and Dutch-style gardens of patterned, interlocking designs to bring in his naturalized landscape. Page disagreed with Brown's decision: "British tradition

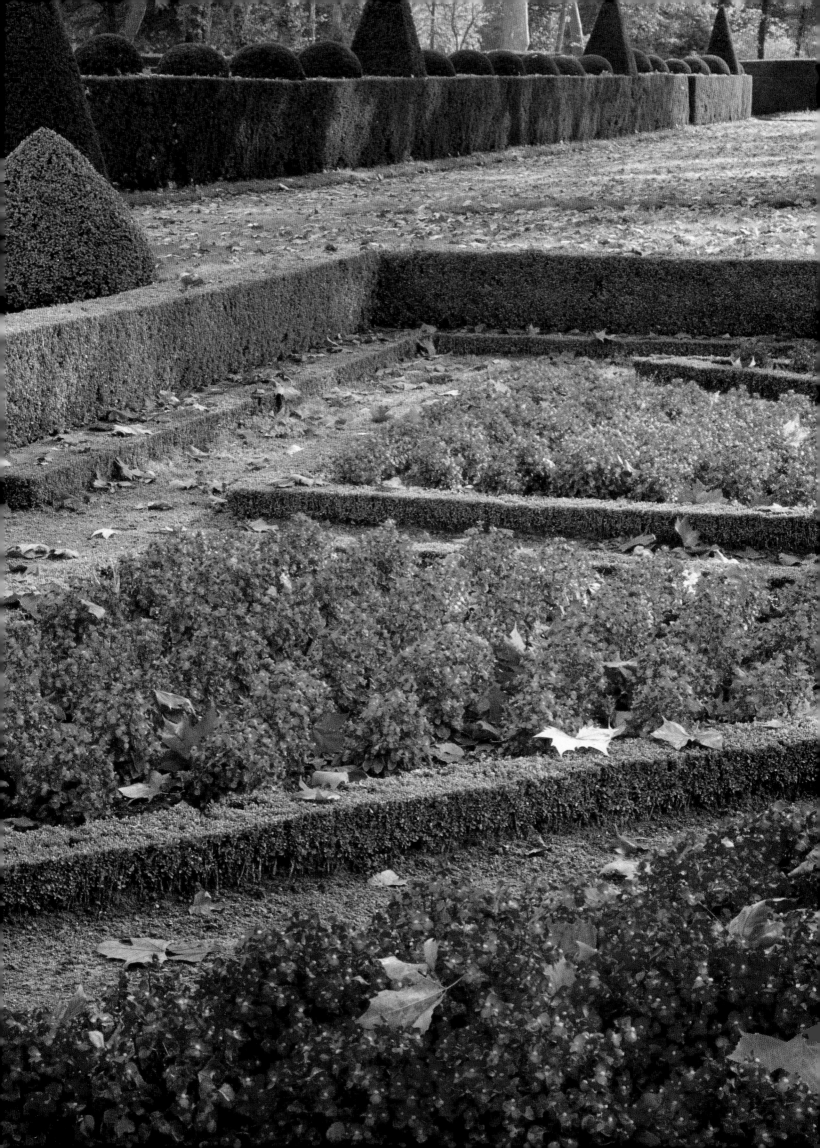

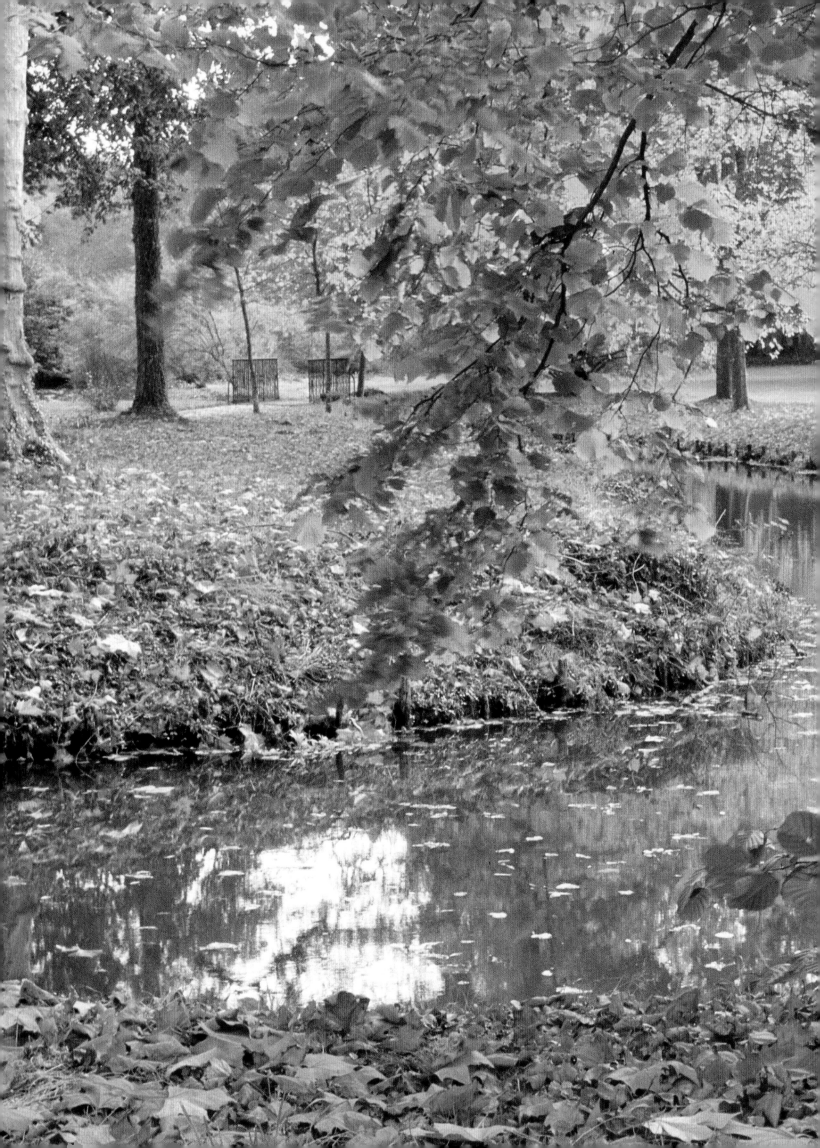

sets the great country house in a green breadth of park but the rectangular forms of a Renaissance house were originally reflected in a surrounding complex of enclosed gardens."[8] He added a large grassed allée of fifty-two pleached linden trees (*Tilia europaea*) (as many trees as chimneys on the roof of Longleat), clipped yew hedges, and cypresses to emphasize the architecture of the building. The allée also provided ample space for the flow of large numbers of visitors.

In dealing with the question of the circulation of people in public gardens—a problem that continued to fascinate Page throughout his career—Page looked to Vaux-le-Vicomte and Versailles in France, whose unusually broad avenues and majestic allées were destined for the large number of people that made up the entourage of the king and myriad daily visitors. At Longleat the marquess hoped for even bigger

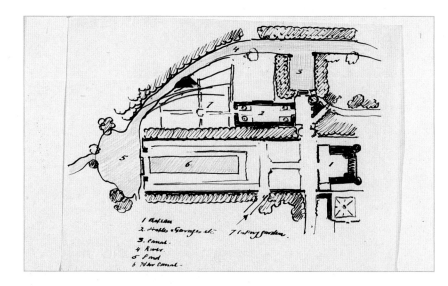

Preceding pages Page diverted the river to create a small, natural-looking peninsula planted with plane trees and hazelnuts on the periphery of Mivoisin.

Left A sketch by Russell Page shows the various buildings, the river, pools, and ponds that he designed for Mivoisin.

Opposite One of Russell Page's favorite devices for enlivening a dull landscape was to use a body of water to mirror the sky. The rectangular pool, number 6 on the sketch, is on the main axis. Page was also responsible for the design of the two flanking pavilions.

crowds. Page carefully calculated a network of wide paths and allées, with bold effects and simplified plantings to hold the attention of passing groups of people. The last traces of the garish, labor-intensive Victorian garden beds, which had been furnished with 40,000 new bedding plants every year, were cleared away and replaced by four box-edged squares set in a lawn around a circular fountain. The massive yew hedges near the orangerie were repositioned and moved back by twelve feet, as there was no time to start growing new shrubs.

For the areas surrounding the orangerie, Page designed a simple peacock topiary garden that also included Japanese crabapples (*Malus floribunda*) and roses near a 150-year-old black locust (*Robinia pseudoacacia*), echoing the gardens' free-wandering white peacocks, which, incidentally, he hated. Behind the orangerie, he made a walled secret garden around the statue of Sir Jeffrey Hudson, a dwarf who had been presented to King Charles I in a pie. Next to this garden, which was planted with circular beds of shrubs and roses, he designed a small

and rather severe evergreen garden with bold yew columns and hedges. Earlier he had created long, intricately patterned formal rose beds alongside the linden allée and the house.

Page returned to Longleat yet again in 1950 to redesign the curved avenue between the house and the South Lodge. He replaced it with a straight drive, which he flanked with tulip trees, as their predecessors had fallen victim to Dutch elm disease. Later, he began to work on Capability Brown's Pleasure Walk. The present-day Lord and Lady Bath, both keen gardeners, have changed some of the original plantings but otherwise have preserved Page's design.

Russell Page's professional point of departure was on a grand scale in the grand manner. The projects at Longleat, Le Vert Bois, and Mivoisin were demanding and complex for a young man at the start of his career. At Longleat he followed in the footsteps of England's two great eighteenth-century landscape artists, Capability Brown and Humphrey Repton. The long summers of travel and study in France and the influence of Le Nôtre's classical clarity prepared him for gardening in the French style at Le Vert Bois and Mivoisin. But despite the obvious impression his forebears made on him, Page learned how to adapt rather than imitate. Above all, he learned to link the house to the garden, the garden to the site, and the corresponding style of architecture to the whole—to link, in effect, the past to the present.

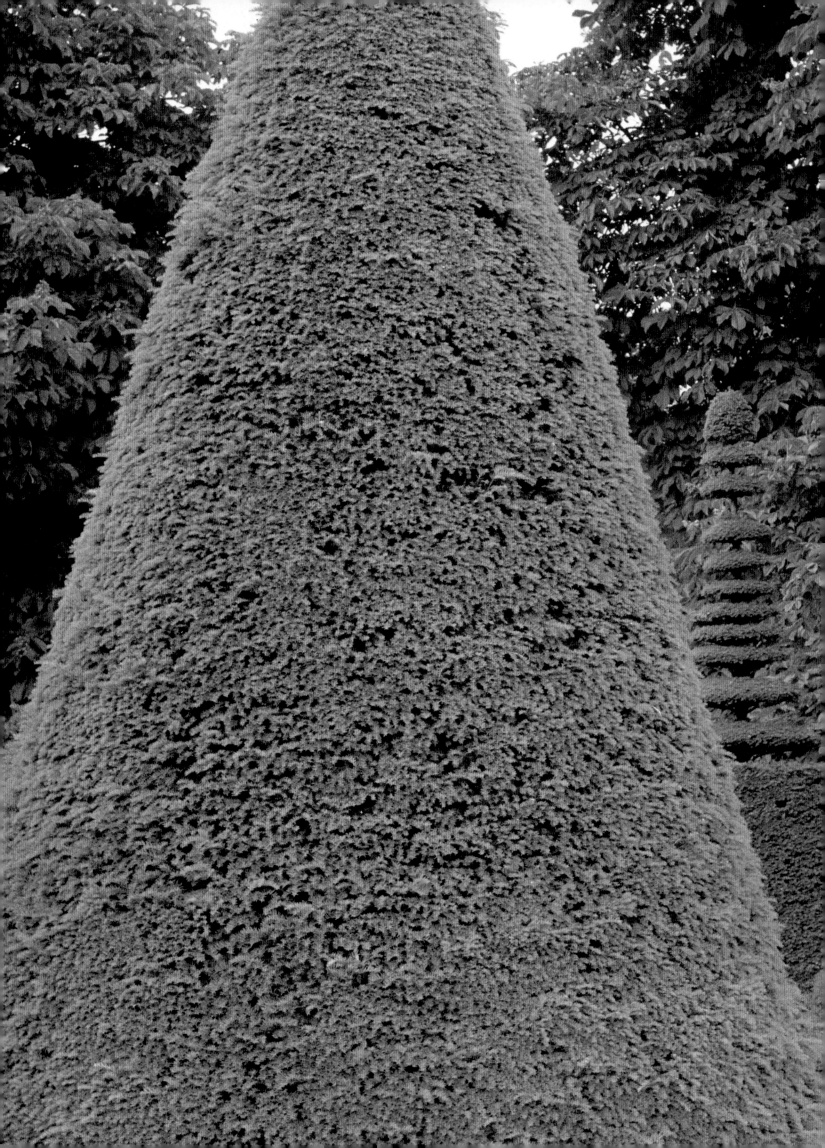

Chapter 2

Postwar Gardens

World War II proved to be a disruptive force even in the lives of the rich, many of whom saw their personal fortunes destroyed, as well as, consequently, their particular style of living. The studied opulence of château life, for example, was finished. After the war, Russell Page wrote, it was "no longer possible even in the great houses to find the footman who would carry the wicker tables and chairs, the chintz cushions and all the shining paraphernalia of tea across the wide lawns to the cedars' shade."[1] ❧ Before 1939, the typical English country house had ten gardeners or more. After 1945, two or three men had to do all the work, and they were hard to recruit, as many no longer wanted to be "in service." With the scarcity of hired help, in many homes the kitchen garden as a luxurious adjunct of grander gardens had to be given up first, soon followed by the elaborate flower beds and borders. The country-house garden had to be redesigned to survive in a new era of limited available labor and rising maintenance costs. Despite these necessary adaptations, there were still people who wanted their gardens to reflect a certain elegance. ❧ The gardens Russell Page designed during the postwar years of the 1940s and 1950s are proof of his ability to adapt his style and vision, while betraying neither, to suit his clients' desires and the demands of a changing world. He continued to develop his versatility in both the English and French large-scale garden traditions, but now he also began to design a series of smaller gardens that evoked the grand manner in miniature. His postwar work included both the private and the public—the smaller intimate garden as well as the ephemeral large public exhibition. ❧ Page had spent the wartime years abroad working for the Political Warfare Department of the Foreign Service in the Middle East and Southeast Asia. Demobilized late in 1945, he returned to London without money or occupation. The transition was abrupt and painful; at first, like many others, he was lost in this new world. By chance, he happened to meet the Austrian Expressionist painter Oskar Kokoschka. Page showed Kokoschka some of his wartime drawings and after this encounter began to paint again. Page found that the self-imposed discipline of painting quietly stripped away

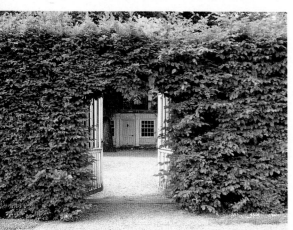

ABOVE A wooden gate in a hornbeam hedge allows a glimpse of the eighteenth-century pavilion, set under two old chestnut trees, at the garden of a property known as the Creux de Genthod.

OPPOSITE At the Creux de Genthod, Page not only assisted in simplifying the garden but took the liberty of making this eastern axis leading to the Lake of Geneva its main view.

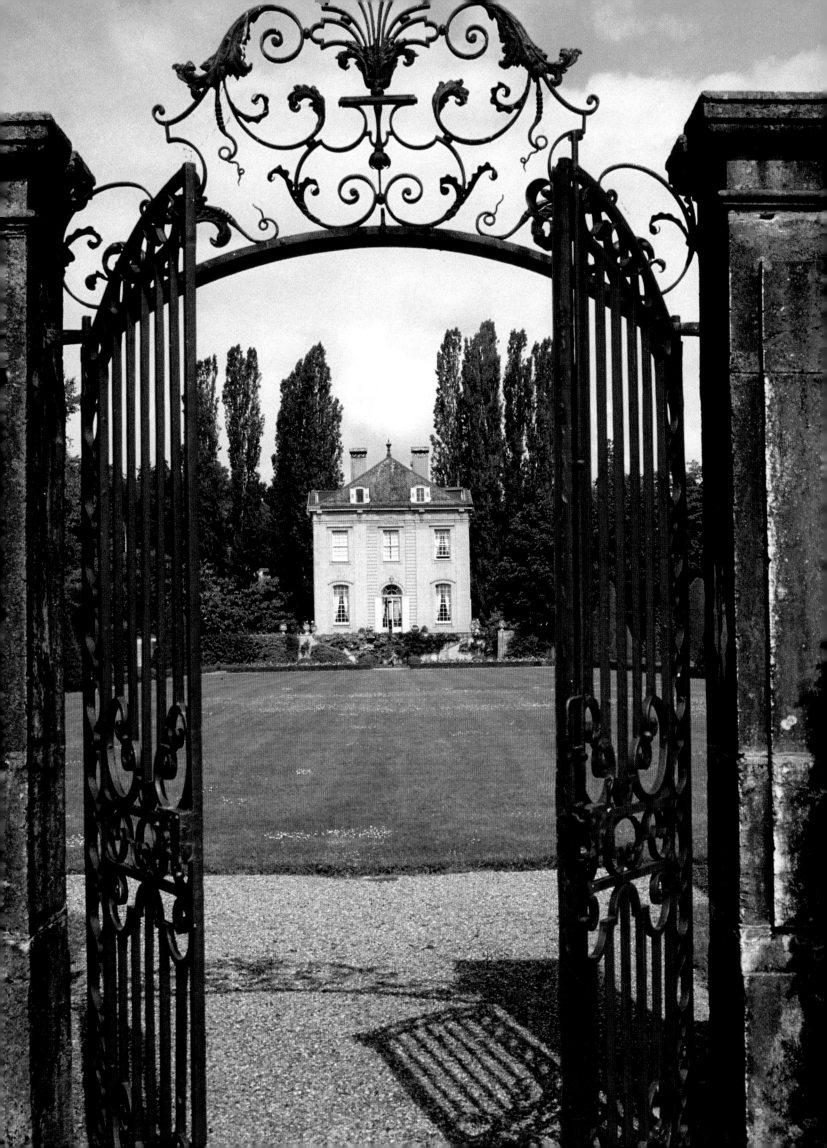

the exhaustion of the war, the tensions and superficialities of daily life. In thus reawakening his "eye" he rediscovered the artistic sensitivity he needed for a fresh start in designing gardens.

On a visit to Paris, Page renewed his friendship with Stephane Boudin, who helped him find a number of prestigious commissions, including the opportunity to resume work at Mivoisin and Le Vert Bois. Page said of those first postwar years: "It was not easy to start again. For several years I had been, like everyone else, a small cog in a large machine. Now I had to make my own policy, take my own decisions and stand on my own legs again. To discuss lawns and

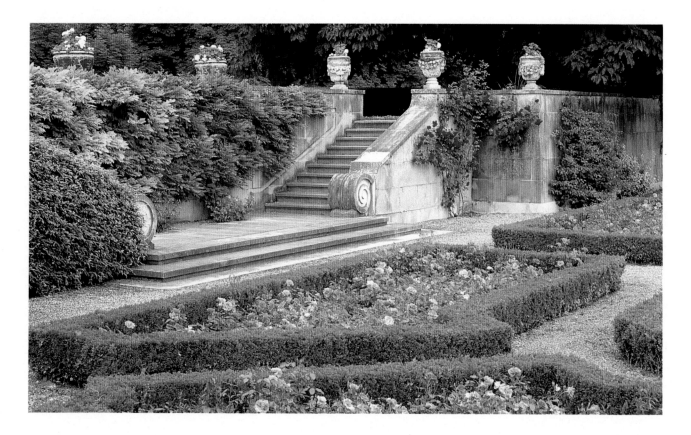

flower-beds at first seemed strange enough, and I had to learn to draw garden plans all over again. My first job, which was to plan a small garden in Paris, almost gave me sleepless nights, so lost and uncertain did I feel in a profession I had for years thought of as gone for good."[2]

Around the same time, Page contacted his old friend from his art-student days, André de Vilmorin, who had assumed the running of his family's seed and horticultural business. Vilmorin was convinced that the time was ripe to popularize the idea of smaller gardens that required minimal maintenance in France. During the war years, the French had become used to growing their own fruit and vegetables. Now, he believed, they could be persuaded to grow flowers. The Frenchman asked Page to join him in this campaign and offered him an office of his own, from which he could continue his grand projects

Russell Page designed and built this elegant double staircase to replace the rough grass bank on which the eighteenth-century mansion had been situated. Page softened the contours of the new sandstone walls with plantings of wisteria, Cotoneaster salicifolia, *and japanese quince.*

for the wealthy with Boudin, counsel the Vilmorins, design easily maintained smaller gardens in France and around Europe, and introduce plants, trees, and shrubs to France that had been developed on the trial grounds of the Vilmorin family château. And so Page's life of professional independence began in a small office on the quai de la Mégisserie, located in the heart of old Paris. Clients came from far and near to reserve his time and talent. Never again did he go into partnership with another landscape architect or take on assistants, although he was always helpful and kind with the young starting out in the field.

Despite his professional status, Page had an ambivalent attitude toward the financial side of his practice. Perhaps it was a combination of his pride and upbringing, as well as his total absorption in creative problems, that made him feel uncomfortable discussing cost with his clients. When working alone without Boudin, he usually sent a bill at the start of a job, a small fixed consulting fee, which he rarely followed with another bill. As he grew more well known, he was only at ease working for friends or people he liked. Then, of course, it was even more awkward for him to speak of money. This reluctance on his part did not prevent Page from using costly installations if he felt they were the best solution for the site, but fees were not, for the most part, forthcoming.

The early postwar period was, nevertheless, an active time for Page, and the variety of work that came his way suited his character. Many of the jobs were small-scale gardening exercises. He designed a small garden for Jean-Louis Barrault, the French actor-director, near Paris; a heather garden outside of Orléans for a ducal family; a garden with a Roman dry wall near Chantilly; a garden designed with privacy in mind for Prince Aly Khan on the Lake of Geneva; and many others. Some of these, unfortunately, are no longer in existence, such as one, now buried under cement, that he had designed for the Duke and Duchess of Windsor. After the war they had acquired a mill at Gif-sur-Yvette, near Paris, that they named the Moulin de la Tuilerie, and they called on Page to help them make a proper English cottage garden there. Page was in perpetual consultation with the duke over every detail of this small but concentrated enterprise. He was becoming an expert at designing small gardens in which every nook and corner were utilized, using flowering shrubs to reinforce herbaceous plantings to give the whole body, weight, and point.

The plantings of many of these smaller-scale gardens show Page's adept handling of the limitations of the new era, which he accepted just as calmly as he did the natural limitations inherent in every garden site. If a client wanted a garden in the old grand manner, he devised arrangements to suggest, rather than elaborate, a certain formality. He

substituted simple but suitable hedges and flowering shrubs for the intricate flower schemes that needed the constant attention of gardeners no longer available and replaced complicated borders and parterres with grass and trees.

What distinguished Page from other designers, however, was the sensitivity and clarity of style he combined with his respect for the

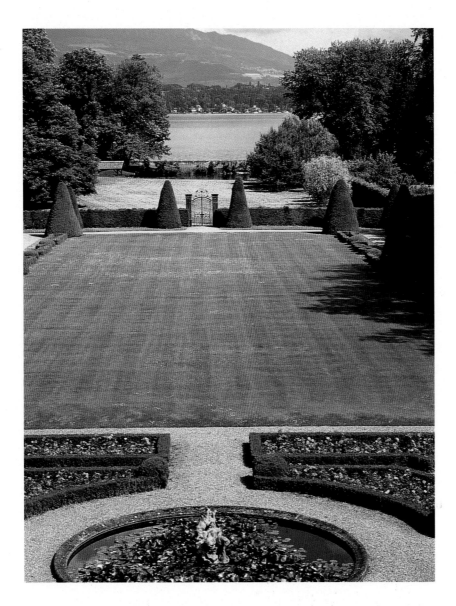

Left and opposite This lawn, located on the lateral axis that leads from the east side of the house to the lake, is on the site of the manor's former walled kitchen garden. Page designed a formal rose parterre and a round pool with a bronze sculpture by Bourdelle to highlight the transition from the lawn to the staircase that leads up to the house.

site's existing constraints. He always considered the style and architecture of the house, as well as the surrounding landscape, the climate, and the nature of the soil. Although these variables and the client's likes and aversions imposed further restraints upon him, they also provided new ideas and solutions when handled with ingenuity. Page was intent on an original and creative approach whenever faced with a new setting. His aim was to create a harmonious whole by working hand in hand with nature and enhancing some existing features, while avoiding trendiness and fashion. The result, most apparent in his best

gardens, is a balanced and timeless congruity of the natural and the man-made.

Page's success in redesigning the grounds of small châteaux and manor houses was due in part to his study of past landscaping styles and earlier architecture. As his reputation as a landscape architect with taste and an educated eye grew, he was often consulted by the owners of fine country houses to do their gardens. André Firmenich, owner of the Creux de Genthod, an elegant eighteenth-century Swiss house on the Lake of Geneva, had attempted to remodel his garden himself. He had eliminated a walled kitchen garden on the east side of the

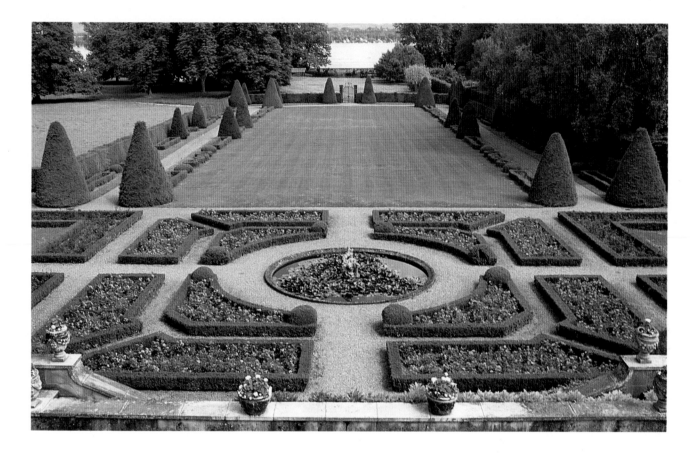

house, as it blocked a splendid view of the lake and Mont Blanc in the distance. But after the walls of the vegetable garden had been taken down, the house was left sitting on an ugly grass slope, facing a long expanse of lawn bordered by yew hedges. Other parts of the garden were but an incoherent remainder of what had originally been a grand formal garden.

Firmenich, unable to link the house to the garden in a cohesive manner, realized he had major problems that needed professional handling. Page immediately saw that the eighteenth-century architecture of the house was of such high quality that it would not tolerate any trifling with its surroundings. To establish a compatible garden setting, he followed one of his basic principles: to adhere closely to the

style and material already on the site. After long reflection, he replaced the grass bank on the east side with a terrace and long retaining wall made from the same green sandstone as the house. He had a double staircase descend from the terrace, with each flight of stairs flanked by a parapet, ending in a simple fat scroll: an eighteenth-century design that nicely complemented the style of the house. The two squared-off bottom steps led to a parterre of box-edged rose beds. A circular stone-rimmed pool was positioned in the middle of this axis to emphasize the view to the lake. The transition from the house to this garden was further strengthened by a thick planting of Japanese quince, wisteria, and *Cotoneaster salicifolia* on the retaining wall. In addition, six large English stone vases were spaced out along the top of the wall. The bank leading to the big lawn on the north side of the house, which replaced the main parterre of the original design, was reshaped into a semicircle and planted with curving box hedges. Off to the side of the eastern prospect, Page converted a wood yard into a simple courtyard. At the far end, he installed an eighteenth-century miniature wooden summer house under two old chestnut trees to provide a focal point from a wooden entrance gate. On one side of this courtyard, he designed a walled flower garden for Madame Firmenich's gardening pleasure. Thus the garden at the Creux de Genthod was reinstated to its former

Page felt that a garden should never compete with a dramatic view, such as this one from Schloss Freudenberg.

glory, its style reflecting the eighteenth-century manor house. Easy maintenance has helped ensure its survival as one of the purest examples of Page's harmonious yet permanent garden settings.

Another Swiss château that Page addressed in the 1950s, Schloss Freudenberg, presented him with landscape problems similar to those of the Creux de Genthod. Built in the thirties, south of Zurich on the Lake of Zug, it belonged to an English expatriate married to an illustrious Swiss banker, Eleanor Hürlimann, who later became Lady Glover. The main view from the central terrace led over magnificent apple orchards toward a placid lake backed by jagged mountains; a panorama that was bound to distract from any garden in the foreground. Page decided it was better left alone and installed a simple lower terrace to make the descent to the orchard below appear more gradual. The terrace itself was unadorned, save for some flowerpots. Recently, yew cones were put in as a means of framing the view. Page also placed two rose parterres alongside the wings of the château to lend formal emphasis to the building. Attached to one side of the house was a terrace enclosed by some bare trelliswork. At Page's suggestion it was covered in greenery and is now a charming outdoor room with openings through which the eye can wander over the

Page left the foreground terrace of Schloss Freudenberg simple, merely adding steps and a lower terrace in order to ease the transition from the house to the orchard below. Rather than distract from the view, the resulting garden leads the eye to it.

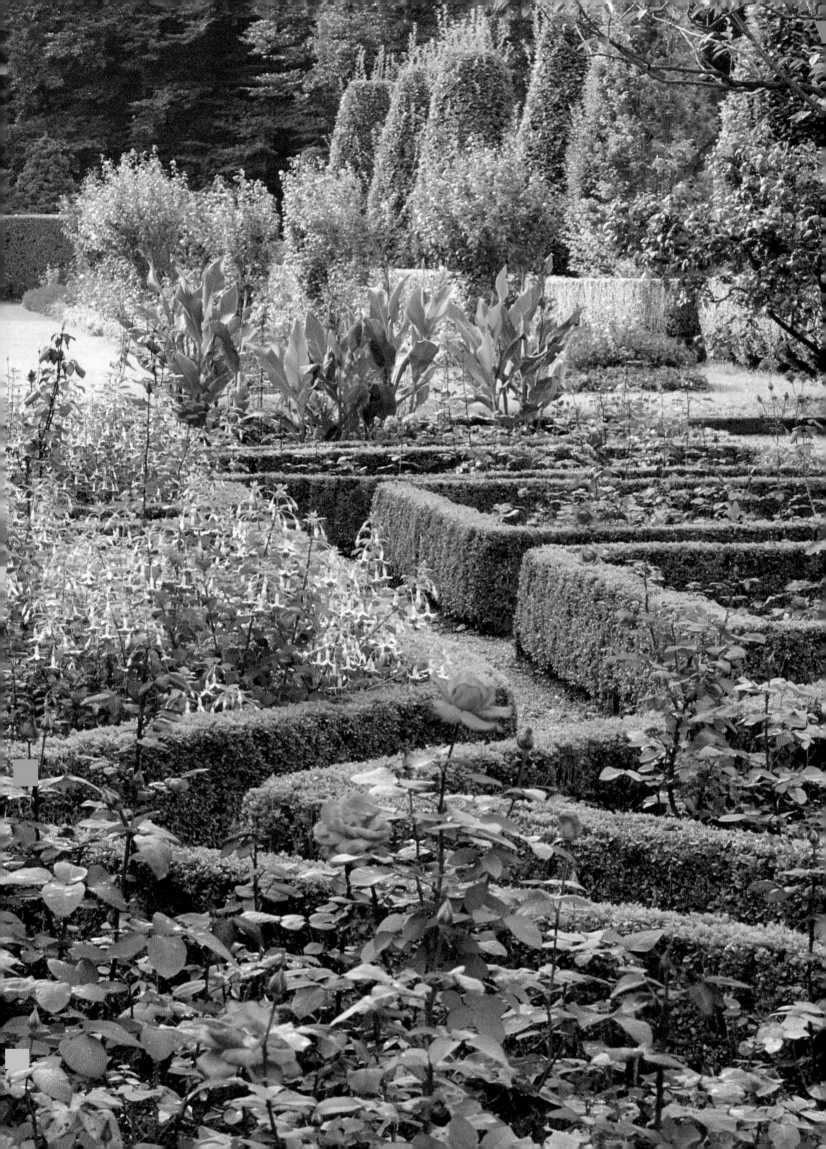

formal flower beds toward the bucolic landscape beyond. Page connected an existing allée in the extension axis of the house to this green room by a flight of low steps and flanked the allée itself with a lilac walk. He also formalized other areas near the entrance of the house to further enhance the patrician look of this lovely property. Under the expert supervision of its owner, a lifelong friend of Page, the garden

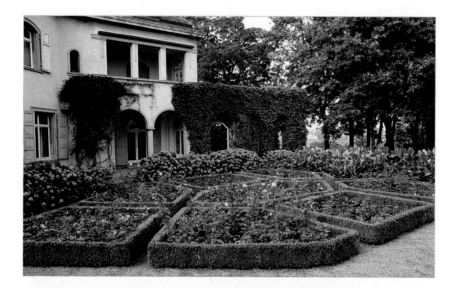

PRECEDING PAGES AND LEFT, ABOVE Schloss Freudenberg was built in the sober architectural tradition of the 1930s. Page softened its lines by placing a box-edged flower parterre alongside each of its wings. Roses, dahlias, fuchsias, and canna lilies fill the beds.

LEFT, BELOW A gently angled flight of steps leads from an allée of trees to an enclosed garden room that adjoins the house.

OPPOSITE Trelliswork clothed in Boston ivy creates an enclosed green room. Flowerpots, a stone turtle, and a central fountain adorn the simple enclosure.

of Schloss Freudenberg has been faithfully maintained. A few years before his death, Page had the pleasure of assisting British prime minister Margaret Thatcher plant a tree during a summer holiday at Lady Glover's estate.

Back in France, Page was commissioned to enliven the grounds of a Louis XIII red-brick country house encircled by a moat at Bleneau, a few miles upstream from Mivoisin on the river Loing. Page turned the island inside the moat into a wide lawn and added a small formal rose garden to one side of the house, connecting it to the piano nobile

by a slender double flight of stone steps. "To add gaiety to a static composition," he explained, "I designed the little rose garden round a series of yard-square stone-edged pools, each with its tiny water jet to sparkle in the sun with its splashing."[3] Firmly based on practical principles drawn from his broad knowledge of historical garden design, Bleneau is an excellent example of one of Page's well-planned smaller compositions.

Like the rose parterres alongside the wings of Schloss Freudenberg, the pattern of the garden at Bleneau (and of many others Page did later on) took its inspiration from Islamic culture. During his wartime

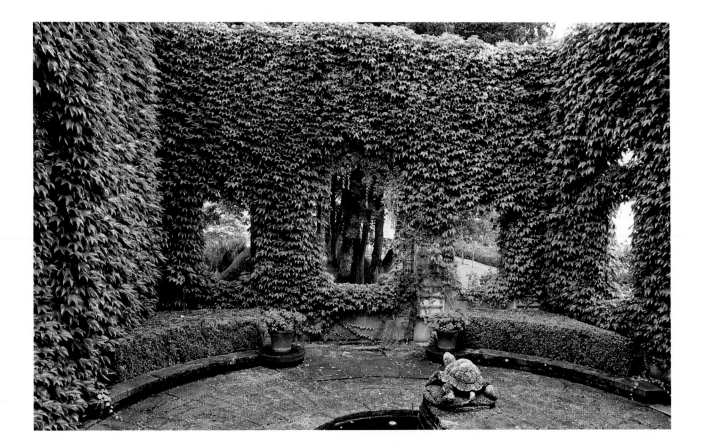

travels in the Middle East, Page had been impressed by Islamic design, with its foundation of geometric forms, rectangles, squares, and crosses, in a variety of configurations. The framework for many of his smaller postwar gardens is rooted in these elementary shapes, which are easier to install and maintain than the curves and scrolls common to baroque gardens.

Page's postwar years were not devoted exclusively to château gardens. Page also designed gardens for a number of medium-sized houses, usually farmhouses or small manors belonging to a younger generation of industrialists with growing families, who wanted a country environment but needed to be close to the towns where they worked. Many of these homes were in the flat countryside of Belgium

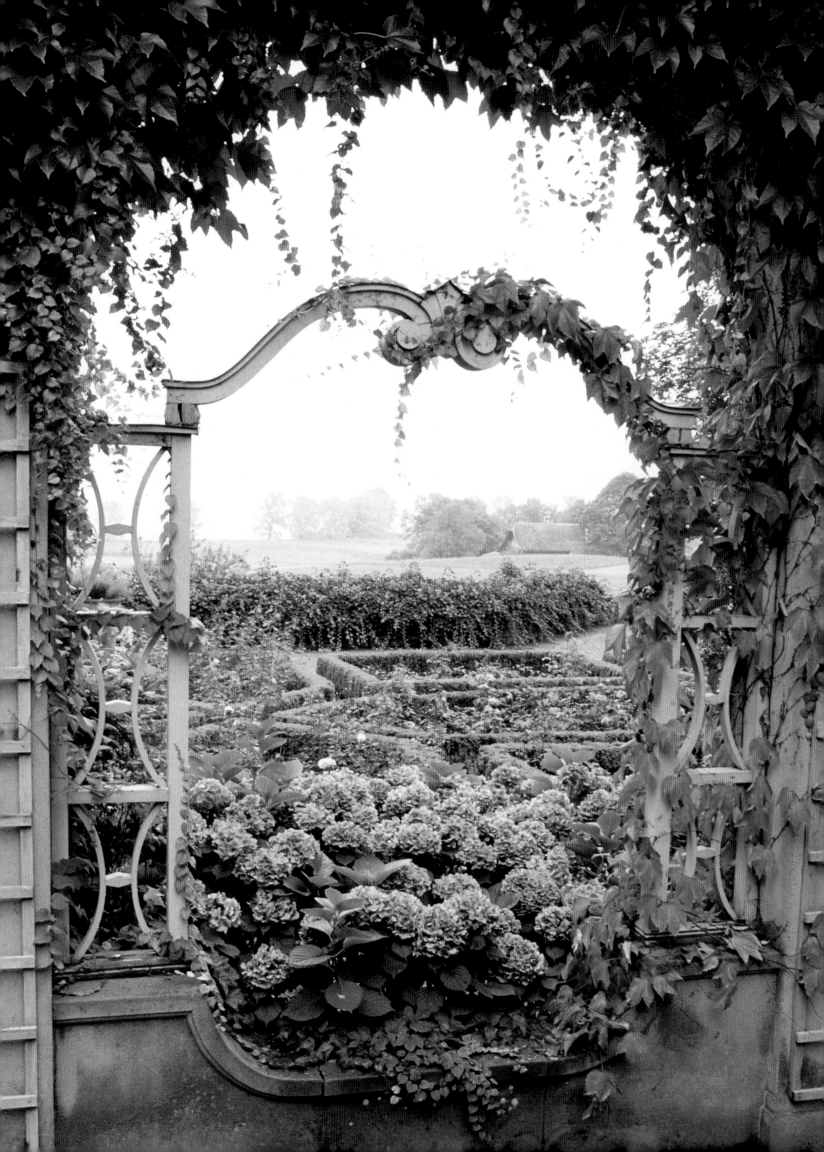

Opposite *Russell Page was always sensitive to the transition from the formal gardens near the house to the countryside beyond. At Schloss Freudenberg he achieved a particularly harmonious flow that guides the eye through an opening in the trellised room over the flower parterres to the pastoral Swiss landscape.*

and did not often have a view that would interfere with the freedom of garden design. Madame Frank de Poortere asked Page to develop a new garden near Kortrijk, West Flanders, on a site that was bare except for her moderate-sized modern house. He conceived the garden as a series of outdoor rooms and sections. With this design in mind, Page's immediate concern was deciding which trees and hedges would best form its skeleton, and provide color and interest throughout the year. He chose apple and crabapple trees, since he felt that they were well suited to the character of the whitewashed brick house; furthermore, they were particularly abundant in this part of Flanders,

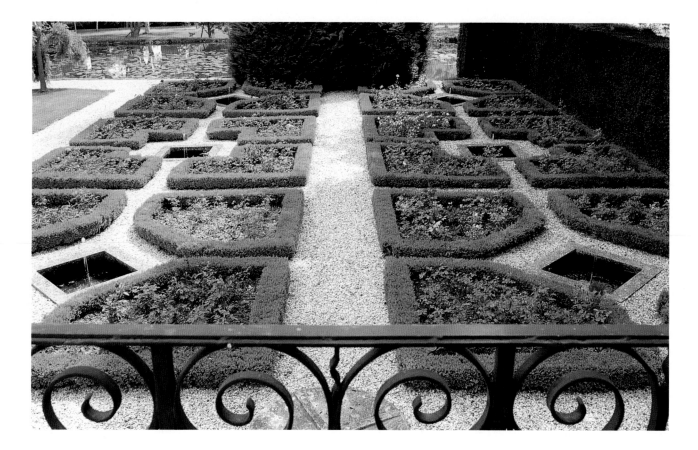

Above *The small box-edged rose garden with miniature fountains at the château de Bleneau, seen from the top of a flight of stone steps that Page conceived to link the piano nobile to the garden below, is a variation on an Islamic pattern.*

as well as fast-growing. He planted them in a small orchard that leads to the house, in its kitchen garden paths, and in the shrub garden to provide shade. Page herein describes the rest of his plan:

In front of the house and its paved terrace there is a plain stretch of grass with two or three trees planted for shade. At the far end of this lawn I made a large rectangular pool to reflect the sky and act rather like a sunk fence or ha-ha to separate the garden from the meadows beyond. High hornbeam hedges frame this lawn on either side, the one on the left hiding the kitchen garden, while that on the right forms one side of a rectangular hedged enclosure only about 150 feet long by 50 feet wide. I designed this whole space as a thickly planted garden of shrubs only. The basic

pattern is very simple. I made a wide grass path down the middle and narrow grass paths next to the hedges on all four sides. These leave a long bed about eighteen feet wide on each side of the central pathway. I divided this bed into wedges by more narrow diagonal grass paths and then planted these quite formal beds with groups of flowering shrubs of all kinds from two to ten feet in height. These make a rich and interesting planting through which you can still sense the formal pattern which underlies the whole garden.[4]

ABOVE A courtyard of apple trees with whitewashed trunks enclosed by hedges, near the approach to the house, sets the theme for the series of garden rooms Russell Page designed for the Frank de Poorteres at Kortrijk in Flanders.

Thanks to its devoted owner and to the well-laid plans and sound installation, this intimate garden, with its design adapted from the William and Mary garden at Hampton Court, survives in impeccable shape to this day.

A few years after Page finished Madame de Poortere's garden, he returned to Kortrijk to design another garden nearby. Page arrived in

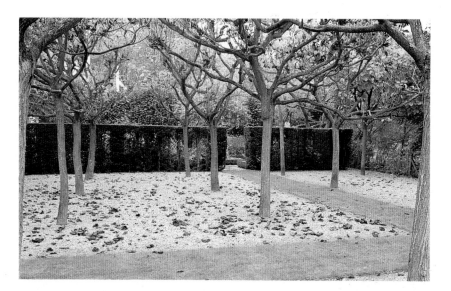

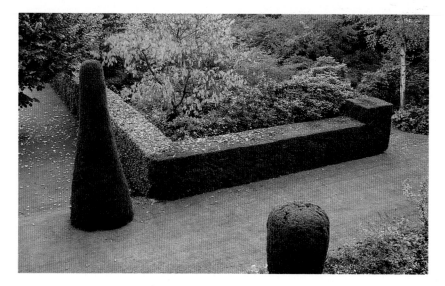

Right, ABOVE In another courtyard on the De Poorteres' property, this one planted with catalpas, Page achieved a particularly interesting effect with the reversal of grass and gravel, turning the paths into green ribbons.

Right, BELOW Hornbeam and yew hedges enclose the rectangular shrub garden, planted with crabapples, ornamental cherries, rhododendrons, azaleas, and many other shrubs.

the late morning from Le Vert Bois, asked what kind of a garden the owners had in mind, refused lunch, but ate a sandwich outdoors while he considered the possibilities of the site. The finished plans arrived two weeks later. This garden, too, has been wonderfully cared for and remains intact; further proof that when a garden is well designed and can be easily maintained, it will endure.

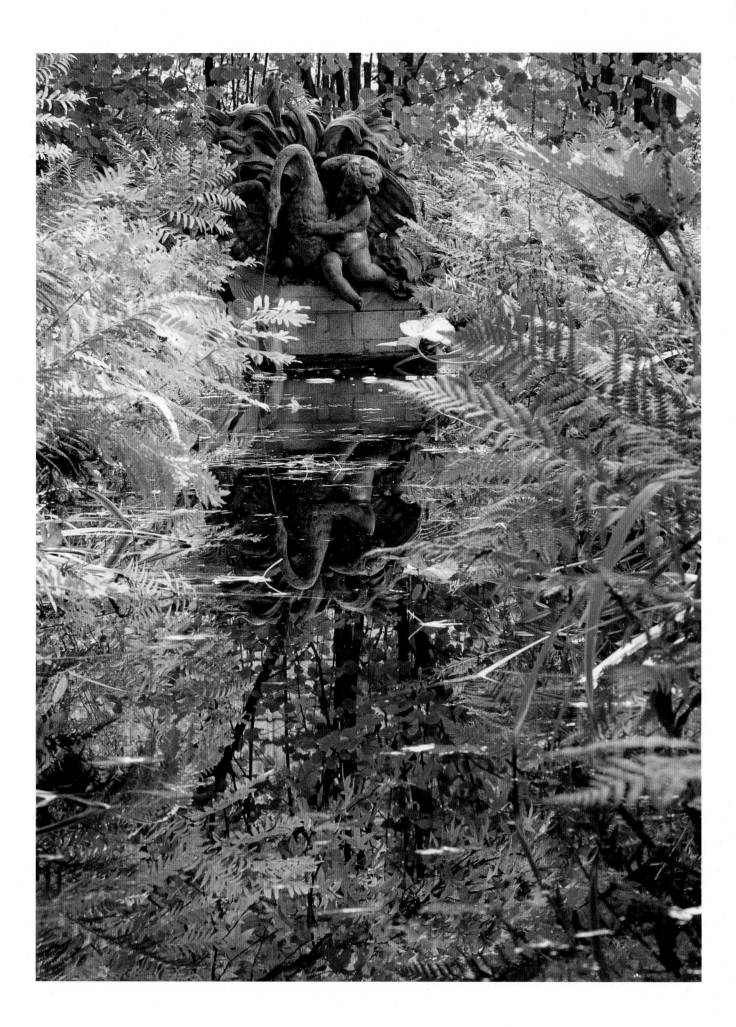

𝒫RECEDING PAGES *The De Poorteres' shrub garden at its peak in the fall is divided into wedges by rectangular and diagonal paths.*

𝒪PPOSITE *At the far end of the De Poorteres' property, Russell Page installed a canal to break up the lawn and to act as a sunken fence. Ferns and a fanciful sculpture lend a touch of fantasy to the quiet composition.*

𝑅IGHT *Russell Page designed the framework of hedges and beds for this white garden near the De Poorteres' house. It later was elaborated on by landscape architect Jacques Wirtz. Now, hostas, astilbes, cimigugas, and anemones fill the beds.*

𝐵ELOW *Another garden compartment at the De Poorteres is adorned with a central sundial.*

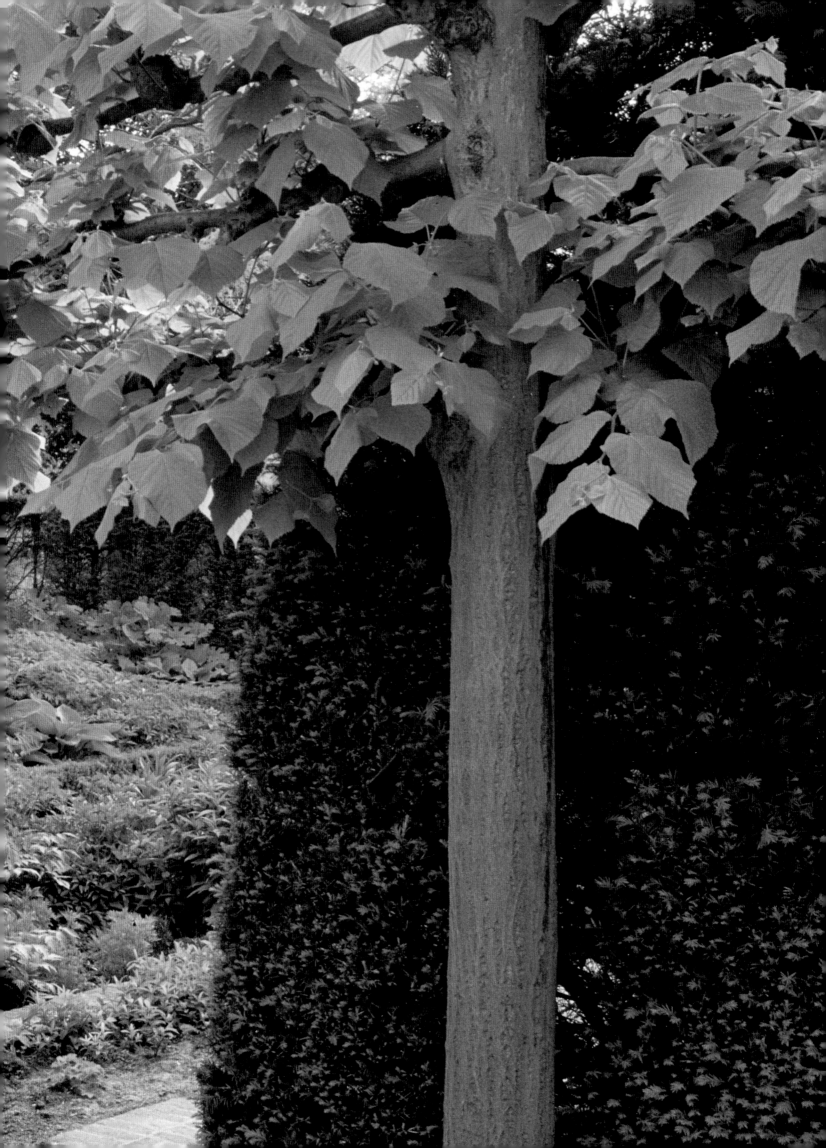

PRECEDING PAGES *A neatly pleached row of linden trees separates the De Poorteres' kitchen garden from the white garden.*

OPPOSITE *Page planted this freestanding hedge to create a formal backbone for an informal planting of rugosa* roses, alchemilla mollis, *and* sedum spectabile.

RIGHT *Page worked out innumerable variations on the design of hedges, a deceptively simple garden staple. He drew the graceful curve of this hedge to act as a foil for hydrangeas and fall-coloring bushes.*

BELOW *Page liked to use a dark backdrop, such as the solid hedge in this garden, to help set off the colors of a herbaceous border. A solitary tree behind it provides interest off season, when the flowers are not in bloom.*

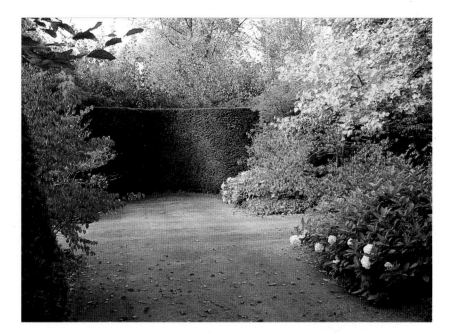

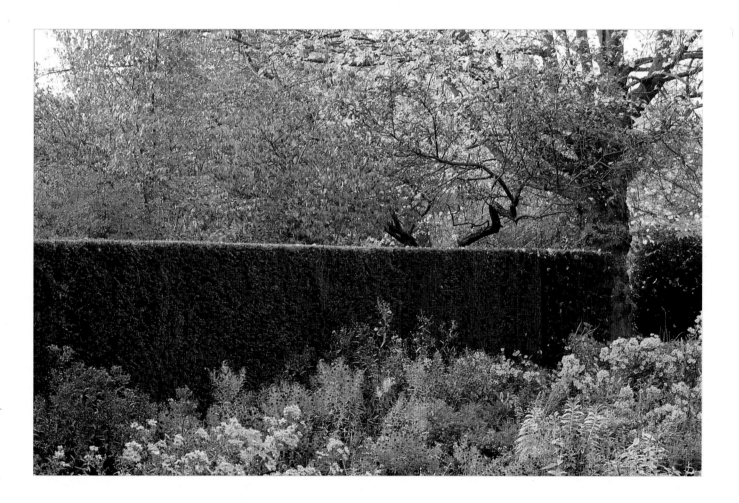

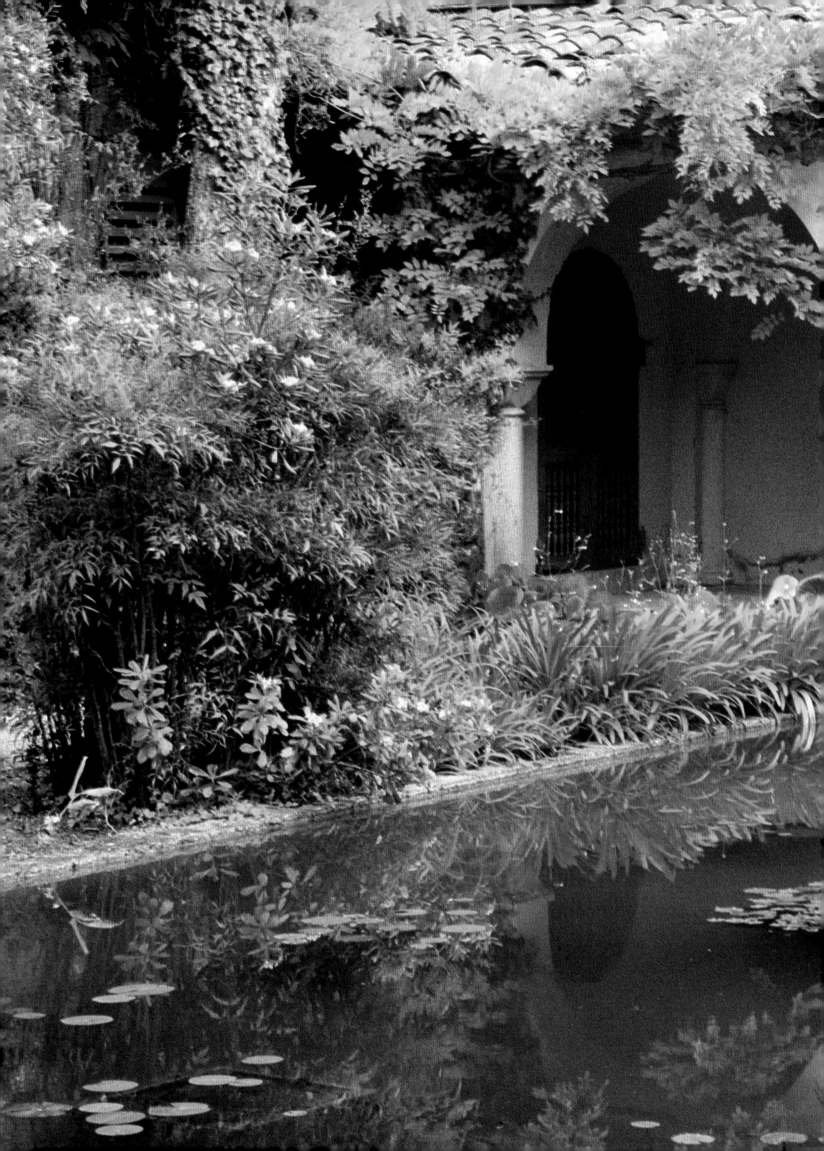

Russell Page first traveled to the Mediterranean as a young man in 1928: "I stayed there a month greedily absorbing the reality of the Mediterranean scene, and seeing and touching plants I had known only through my reading."[1] Throughout his life, Page thrived on travel and change of climate, and the new spectrum of color, different quality of light, and new plant material they presented. By the end of his life Page had crisscrossed the world designing gardens in Europe, India, Ceylon, the Middle East, North and South America, and Australia. In addition to the stimulation of a larger palette of plants, he was fascinated by the various cultures and styles of architecture he encountered. In character, Page was not unlike the English explorers and botanists of previous centuries who left their seabound island for a wider

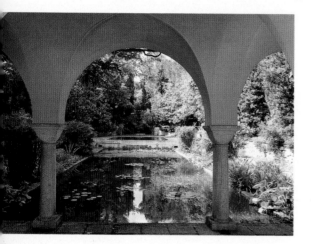

ABOVE AND OPPOSITE *Page indulged his love of aquatic plants when he designed a water garden for a house on the Riviera near Grasse. The formal lily pool adjacent to the patio fills the intervening space between the loggia and the swimming pool, which is situated at the foot of a steep bank. He flanked the pool on either side with a yard-wide bed planted with lush, large-leaved plants.*

world. He remained unmistakably English, yet was always receptive and adaptable to new climatic and cultural situations. Page was an experimenter and an innovator by nature; variety was the key to the ever-expanding range of his work. ❧ Page's early introduction to the plants, soil, and climate of the Mediterranean coast in the South of France was not forgotten when, twenty years later, he returned there with his mentor and friend, Stephane Boudin, to design a garden. But the Riviera had changed since his 1928 visit: It was no longer the winter resort enjoyed by the wealthy, garden-loving British; after World War II it was colonized mainly by French, Belgians, and Swiss for the short three-month summer season. These new vacationers wanted their gardens to be in flower while they were in residence. Designing gardens there Page had to contend with a number of other problems besides his clients' demand for summer color: the excessive variations of terrain, soil, temperature, and climate along the coast as well as inland, and the difficulty at that time of obtaining the most basic of plant material (nursery gardens on the Riviera were scarce and poorly stocked). ❧ Characteristically, Page managed to rise above these obstacles with his straightforward methods and innate creativity. Whenever called upon to design a new garden, one of the first things he did was to walk the area to see which species of plants flourished nearby and to discover which wildflowers and trees were indigenous to the area. The added

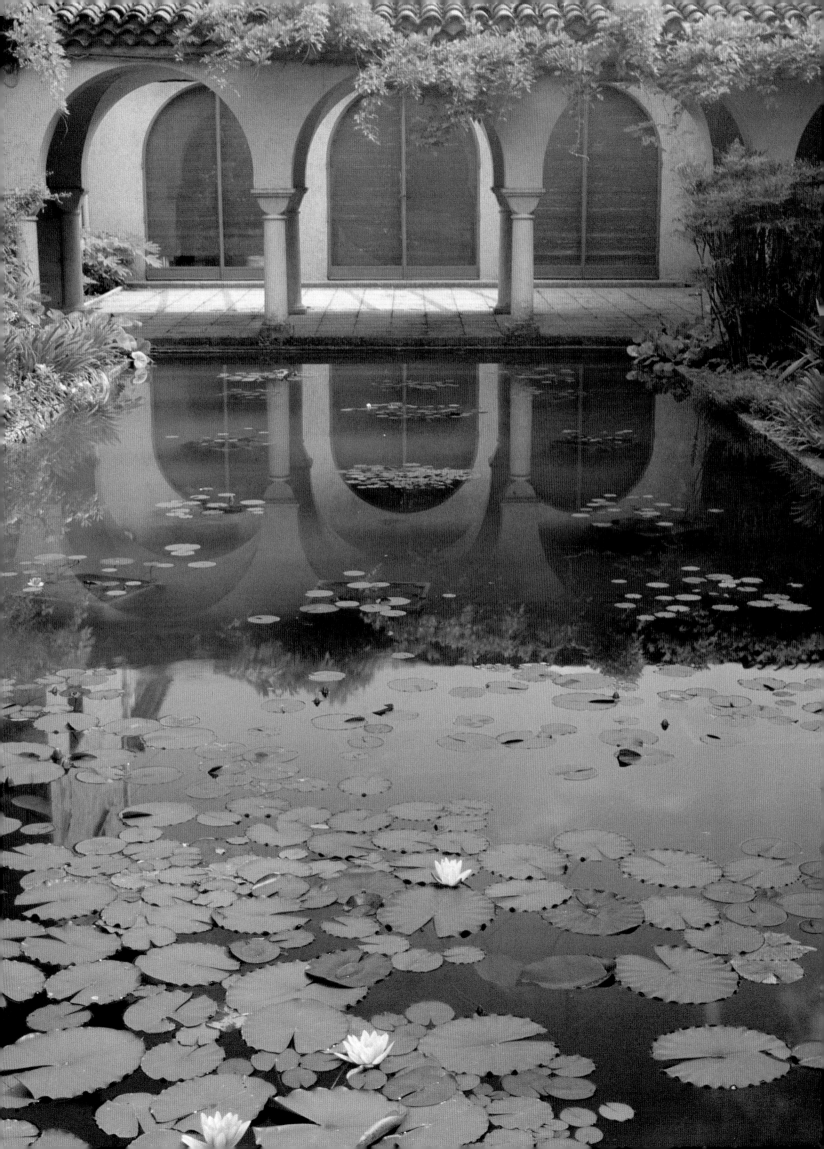

impetus of a new climate sparked off further exploration of the regional plant life. As he found new species, he would learn their Latin names by writing them down. Familiarizing himself with the size, color, texture, and cultural requirements of native plants was part of the learning process that Page continued throughout his life. He always found challenge in new surroundings. Visits to Chile toward the end of his life filled him with the same excitement he had experienced on his first trips to the south of France. No matter where he was, Page always found that the surroundings stimulated his interest in garden design.

Page discovered a wealth of new and useful plants on the Riviera. Cypresses, umbrella pines, and sago palms, with their predictable performances, became favorite trees of his. He found a large number of hardy, native gray-leaved shrubs, such as *atriplex,* sea buckthorn, lavender, rosemary, *santolina,* and *caryopteris,* that proved indispensable for toning down color schemes and muting garden scenes that competed with a view onto the blue Mediterranean Sea. Despite such botanical riches, Page was well aware that he had to limit the choice of plants to keep the composition coherent. The character of the local architecture helped set these limits and imposed a discipline upon him that he welcomed.

Unfortunately, few of Page's original plantings on the Riviera have survived, as most of the properties have been sold or neglected. Only the basic outlines remain, for example, of the water garden he did for Jean Prouvost, a French industrialist and press magnate, in 1967. This project provided Page with an opportunity to delve into the sumptuous world of water plants. At a villa set in the foothills beneath Grasse he was asked to add a swimming-pool garden to work he had already done there. Page arrived from Paris to find that an enormous rectangular hole, one hundred feet long and thirty feet wide, had been made in an area of gently rising ground. With the owner's consent, he had a small, slightly elevated swimming pool placed at the far end of the excavation. He then filled the intermediary space between the house and pool with a long shallow canal. In the canal, he planted pink and yellow water lilies (*Thalia dealbata*) and pink lotus (*Nelumbo nucifera*). He flanked either side of it with a yard-wide flower bed thickly carpeted with cannas, clivias, hostas, agapanthus, and other plants with exuberant foliage. He set four *Magnolia grandifloras* symmetrically in the paving around the swimming pool to give height to the middle composition and emphasize its integral role in the garden. Beyond the pool, there was a long bank that rose up to a reservoir. To continue the water motif and, Page wrote, "to accentuate the effect of length, I worked out a narrow central water-staircase down which

At the garden near Grasse, Page built this narrow water staircase, reminiscent of Italian Renaissance cascades, to connect the property's reservoir above with the swimming and waterlily pools below. Broom, pittosporum, and cypresses grow on either side of it on the rocky bank.

flows a thread of tumbling white water from the reservoir, to fall between thickly planted bushes of dark green pittosporum which I clipped into low green mounds. A single jet in the reservoir above, and pointed cypresses which flank the cascade, accentuate the perspective still further."[2] Today, only the ghost of this garden survives. Page's beloved pink lotuses have vanished, as has the lush poolside planting. Unclipped pittosporum shrubs form impenetrable banks on either side of the water staircase, but water still tumbles down the Italianate stairs toward the heart of the water garden. The canal still reflects the columns of the loggia and the cypress spires as Page intended.

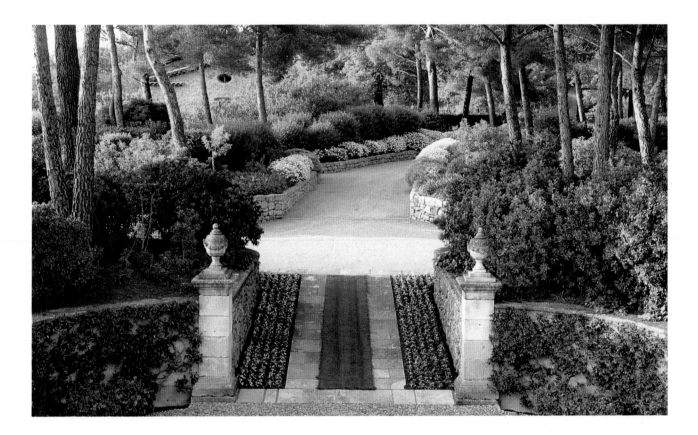

ABOVE AND FOLLOWING PAGES
Russell Page persuaded the Marquis de Ronalle to build his Provençal villa, later known as the Castel Mougins, not on the crest of the hill but farther down on the slope. The lower situation allowed Page to design an elegantly curved, descending driveway to the entry courtyard. The raised beds lining either side of the drive are planted with clumps of daisies and Mediterranean shrubs.

Another commission that brought Page to the South of France was the Castel Mougins, near Aix-en-Provence. The Marquis de Ronalle wanted to build an eighteenth-century-style house on some gently sloping rocky ground that looked across a shallow valley to the old hill town of Mougins. He asked the Englishman for advice about where to place the house and garden. Page, instantly assessing the site's possibilities, was able to persuade his client and the architect to place the house at a lower level than their initial preference, which was on higher ground near the entrance to the property. Page made a preliminary sketch to show how this new location would permit a more indirect approach to the courtyard of the house.

Once the architectural work was completed, Page was able to

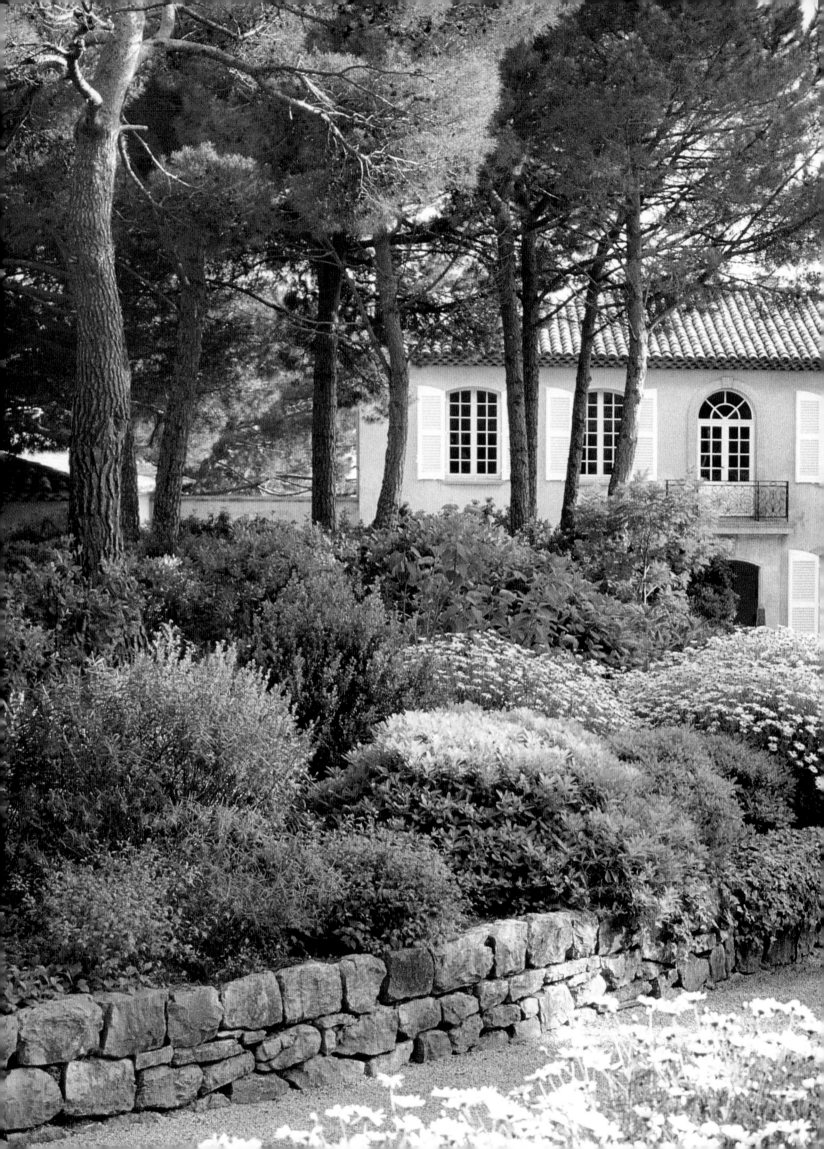

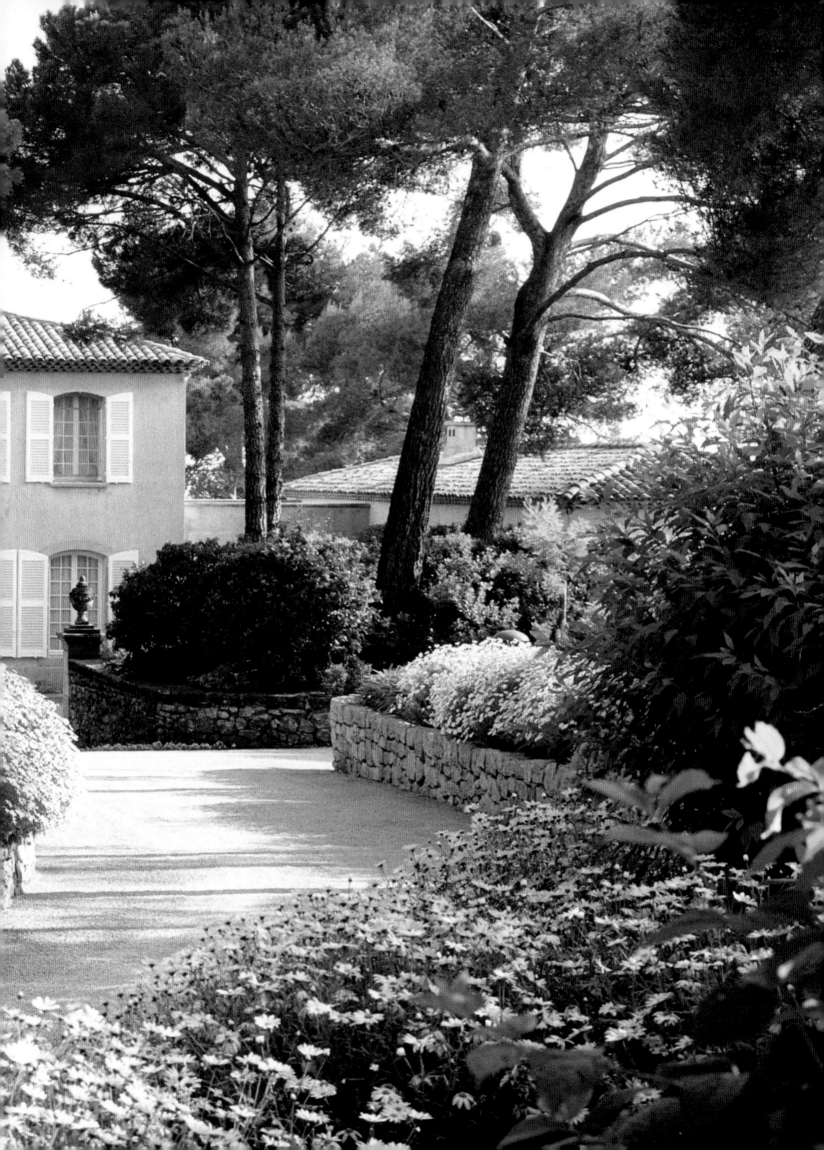

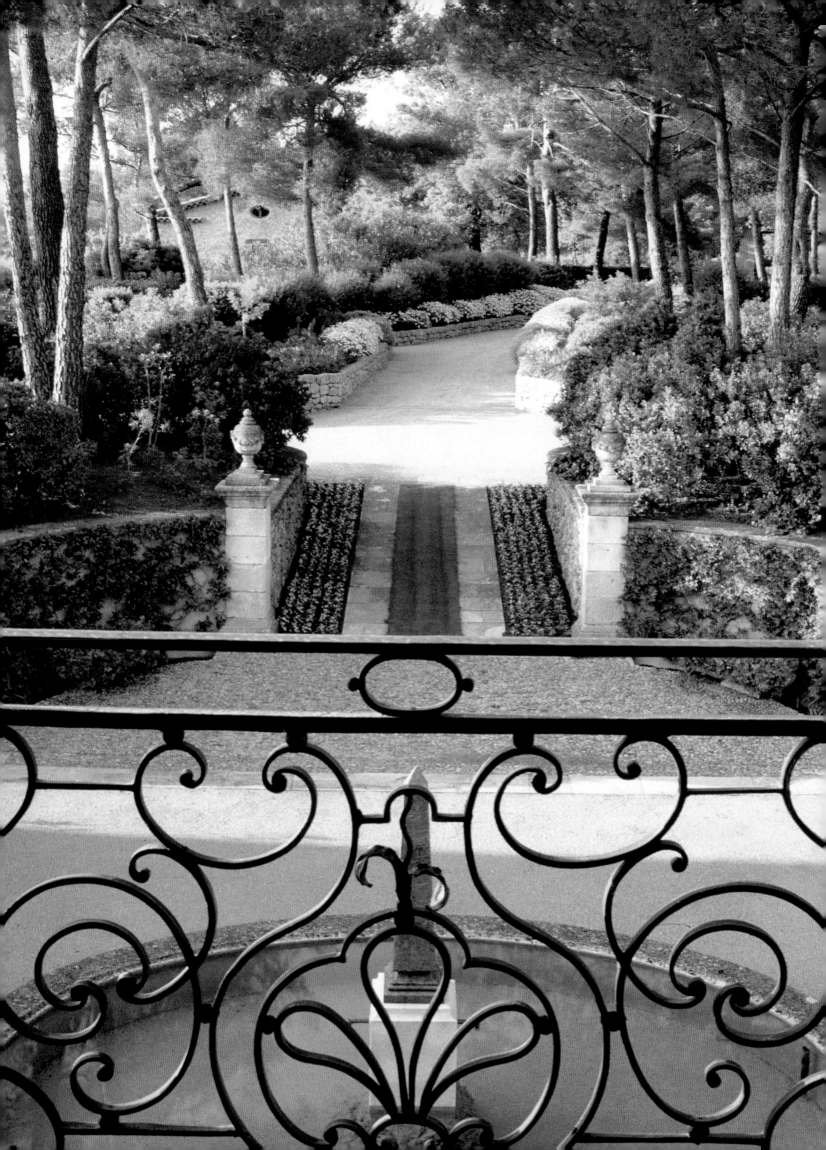

concentrate on the garden and courtyard design. He used ornamental urns set on stone pillars to line the ramp leading into the walled courtyard. He put in two side beds, each containing two *Magnolia grandifloras* surrounded by a ground cover of camellias, pieris, and azaleas, to break the line of the flanking wings of the small, two-storied house. The remainder of the courtyard he had paved with stones,

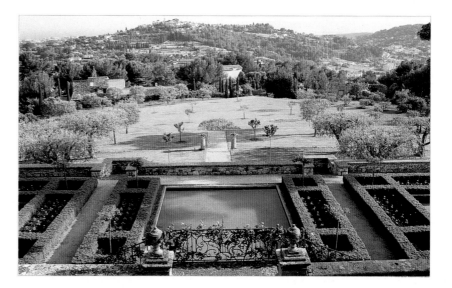

*O*PPOSITE *The view toward the decorative entrance from the first floor of the Castel Mougins reveals Page's meticulous attention to details, such as the ramp and gateway. Page also designed the courtyard, including its centerpiece, an oval fountain topped with a dark green obelisk.*

*R*IGHT, ABOVE *For the terrace below the house Page designed one square and two rectangular water basins framed by box-edged flower beds.*

*R*IGHT, BELOW *The stonework at Castel Mougins being of particularly good quality, Page placed two ornamental stone urns near the staircase in front of the house that leads to the lower terrace.*

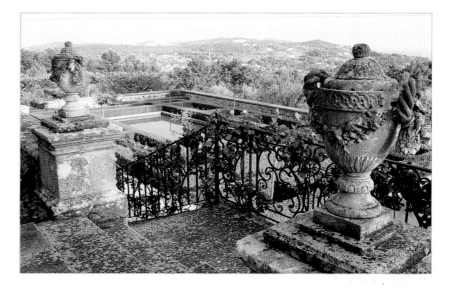

except for the central area, where he installed a stone-rimmed raised oval pool. "In the middle of the pool I set a stone basis from which two taps ran continuously, and on this base I set a small obelisk of dark green serpentine. I had noted that the keystone of all the 18th-century doorways in St Tropez, some forty miles away, were carved in serpentine."[3] Huge terra-cotta pots of white oleander enlivened the facade of the house.

The classic reticence of the courtyard leads onto an elegant series of three terraces at the front of the house that offer a spectacular view of

hill and town across a valley of olive trees. The harmony between the house and the view depends, to a great extent, on the lower emplacement that Page had suggested. This site proved an ideal setting for the first two broad terraces. Four tall cypresses, yearly clipped needle thin, and two old umbrella pines cast a varied pattern of changing shadows on the grass and pavement of the first level. A bordering wall capped by a sober, flat eighteenth-century coping rises two feet above the level of the top terrace. A double set of narrow stairs descends from the

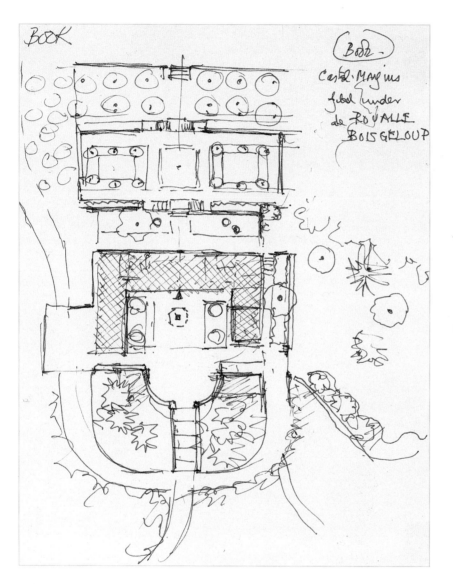

LEFT *Page's sketch of his design for the Castel Mougins shows the arrangement of driveway and courtyard (on the lower half of the sketch), as well as the terrace in the front.*

OPPOSITE *Umbrella pines, cypresses, and orange trees add vertical accents to the otherwise flat plan.*

elegant ironwork-trimmed landing to the second garden terrace, which is the key to the composition. Page describes it in an unpublished writing:

> I made it as a simple water-parterre with three rectangular stone-edged pools framed in a band of box-edged beds some five foot wide. In these beds I spaced out standard orange trees with carefully pruned rounded heads. The box edging is panelled into

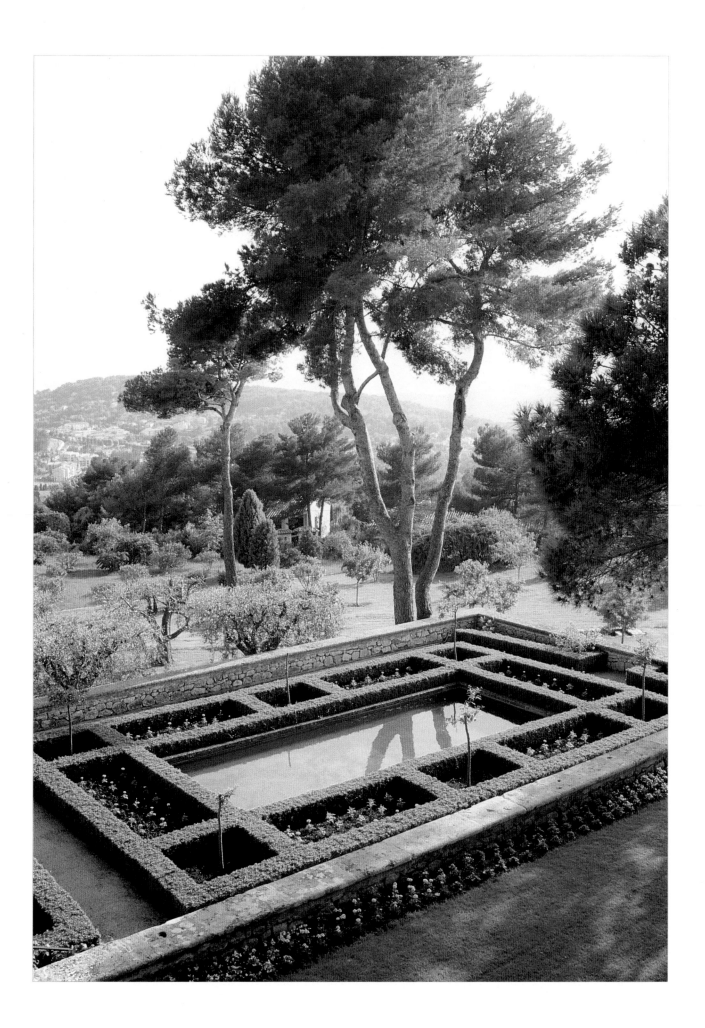

square and rectangular beds which are filled with blue and white pansies, replaced in the latter months by white petunias and blue-mauve *Ageratum* or pale blue petunias. Another double flight leads from here to a still corner terrace level. This time I felt the need to begin to meet with the countryside, so I used trees to line the garden to the olive orchards below, but I still formalised

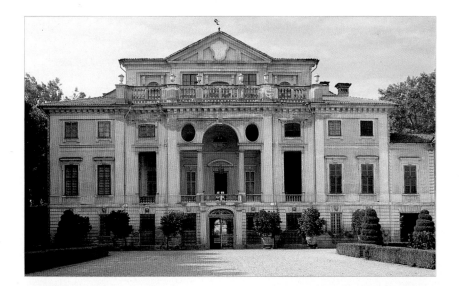

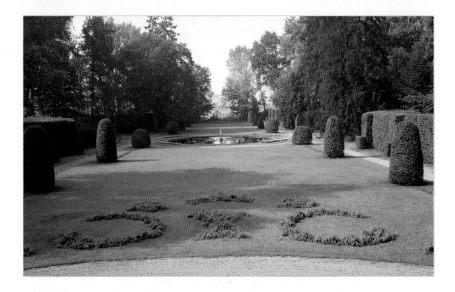

*L*EFT, ABOVE *When Russell Page saw the magnificent façade of La Loggia, the Piedmontese villa of Count Theo Rossi di Montelera, he was inspired to design an overly baroque garden, which was not executed.*

*L*EFT, BELOW *Count Rossi found this simple and serene view at La Loggia more in keeping with the spirit of the place. The long lawn, framed with trees, has a round pool and a mere suggestion of some flower beds incised into the lawn.*

*O*PPOSITE *When Russell Page designed this shallow canal, here seen from the reception rooms of La Loggia, he created an illusion of length by slightly narrowing the canal at the far end. The two short lateral arms form the letter T, for Theo.*

them a little in setting them spaced out in two lines parallel with the house and two retaining walls. Originally the olive trees were underplanted quite informally with largish drifts of *Agapanthus, Amaryllis belladonna,* paper-white *Narcissus, Iris, Anemone Japonica,* bold blue *Echium* and other plants with good bold foliage.[4]

The low west wing of the house is bordered with white-flowered photinia and hybrid musk roses that flower every six weeks. Below it

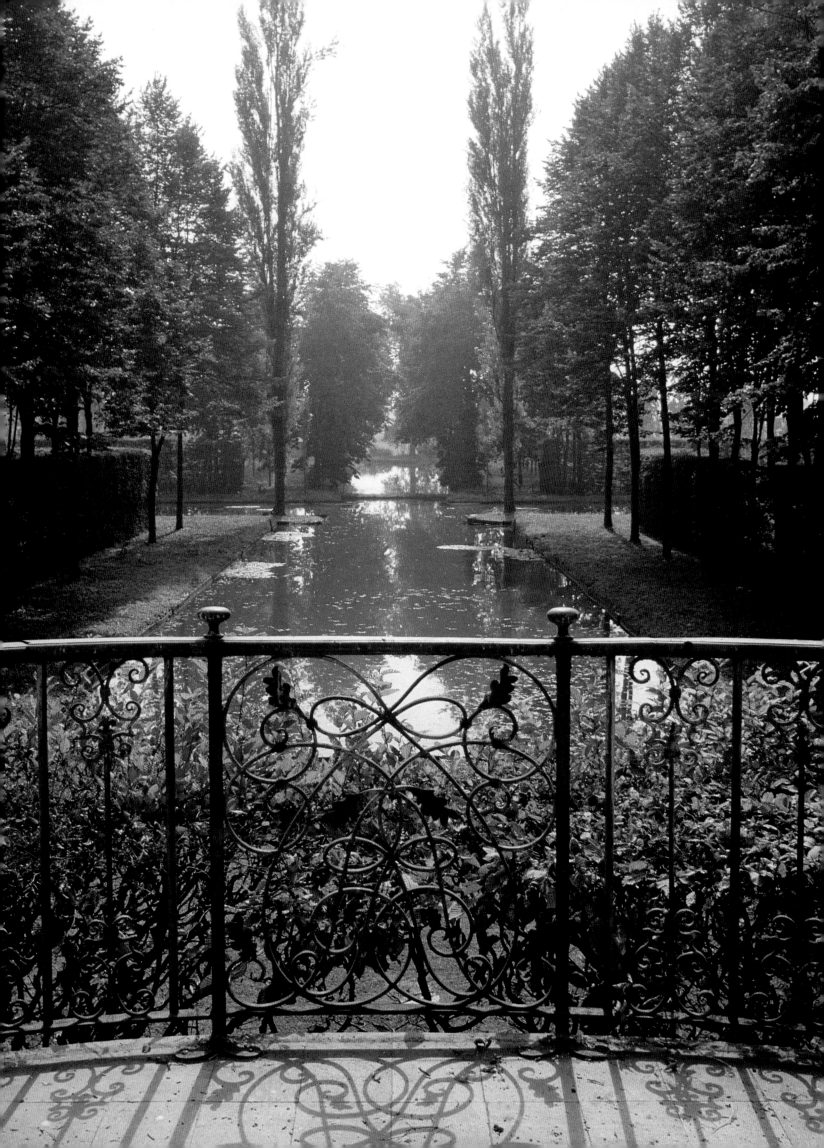

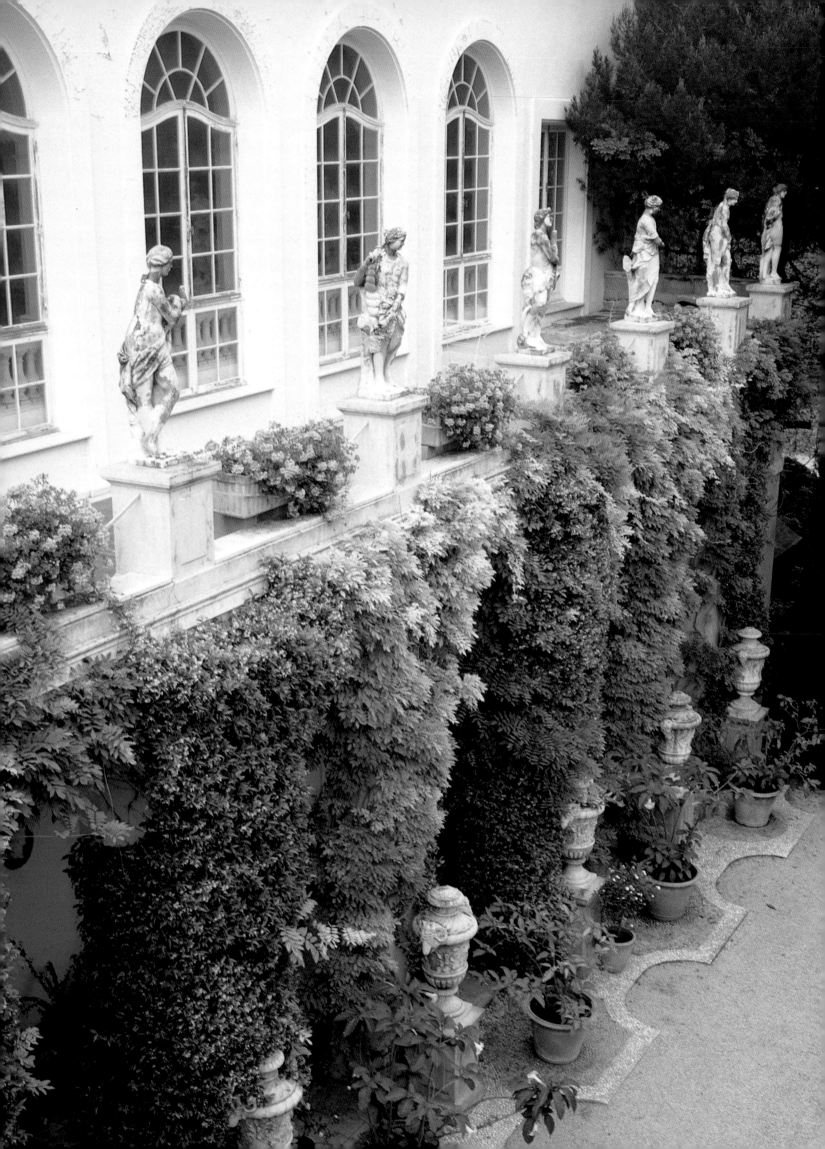

lies a series of side terraces planted with the best of the mimosas, 'Clair de Lune.' Almonds and grapefruits and a mixture of other flowering fruit trees curtain the kitchen and cutting garden. The present owner of Castel Mougins has preserved the calm elegance of this classic green garden set in the Mediterranean landscape of southern France.

During the time Page was working around the Mediterranean, Count Theo Rossi di Montelera invited him to design a garden at his splendid eighteenth-century villa, La Loggia, near Turin. This project served as Page's introduction to the unfamiliar climate and landscape of northern Italy. It was there that the Englishman learned an important lesson about the harmony of a property and its sur-roundings—the spirit of a place. "Here," he wrote, "was a site which demanded a composition in the grand manner."[5] His first series of plans

Opposite Page dressed the ornate façade of Count Rossi's other villa, the château de l'Hermitage on the French Riviera, in wisteria and jasmine.

Right Though now overgrown, this slope still bears the traces of Russell Page's collaboration with Count Rossi, a man of distinctive taste. Pink pelargoniums cover the rocky cliffs under the palm trees. Roses grow up the trunks of Aleppo pines, echoing the façade of the house. A gravel path leads to a rose garden in the back.

for an elaborate baroque garden to equal the grandeur of the house were courteously rejected. But rather than criticize or comment, the count simply drove Page around the surrounding countryside. "I saw how the great houses are set in immense expanses of gravel with gardens merely sketched in by lines of trees or a hedge or a wall,"[6] Page wrote. He realized that he could remain true to the architectural traditions of the Piedmont, the spirit of the place, and still exercise his own creativity, by simply replacing the stretches of gravel with spaces of water. He thus set about creating a classical design that was a perfectly balanced equation of water, trees, and grass. In the middle of a well-trimmed lawn, he installed a shallow canal, with two short lateral arms midway down, that extends from the eastern facade of the house to the end of the property. As the original name of the estate was Il Carpeneto, "place of hornbeams," Page chose these native trees to make a double hedge around the first part of the canal and its branches.

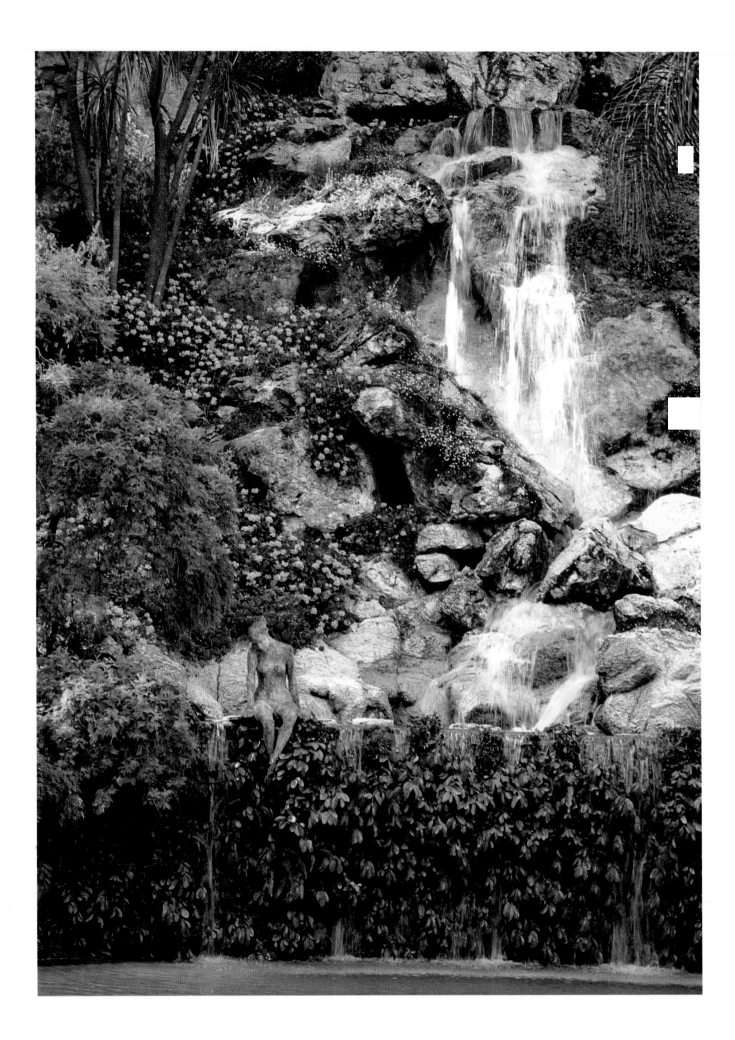

He added four Lombardy poplars at the corners of the lateral arms to add height and distance to the overall composition.

Years later, the count asked Page to do another garden for him on the Côte d'Azur at the château de l'Hermitage. There the designer created a setting with a completely different feeling, which he described in notes for an unfinished book:

Opposite At the château de l'Hermitage Page designed an artificial waterfall, tumbling down the steep cliff to a pool below. He planted the palm trees and pelargoniums in every available pocket of soil on the rocky slope.

Following pages Russell Page chose to make a swimming pool the central element in this garden near Pibonson, not far from Cannes. He placed a second, ornamental pool in the foreground and planted groups of clipped cypresses to contrast with the long perspective.

> In the sixties I was to make one more garden quite close to Monte Carlo, for a relatively small new house replacing a huge late Victorian villa of which only the front hall, some sixty foot long by thirty foot high, remained in the most elaborate bastard Rococo imaginable. The site was some 26 acres of precipitous and rocky hillside, thickly treed with Aleppo pines—only a small area near the house was approximately level, leaving room for a large entrance courtyard on one side, and on the other a relatively small lawn with steep scarfs of rock like a broken cliff running uphill to the Moyen Corniche to the north and down to the Lower Corniche and the sea to the south at the far end of the lawn and banked by superb groups of pine. I made a simple loosely curving swimming pool, fed by an artificial cataract of water tumbling over great rocks from thirty foot up the steep hillside. The planting is very simple. We found in a neglected garden one fine old sago-palm, *Cycas revoluta,* which set us searching for miles around to discover more specimens. Finally we accumulated seven superb specimens, mostly with two or more stems, we set them in the lawn, being very careful to study the various forms and the volumes and, even more important, the spaces between them. It was an operation like the placing of sculpture, and I have to admit that my admiration of the relation between the stones in the Ryoangi sand garden in Kyoto taught me how to handle the volumes and cast shadows of the sago-palms, interesting in themselves, giving a sense of added distance between the house and pool beyond which was a gentler slope under the picturesque forms made by the reddish trunks of pine trees. My first thought was to under-plant these trees with colonies of blue agapanthus, but my client, whose taste I had admired for many years, decided he disliked agapanthus and suggested pink ivy-leaved Pelargoniums, which I had always disliked. However, it was his garden so we raised literally thousands of cuttings, and under the pines and wherever we could find pockets of soil in the cliffs—in went the pink Geraniums, which in the broken sunlight under the trees have lost their window box vulgarity and complete a garden scene like no other which takes on extra magic at night when, from a keyboard inside the house a sense of discreet and differing lighting schemes illuminate the waterfalls and trees and cliffs.[7]

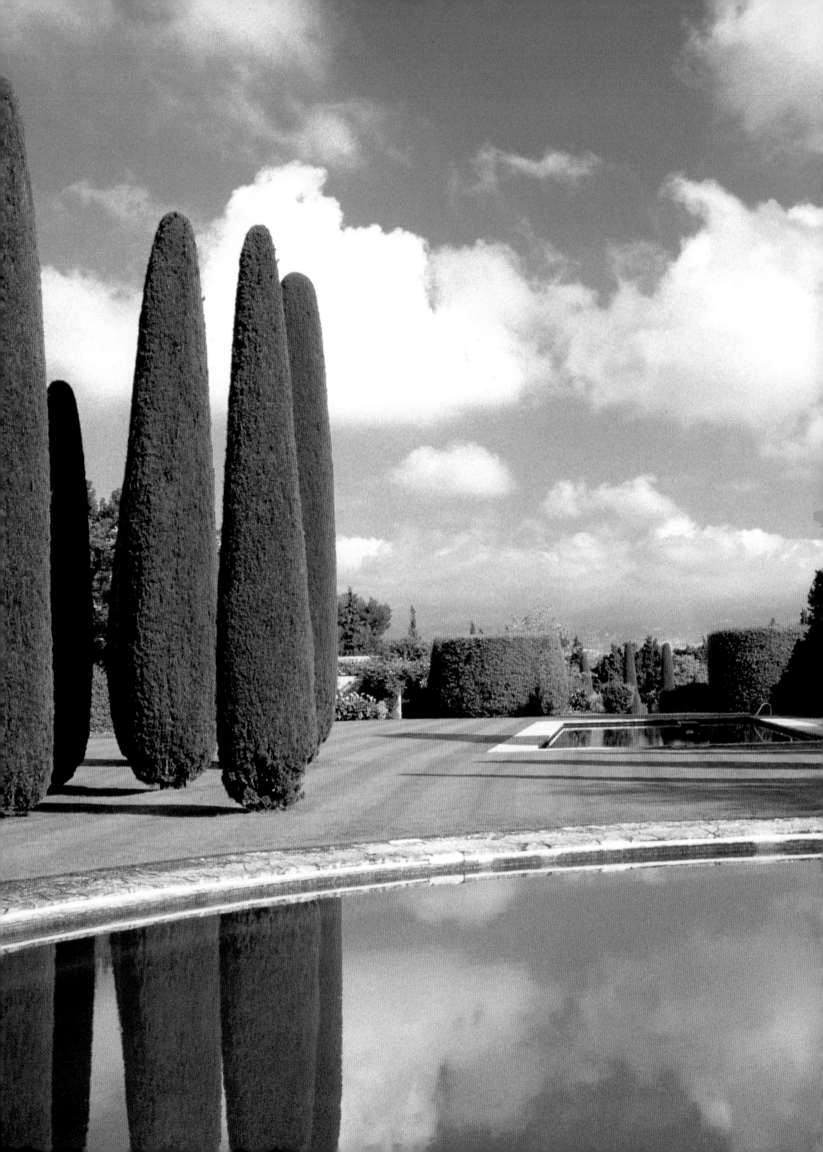

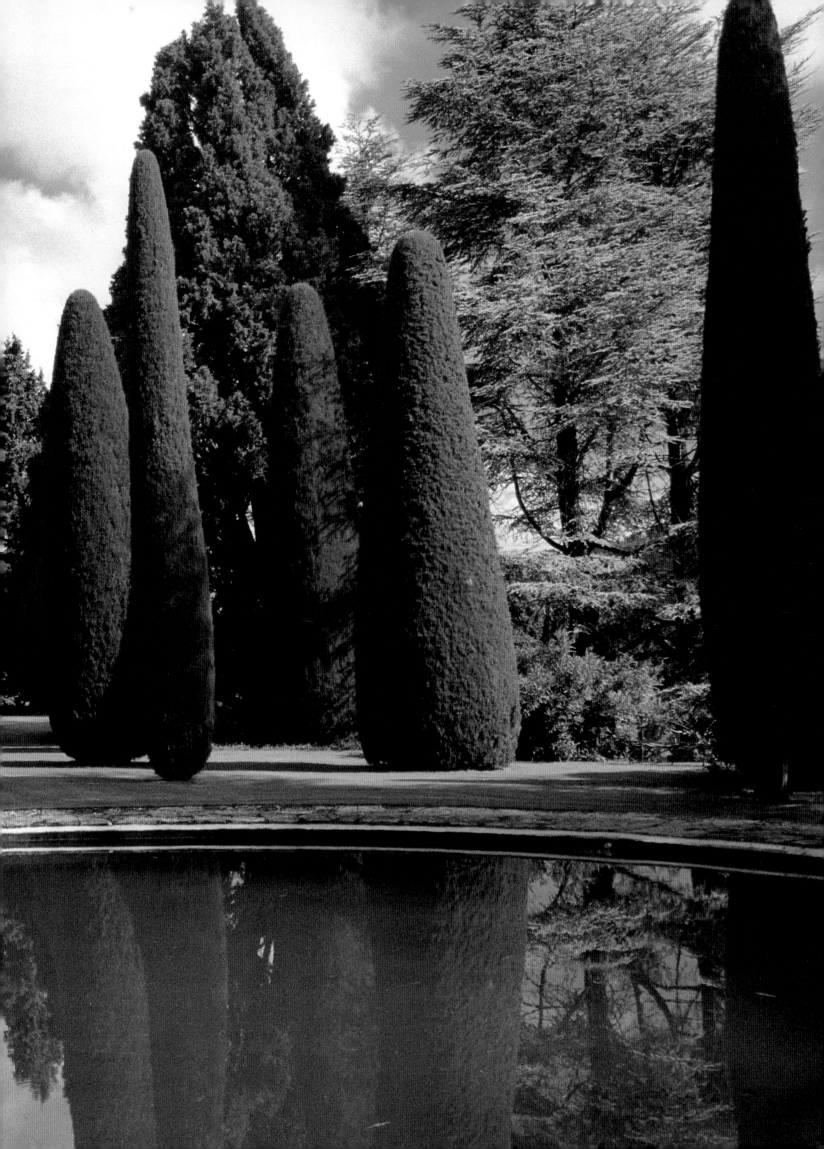

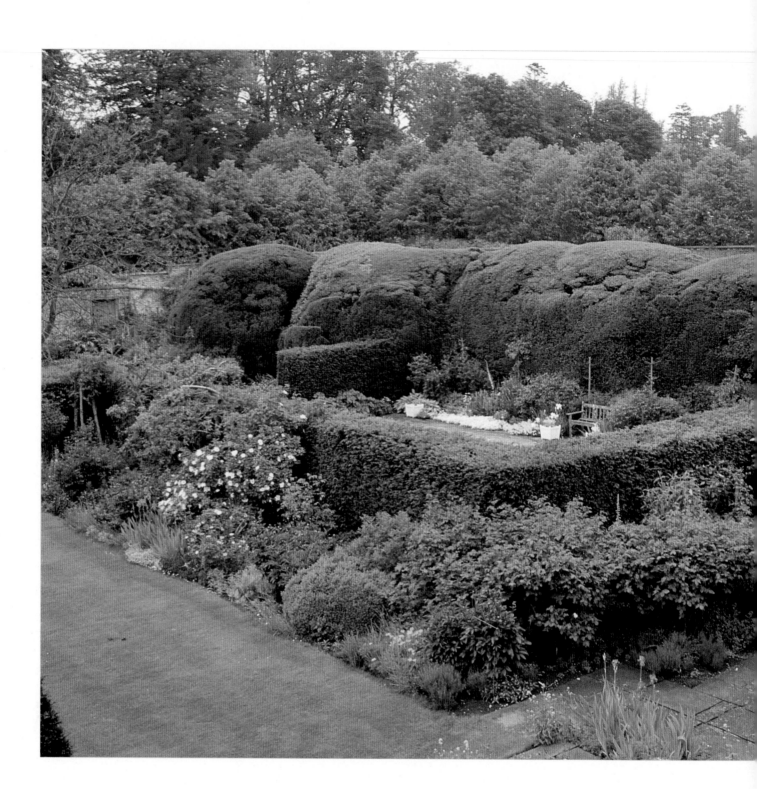

By the time Page was working in the South of France, swimming pools were already an integral feature of garden design. It did not take him long to become well versed in all aspects of their construction—shape, proportion, location, and color—as well as the functional details of their operation, such as scum channels, pumps, filter systems, and linings. In general, he preferred to conceal a pool with hedges or a wall, either in a compartment of its own or to the side of the main garden or on a lower terrace. Sometimes, of course, it was necessary to place it in the central axis. As for shape, he preferred

ABOVE Page became something of an expert at swimming-pool design and devised many different settings for pools, some in the open, others within a separate compartment. At the former garden of Lady Caroline Somerset in Badminton, Page concealed the swimming pool behind ancient yew hedges; here seen from an upper-floor window.

rectangular pools for formal settings, and found circular ones monotonous, ovals charming, and free-forms popular but requiring careful treatment.

The color of water varies as greatly in a pool as it does in nature, depending on the color and depth of the container, whether the water is moving or still, and the colors it reflects. Page found it a challenge to choose just the right color for a pool lining, saying, "I like white, as the general colour tone will then be a quiet grey-green. Green is a dangerous colour if there are trees or grass anywhere near. A greenish or turquoise blue is better than cobalt or ultramarine, which will again look false in most outdoor surroundings. I have nothing against black or navy blue or a dark bottle green in suitable circumstances."[8]

At an estate high in the hills behind Cannes, near Pibonson, Page

made a swimming pool the central element of a striking garden design. He used a classic round stone-edged basin to give formality to the front section of the composition. He then set a rectangular swimming pool in the middle distance in the same axis to prolong the perspective of open sky and hazy hills beyond a long lawn. The lawn is framed by an informal planting of tall, grayish blue atlas cedars (*Cedrus atlantica*) and large loose shrubs that serve as a windbreak. Groups of cypress, some allowed to fatten at their bases, some deliberately kept small, others clipped pencil thin, make vertical accents on the surface of the two pools. The result is a serene and simple Italianate green garden composition.

It is rare in the South of France to find a flat garden, and this estate was no exception. Classic dry stone terraces, known as "*planches*," are a typical feature of the region, where they serve the dual purpose of retaining the soil and helping with irrigation. Page incorporated a

Right A doorway in the yew hedge provides the approach to the swimming pool at Badminton.

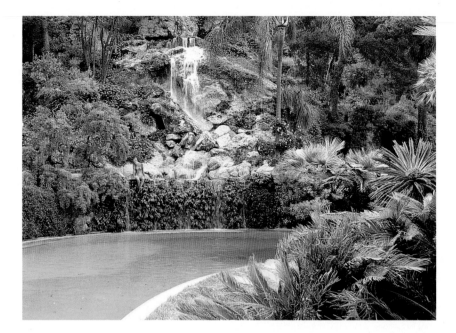

*ℒ*EFT *The curving swimming pool at the château de l'Hermitage forms the heart of a garden set between a steep cliff and some sago palms.* BELOW, *A substantial laurel hedge sets the swimming pool at San Liberato, near Rome, apart from the rest of the garden.* OPPOSITE, ABOVE, *Mary Melian's pool in Sotogrande is tightly enclosed by tall oleanders and palm trees.* OPPOSITE, BELOW, *A pool nearby is bordered by a field of petunias.*

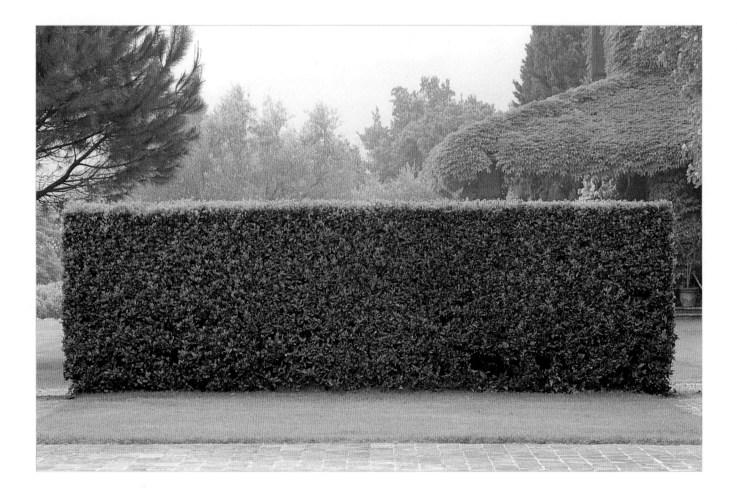

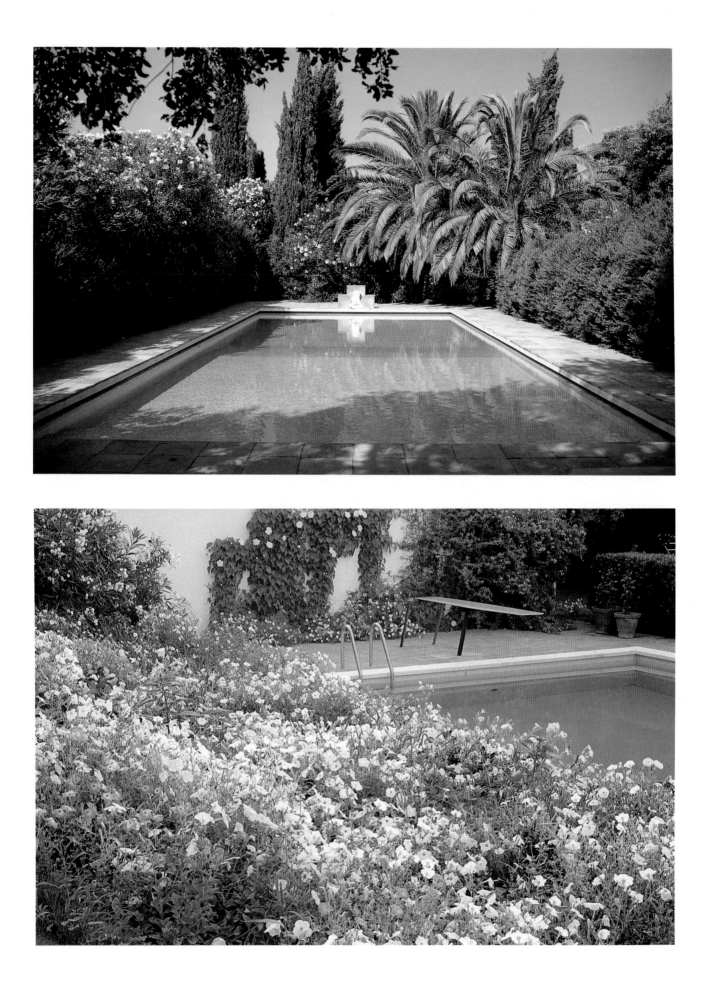

series of planches on the far side of the estate into the architecture of the garden. Below the house he added a high stone retaining wall from which descend stone steps and paths that join the various levels. The planting along the planches, typical of all his work in this region, echoed the surrounding scented maquis: native lavender, cistus, white, spring-flowering *Ericocephalus,* Jerusalem sage (*Phlomis fruticosa*), and rampant-growing, silver-leaved *Convovulus mauritanicus.* Page particularly liked the magnificent blue echium, a plant originally imported from Madeira that, in frost-free climates, rapidly develops into a large shrub with silky, silvery leaves and large dense flowering spikes of deep delphinium blue. He used groups of echium and massed summer-flowering blue and white agapanthus to make a bold statement in the natural frame of the landscape.

Another estate, the Villa Plein Ciel, perched high above Cannes, gave Page an opportunity to put into practice the specific ideas he had developed on gardening and swimming pools on the Côte d'Azur. He felt strongly that a view should never serve as a mere backdrop in this, or any, region, but instead remain the dominant factor, and that plantings, therefore, should reflect quiet colors so as not to distract the eye. He also believed that in this climate trees should replace flowering plants as the major element in any composition.

At the Villa Plein Ciel in the South of France, Page placed the swimming pool on the lower terrace, hidden from view. His simple composition in front of the house, a lawn beneath umbrella pines, quietly complements the color of the Mediterranean sea.

The secluded swimming pool at Plein Ciel is enclosed by cypresses.

The garden at Plein Ciel nicely illustrates these views. He planted twelve-year-old olive trees on the lawn between house and view to add perspective, then planted a predominance of gray and silver foliage plants under them, a perfect foil to the dull green of the trees. Elsewhere, he chose umbrella pines, with their somber strength, to balance the bright green of the lawn and to allow a controlled use of vibrant color in pots on the terrace. He set a swimming pool beneath a high stone retaining wall that he had built to replace a series of short steep terraces in front of the villa. Surrounded by cypress hedges, the pool remains hidden from the house, in obedience to the rule of noninterference with the view. Forty years have passed since the garden was designed, and much of the planting has been modified or suppressed, but Page's excellent basic plan remains.

The late 1950s and early 1960s found Russell Page busily crisscrossing Europe, designing gardens in France, Italy, Switzerland, and Belgium. Of these hectic years, he said, "It was quite usual for me to spend four successive nights in a sleeping-car, rushing from one job in hand to another in a different country and a quite different climate."[1] Sometimes he stayed as a guest at the house of his patrons for several days to contemplate the situation. "In the town as in the country," he explained, "a wise garden designer will study his site in silence and consider carefully his clients, their taste, their wishes, their way of life, their likes and dislikes, and absorb all of these factors at least as important as the ground that lies in front of him."[2] Page would then make bold rough sketches on the spot. Later he worked out his composition at the drawing board. Most questions, however, were addressed at the site, often in the presence of the client, which could result in frustration. On one such occasion Page was so exasperated by a hesitant client, who complained that she could not visualize the width of the paths indicated in his sketch, that he stretched himself flat on rain-dampened ground and announced, "There's your two meters."[3]

Among the many projects Page was involved in during those years were a number of private town gardens. These were, of course, in towns or cities, or a few miles away in their peripheries. Page's town clients, like those that owned country homes, had varying needs and ideas for their gardens. They might want a garden that would capture the mood of the countryside, or one that they could use as an outdoor room. Others wanted a garden solely for admiring, perhaps from the window of a house. Although the actual area of these town gardens was usually small, many of those on the outskirts of an urban region had a wide belt of land surrounding them, which Page had to consider in his design.

One such landed property was the Villa Silvio Pellico, an eighteenth-century orange stucco villa set on a hill on the outskirts of Turin, named for a nineteenth-century writer and owned by Signora Ajmone Marsan. In front of the house a lawn stretched to the edge of the hill, and beyond that, an abrupt bank gave way to an untidy kitchen garden with an assortment of cold frames linked by

ABOVE Russell Page completely reconstructed the garden at the Villa Silvio Pellico in Moncalieri outside Turin. He composed two diamond patterned beds, edged with box and filled with santolina, for the parterre on the main axis of the garden.

OPPOSITE Page installed all the stonework and replaced a twenty-foot-high bank with an imposing staircase. This view shows the main axis of the garden from its lower end.

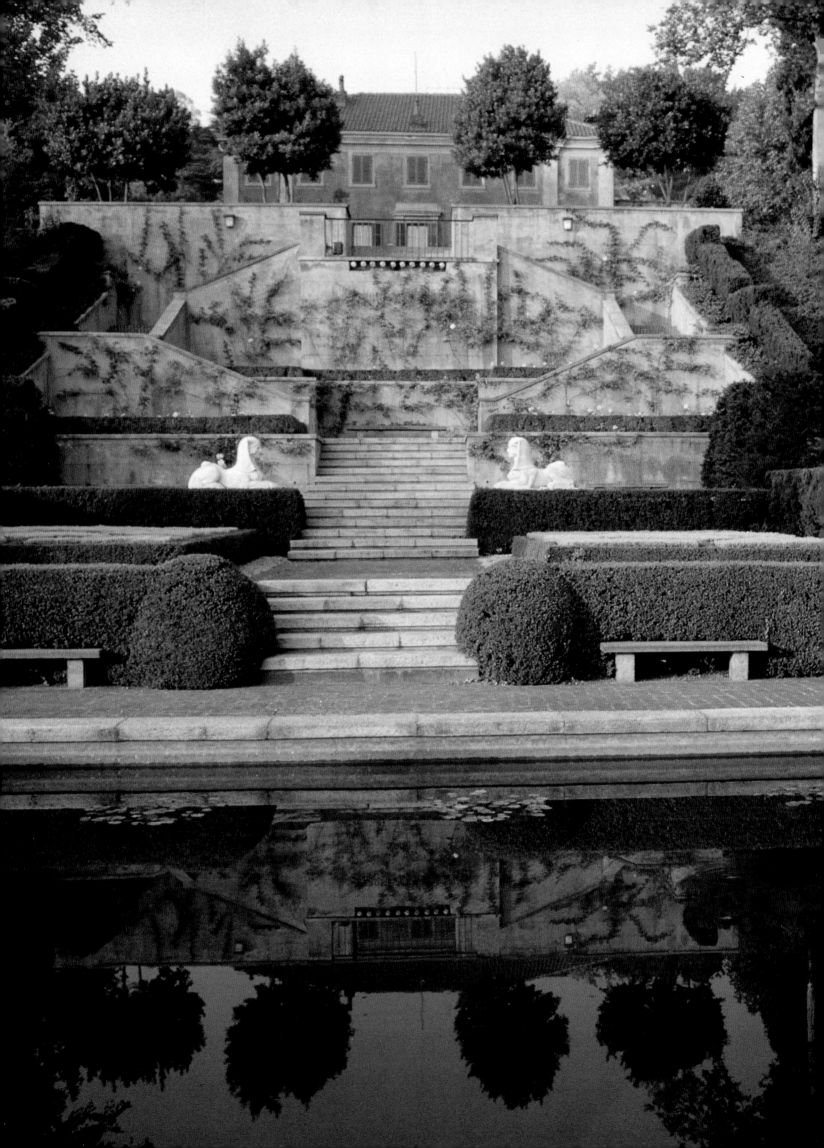

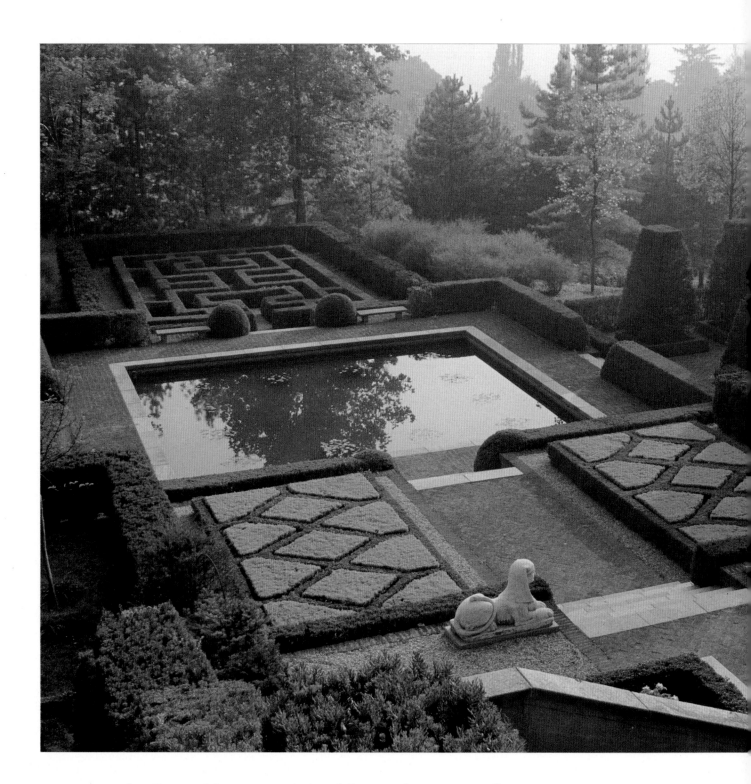

numerous paths. Signora Marsan commissioned Page to design a garden that would provide interest and pleasure when seen from the house. His solution was to build a new garden on a series of horizontal levels, framing each section with hornbeam hedges and linking them with stone-edged pools. With this general outline in mind, Page had the ground leveled, steps built, and the pools excavated before even figuring out what he would do with the steep bank and how he would connect the garden to the upper level of the property. Ultimately he designed a double staircase in three flights to connect the two. In front

ABOVE The focal point of the villa's main garden, seen from the level of the house, is a square pool, from which a cross-axis leads to a higher level on the left and a lower level on the right. The center of this ornamental garden actually occupies six different levels. It is one of Page's finest designs.

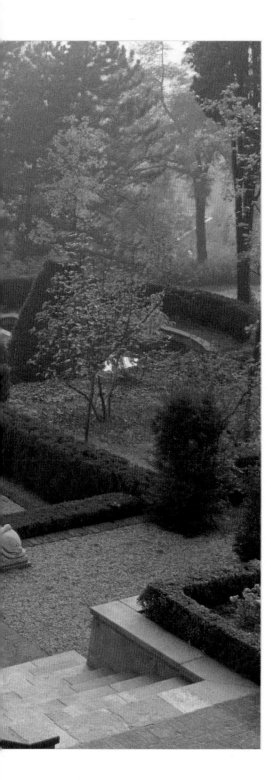

of the villa, he put in a lawn bisected by a brick path. Box-edged borders of roses backed with camellias on either side of the path serve as a quiet introduction to the neoclassical formality of the garden below.

Looking down from the house level, the view along the main axis is first of two rectangular parterres, each box-edged and outlined in diamond patterns. The spaces within are filled with santolina, which is clipped slightly higher than the boxwood. The second section contains a square reflecting pond, while the third is composed in box and white gravel in an arabesque pattern. Pink brick paths set in a herringbone arrangement join these different levels.

Among the most interesting features of this garden, in which plants replace the characteristic Italian stonework, are the cross-axis exten-

sions. To the left of the square central pool, approached by a flight of five steps, is a slightly elevated canal garden, hedged with yews, leading to a statue of Pan. The cross-axis garden on the right is lower and smaller. Framed by four yew obelisks set in box squares, it holds a horseshoe-shaped pool dominated by a statue of Neptune.

No other classical garden made by Page in Europe better illustrates his extraordinary ability to interpret the nature of a site than the Villa Silvio Pellico. The design shows his mastery at turning a problem site, in this case the hilly location, into an advantage. The garden, with its green trees and shrubs, spaces and stone work, and changes of level and perspective, offers an oasis of calm and peace despite its nearness to a bustling city.

Around 1930, Page had helped to reorganize a garden near Melun, France, for Ogden Codman, a retired architect who had an extensive library on garden architecture. Page had the opportunity to study a

RIGHT Five steps lead to the Villa Silvio Pellico's elevated canal garden. Page gave this garden an architectural feel with buttresses of yew hedges.

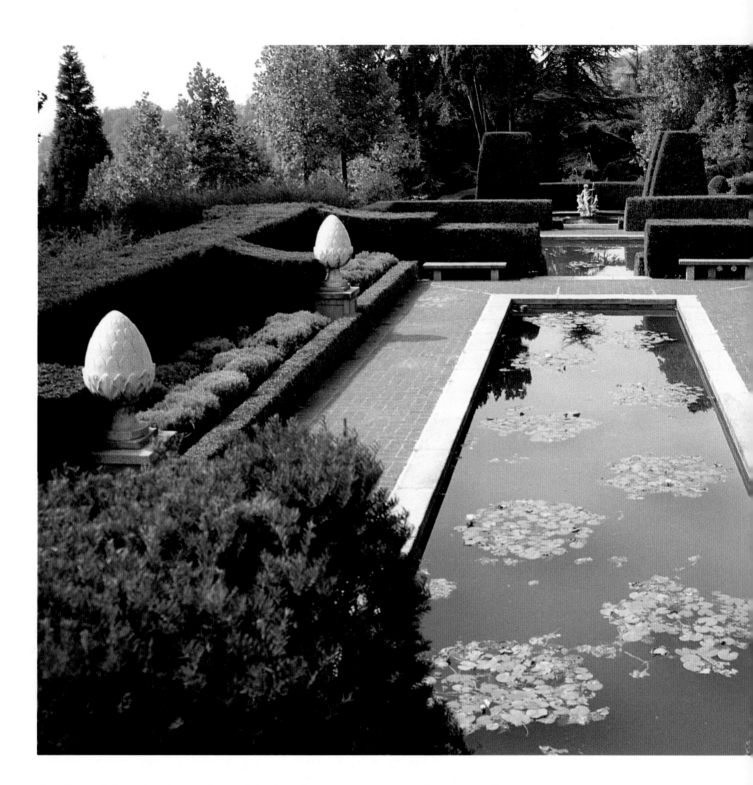

number of these books, and combined with visits to many Italian gardens they helped him to absorb the principles of composition and to view the present world through the lens of the past. "With this way of looking and this quality of information the garden designer really can throw off the strait-waistcoat of historical and literary associations and feel free enough not to re-interpret or copy the copy of a copy. He will learn to grasp the underlying qualities of the area he has to deal with and so authenticate his work,"[4] Page wrote. The Villa Silvio Pellico was the pleasurable proof of Page's understanding of the classical Italian garden.

Above The canal garden looks across the Villa Silvio Pellico's main parterre toward the Neptune fountain at the other end. The beds between the partitions, which are accentuated by stone finials, are planted with lavender.

On a similar sloping site at the edge of Turin stands the Villa Frescot, the residence of fiat owner Signor Giovanni Agnelli and his wife, Donna Marella. While the formality of the garden at the Villa Silvio Pellico connects it to the adjacent urban landscape, here both the house, once the *casa padronale* of a farm, and the garden seem almost to deny their proximity to the city. A country atmosphere

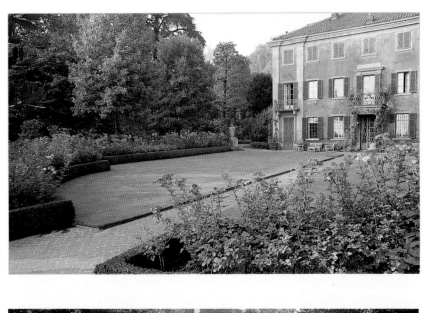

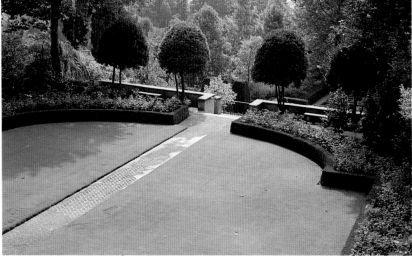

RIGHT, ABOVE *Two curving rose borders edge the front lawn of the Villa Silvio Pellico. The rose 'Masquerade' was chosen to complement the color of the house.*

RIGHT, BELOW *The velvety lawn in front of the villa, with its graceful rose borders, conceals a sprinkling system and leads to a steep staircase, the top of which provides an overview of the parterre below.*

prevails, enhanced by wooded hillsides and an old farm building on the property, which was once the studio of the eighteenth-century sculptor Francesco Ladatte. The garden, which is set below the house, represents the collaborative efforts of Signora Agnelli and Russell Page. Originally Page had suggested turning the lower terrace into a water garden, but Donna Marella had vigorously opposed that plan, preferring to retain the property's rural flavor. Page then had this lower area laid out in a simple geometric pattern, with box-edged rectangular beds filled with various green herbs and vegetables, and low box hedges and espaliered pear and apple trees set against

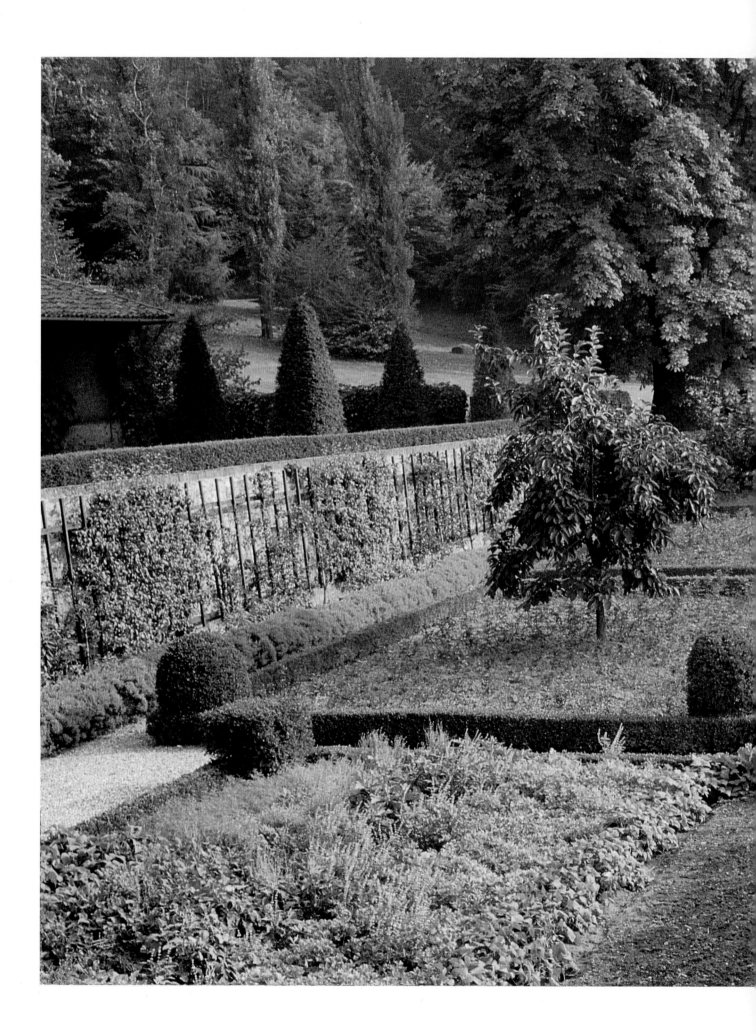

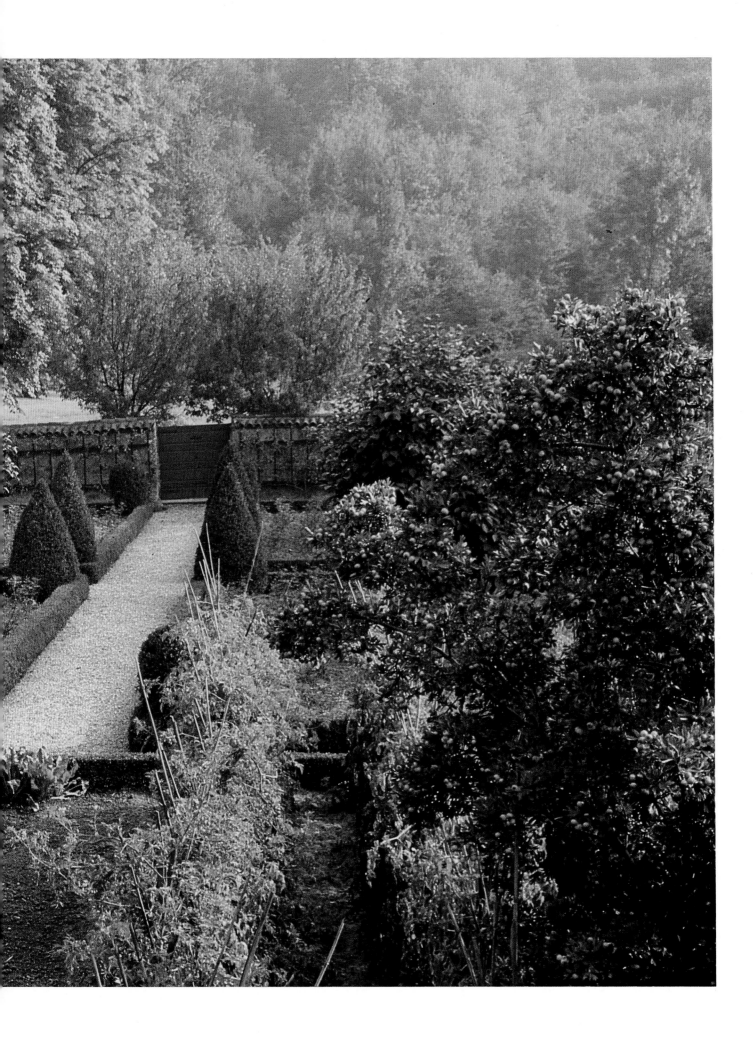

surrounding brick walls. He established formal designs in the more distant beds, using an alternating pattern of box balls and conical yews at each corner to frame the flamboyant red *Rosa multiflora* 'Cin Cin'. A small door in the back wall of the garden leads from this enclosed "rustic formality" to a meadow of old chestnut trees and wooded hills.

In 1966 Page traveled to Switzerland to create a new town garden just a few minutes away from the downtown banks and shops of Geneva for Don Jaime Ortiz-Patiño. It was to be both formal and French in appearance and feeling. The Englishman produced a clean, controlled design, reminiscent in parts of the small rose parterre he

PRECEDING PAGES *The sunken terrace at Villa Frescot, the residence of Mr. and Mrs. Giovanni Agnelli, was landscaped by Russell Page according to Mrs. Agnelli's wishes. Rather than change the vernacular of the former farm, Donna Marella wished to retain its rusticity. Page's design for the kitchen garden, with its clear, simple pattern formalized with box edges, gave it distinction.*

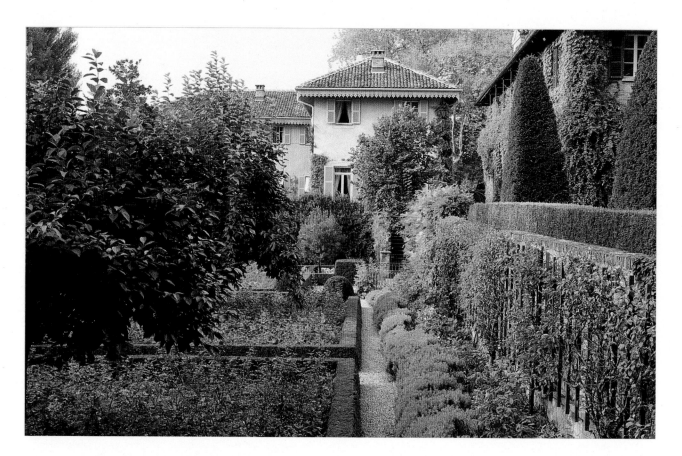

had conceived at the château de Bleneau, but even more so of Hidcote, with its shaped trees, hedges, and compartments. Page immersed himself in all the details of planning the entrance court, various flower parterres, a formal tree compartment, and a *giardino segreto* with serpentine walls and flower beds.

He drew the front terrace width the same height as the roof, raised by a gray stone retaining wall that compensates for the changes in ground level. The terrace was indented in front of the main house block and widened in front of guest and service wings. He joined it to the lawn below, which gives way to a sloping meadow and parkland, by a brief double hemicycle, an echo of the stairs Page had made for Don Jaime's parents at Le Moulinet in the late 1940s. A long, rec-

ABOVE *Page set espaliered apple and pear trees along the brick wall on the upper side of the Villa Frescot's sunken garden. Vegetables and herbs are cultivated in the beds near the house.*

OPPOSITE *To the far side of the terrace, Page added four rosebeds emphasized by balls and cones of yew.*

FOLLOWING PAGES *Page selected the glowing red rose 'Cin Cin,' its bright color clearly visible from a distance, for the rosebeds at the Villa Frescot. A persimmon tree grows in the center of each rosebed.*

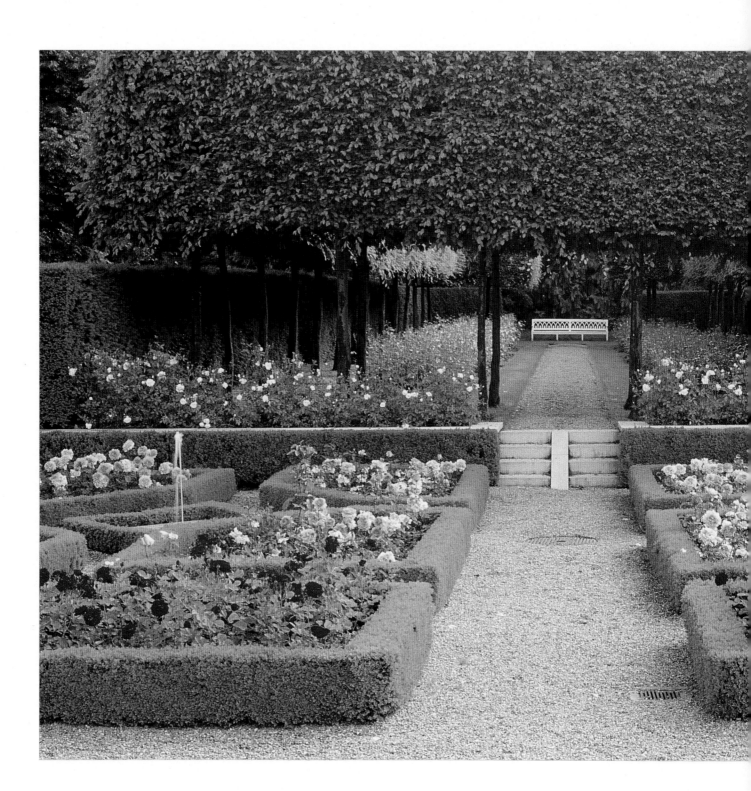

tangular double box-edged rose bed, punctuated by stubby box pyramids set in the gravel, is balanced by a grass rectangle set at right angles to two similar beds planted with the same red floribunda roses. The patterned garden of box and pink floribundas holds two low, box-edged pools with slender splashing jets, a charming touch in the classic geometry. The planting is low to leave the far view of Mont Blanc unobstructed. Don Jaime was so pleased with the results that in 1970 he commissioned Page to do another garden from inception in the south of Spain.

ABOVE For the Ortiz house in Geneva Russell Page placed this formal geometric garden in an extension of the terrace on the side of the house. An Islamic influence is evident in the rose parterre with small diamond-shaped fountains. It lies at the foot of a slightly elevated terrace, the living architecture of which is formed by yew hedges and hornbeam trees.

During these years Page was also eagerly sought after to design a number of town gardens in Paris, particularly around the elegant Faubourg Saint-Germain and the suburbs of Auteuil and Neuilly. In general he felt that "Paris gardens, private and public, are seen as a decoration to be admired."[5] But Russell Page understood his clients and their world, and he learned to view each new town project as if he

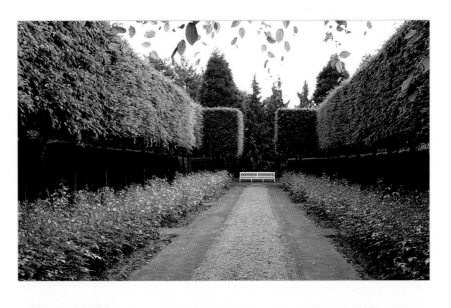

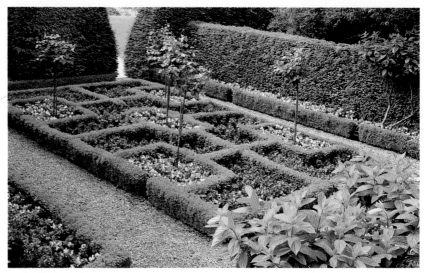

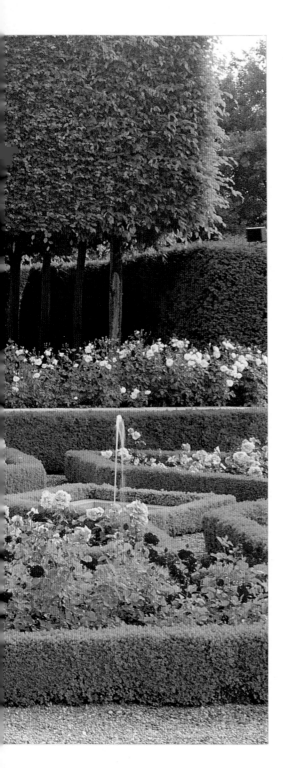

RIGHT, ABOVE *Page formed the walls of the green compartment above the parterre in the Ortiz garden with pleached hornbeams underplanted with Iceberg roses.*

RIGHT, BELOW *A charming mini parterre composed by Page of box, begonias, and standard rose trees is tucked away between yew hedges at the other side of the Ortiz house.*

were seeing and thinking for the first time through the eyes of the French. He knew how to adapt their styles to the disadvantages of Parisian sites, with their lack of light and air.

Page enjoyed designing these rather sober gardens, creating harmony and tranquillity despite the limited range of plants with which he could work. Often walled in for privacy, these urban gardens tend to be formal, with such static elements as clipped box, gravel, parterres, and pleached trees. If the site could support grass, Page sometimes placed a stone basin with one wavering jet of water in a green expanse.

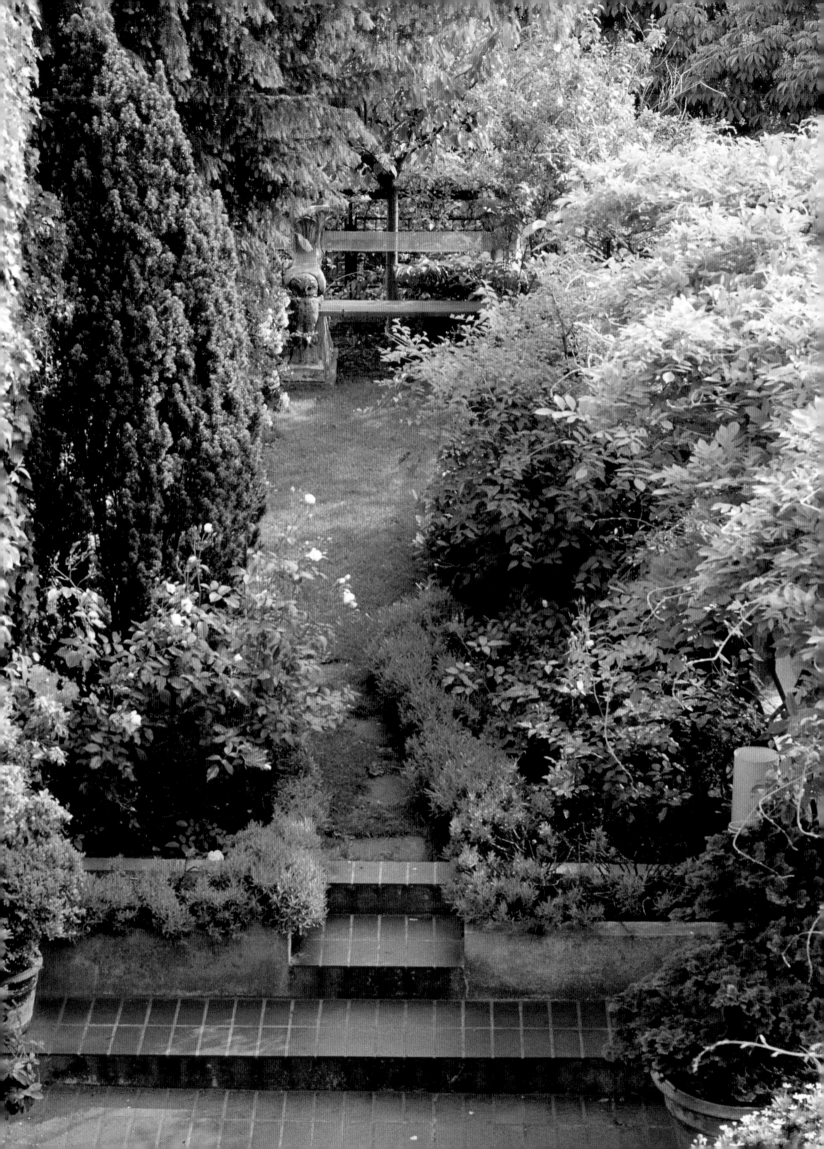

If there was light, he might enclose a simple lawn with slender gravel paths and add a few magnolias for height and interest. He found the constraints inherent in these spaces a challenge to his ingenuity.

Although Page never considered roof gardens to be true gardens, he did one in the 1950s for Marcel Boussac, the owner of Mivoisin, overlooking the Bois de Boulogne. Page's architectural composition was based on two small "Chinese Chippendale" pavilions and a wooden trellised loggia. The "garden" Page planted consisted of flower boxes filled with tulips and pansies in the spring, succeeded by petunias and geraniums. Twenty years later, Page made another roof garden, this time for Maurice Rheims of the Académie Française, on the Faubourg-Saint-Honoré. He enclosed a long open terrace with a high cement wall, painted white and dotted with several square

OPPOSITE In contrast to his other, more formal, city gardens Russell Page gave this Parisian rooftop high above the shady gardens of the Faubourg-Saint-Honoré a naturalized touch with a lush planting scheme of flowering shrubs and climbers, fruit trees, and grapes.

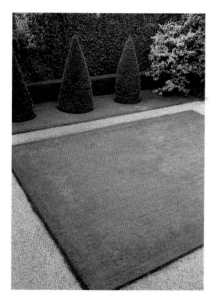

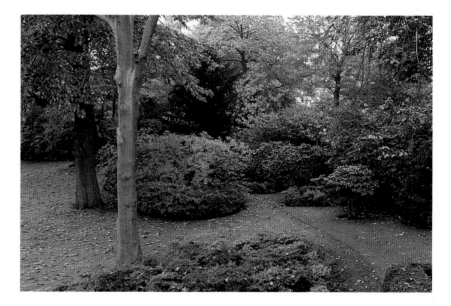

ABOVE Page decided that a simple tapis vert outlined by paths was appropriate for the courtyard of the seventeenth-century Hotel du President Talon in the heart of Paris. Conical ever-greens and four magnolias complete the scheme.

RIGHT For a garden in the center of Brussels Page carefully selected the evergreen and deciduous shrubs for their shapes and textures. He planted them informally on both sides of a path that circumscribes the property's central lawn.

openings, which he planted with lush flowering climbers and grapes. Three brick steps rising from the terrace allowed the necessary depth for soil, and the garden soon became a paradise of small trees, lavender, and Iceberg roses. It is a very naturalized-looking patch of greenery set high over the shady gardens of the faubourg below.

In the mid-1960s in the center of Brussels, Page designed the entrance courtyard, terracing, and garden for prominent banker Jacques Thierry and his wife around an eighteenth-century-style house. The garden is essentially a large parabolic lawn, slightly indented toward the center to give the illusion of space. The crescent-shaped ends of a brick terrace become a curving circular path that follows the rim of the lawn. The path is backed by a dense planting of shrubs and trees, which add depth and privacy to the composition.

By the 1950s Edith Wharton's Pavillon Colombe, in the town of Saint-Brice, near Paris, had been sold to the Duchess of Talleyrand.

Page had visited this garden as a young man. It was based on the Hidcote-type plan of a connecting series of garden compartments, which give a sense of space, even though space was limited by the surrounding buildings of the town. The duchess sought Page's assistance in making a formal garden opposite the blue garden that had been designed by Lawrence Johnstone and the American author. Page chose clipped yews and beds of garden pinks and silver santolina to further enhance the illusion of space.

For the most part, the town gardens designed by Russell Page were formal indeed. Perhaps he felt that the symmetrical, and rather severe, designs would ensure tranquillity in the city. There was another type of town garden that Page designed, however, that seemed the opposite of these permanent, tranquil installations. Several times he was hired

LEFT AND OPPOSITE *Two colored-pencil sketches made by Russell Page in preparation for the 1951 Festival Gardens at Battersea Park in London reveal his concern for over-all atmosphere.*

to design displays for temporary garden exhibitions. In 1950, for example, he interrupted his private work to take charge of and design the Festival Gardens at Battersea Park in London for the 1951 Festival of Britain. The organization and work took him eighteen months. During that time, André de Vilmorin came to England to watch his friend slave as never before, always a step away from disaster and always "pulling it off" in extremis. With the help of E. R. Janes, who had been in charge of the flowers at the Chelsea show, Page managed to find and arrange for the delivery of thousands of colorful plants and shrubs and meet the show's deadlines.

The raison d'être for the Festival Gardens was to provide a pleasure park, like the Tivoli in Denmark, to brighten and lift the spirits of the war-weary English. Page conceived his design in terms of color, working with the bright yellow of twenty thousand massed tulips and blocks of crimson and pink floribunda roses: "I saw that I must mix

my flower colours, plant in wide pools and drifts, let pale pinks overlap into clear lemon yellow, interplant orange with red-purple and use every device I could so that texture, colour, size and shape would combine to make all the flower plantings sparkle, shimmer and seem to move in contrast to the bright, flat and static surfaces of paint."[6]

Impressed by Page's work, André de Vilmorin asked Page to design the Vilmorin exhibit for the first French Floralies (international flower show) in the spring of 1959. It was to be held in a new triangle-shaped exhibitions building. The Vilmorin exhibit was on the main floor in an enormous hexagonal space at the center of the building under the highest point of its soaring roof. Page's composition, consisting of a curving pool and trees, flowers, and rocks, won every prize. One evening, after having given a dinner for five hundred people in honor

of a minister, Vilmorin went to refresh himself with a look at Page s gardens. He saw a man, alone, in tears. Vilmorin asked the supervisor of the men who worked at night to replace faded plants if he had noticed this man. He replied that he had seen more than one visitor crying over the beauty of the garden. Vilmorin commented years later that some can move people to tears with music, but that only Russell Page could move men with plants.

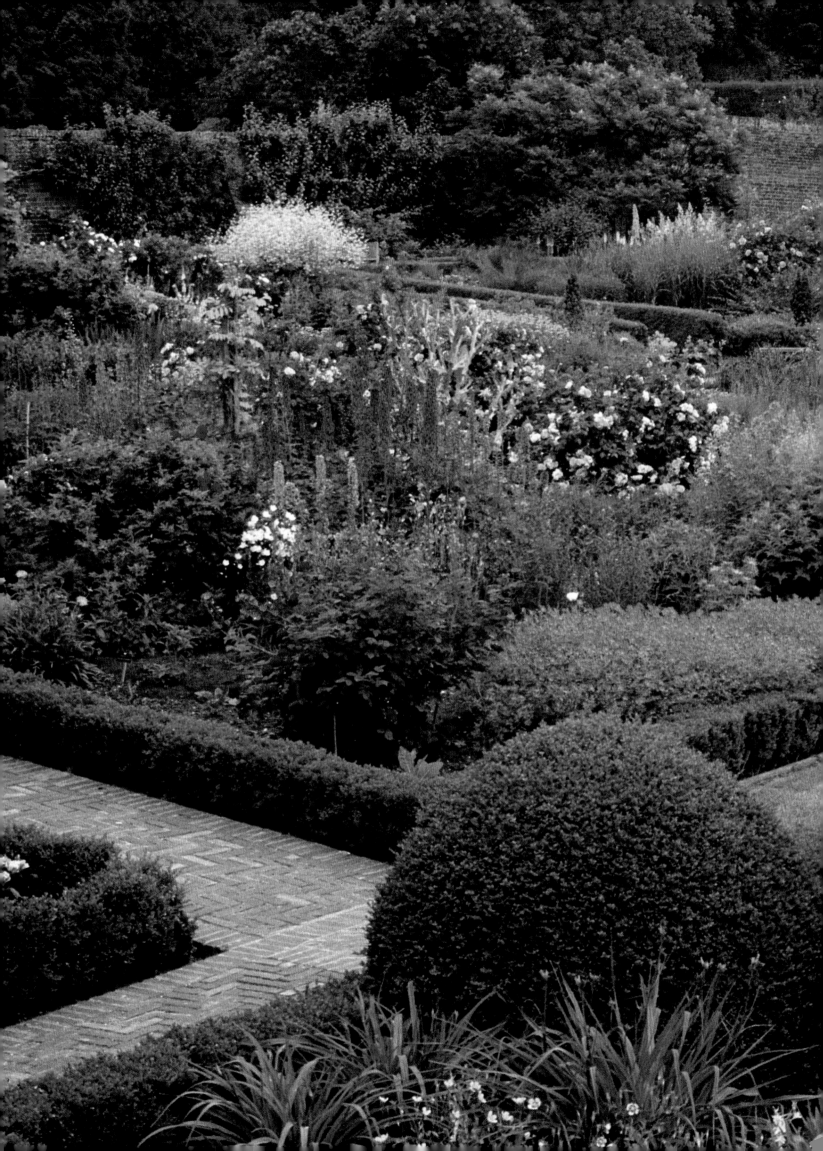

In the 1960s, after many years abroad, Russell Page decided to return to England permanently. Looking back on that decision he wrote: "In 1962 Paris ceased to be my home and place of work and I returned alone to live in England after twenty years abroad. It was strange at first and even difficult to adjust. Scenes and places rediscovered but inevitably different. The quality of life in the country on this island was a great temptation and at first I felt drawn towards a home in a familiar countryside, gardening myself, contacts with gardening friends, the temptations of a quiet life. Within months I discovered this was no way for me. I needed to work—I had to—I needed a wider scope than the Surrey lanes and woods could afford me. I needed the challenge of new landscapes and other geographies—the stimulus of movement and effort and adaptation."[1] ❧ Soon he moved to a small flat, the first of many, in St. John's Wood, which had a tiny garden at the back, the first and last garden that he could call his own since childhood. It was far from ideal, a cement-bordered checkerboard of four-foot squares set in crisscrossing bands of flagstones. These were partially filled with often dispirited plants, mostly one or two of a species begged from friends. He was the first to laugh at it but admitted that it gave him much pleasure. ❧ Page's surroundings reflected his rather nomadic existence and his indifference to possessions. In his studio, piles of Bukharan embroideries lay folded on the floor, and books, many of them technical works about gardening, were stacked everywhere as well as crammed into bookshelves. Each change of flats found him giving away books (at one time he owned around five thousand), furniture, and objects he had collected on his many travels. He chose his last flat, off Sloane Street in London, for its view of a huge winter-flowering cherry tree. It was a place for his books and his drawing board that he could come back to when not boarding yet another plane. ❧ Page had never lost touch with England during the twenty years he was based in Paris. He had returned there regularly for work, which encompassed not only ongoing projects at Longleat House and Leeds Castle, but also major displays at the Festival Gardens in London's Battersea Park in 1951, for which he was awarded an OBE (Officer of the Order of the British Empire).

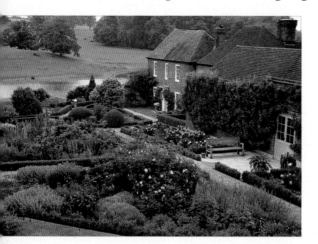

*A*BOVE *The Culpeper garden, the jewel of Leeds Castle, is enclosed by high brick walls on three sides. Russell Page gave it a sweeping view when he created a lake, called the Great Water, by flooding the valley of the river Len.*

*O*PPOSITE *Page undertook the planning and planting of the Culpeper garden in 1980. He chose cottage-garden plants such as geraniums, bergamot, delphiniums, and roses, and set them in asymmetric box-edged beds accentuated by clipped box balls.*

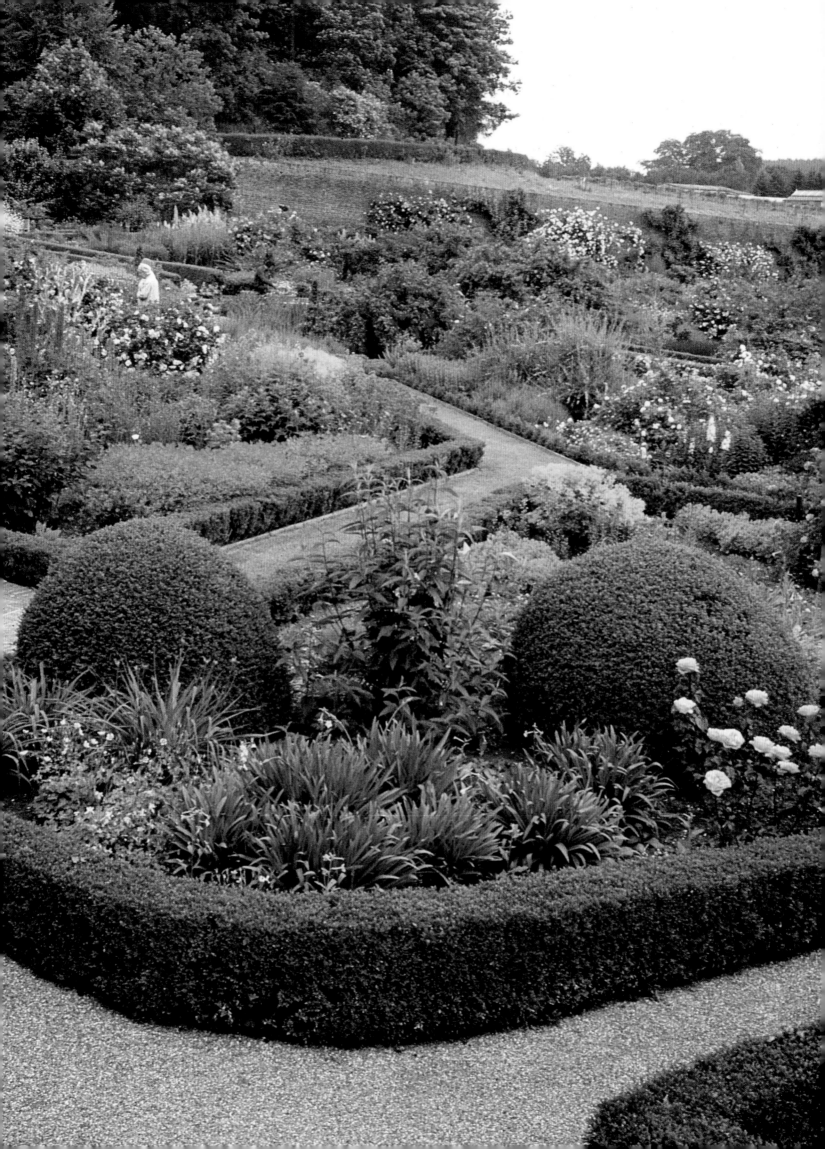

He first went to Leeds Castle in the 1930s to do the plantings around the moated castle and its adjacent buildings. But once the original commission was completed, he found himself being asked back over the years to undertake other projects. He chose and landscaped the site for a swimming pool on the grounds, sheltering it behind yew hedges between two towers of the castle; he transformed the inner moated area into a lawn; and he worked on the design and positioning of an oval entrance drive. Page did most of this prewar work without blueprints. He simply gave instructions to the gardeners directly and checked the results on his next visit, modifying and changing as needed.

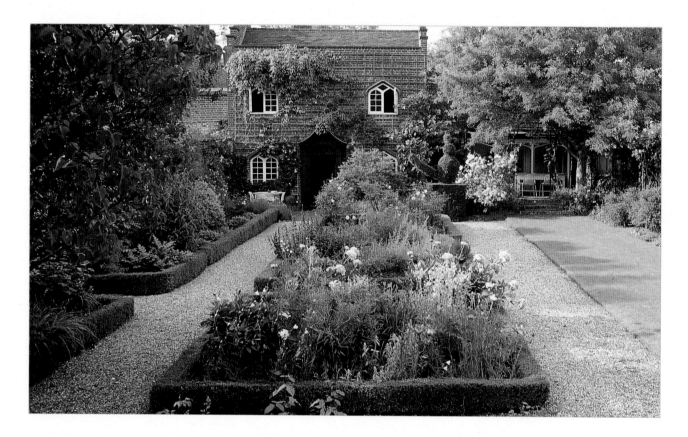

The garden Russell Page designed for Mrs. Reginald Fellow's neo-gothic cottage survives in a much simplified form. Now planted with such perennials as oriental poppies, salvias, lavender, and artemisias, it is more a cottage garden than the small formal parterre Page had conceived.

Russell Page's interests at Leeds, as at other estates, went beyond mere gardening. The modernization of Broomfield village, part of the Leeds estate, for example, also captured his attention. When heating and plumbing were being installed there he helped with the preservation of the brick facades of the village's fifteen brick houses and small church. No detail of the renovation was too small for his consideration—neither the design of the garden fences nor the choice of the village trees, which were to be the same type as those in adjoining hamlets. He even devised special wire cages to camouflage the residents' washing.

Lady Baillie, a celebrated hostess and the owner of Leeds Castle until her death in 1974, had a passion for waterfowl. In the 1960s Page

created a habitat out of a wilderness of fallen trees and brambles for her numerous ducks, geese, and swans. In addition, he turned the banks of the stream as well as the area around two ponds on the property into a naturalized spring garden. He personally scattered masses of narcissus and daffodil bulbs between newly planted willows, ashes, and alders, while the gardeners followed with trowels and spades to complete the work. Unlike the famed designer Gertrude Jekyll, who designed gardens at her desk and hardly ever went on location, Page not only supervised but often did the planting and worked alongside the gardeners, too.

The two largest projects Page participated in at Leeds Castle were the Culpeper garden and the creation of a lake. The former was named after the seventeenth-century owners of Leeds, who used the oddly shaped plot of ground, enclosed on three sides by high brick walls and some brick cottages, as a kitchen garden. Page made it into a flower garden of informal box-edged beds and warm brick paths. He had the valley of the river Len flooded to redefine the lost sweep of the landscape, and in so doing, created a lake, now known as the Great Water. The Culpeper garden looks out over it.

Page's method of planting the Culpeper garden was practical and fast. He drew up his plant list alphabetically and sent instructions to Leeds to have the flats of plants laid out in twenty-six alphabetical rows. He arrived at the castle armed with a long stick and, assisted by seven gardeners, simply pointed to the easily found plants, and into the soil they went. The garden was made in one day, and not one plant was subsequently repositioned. When Page and his crew broke for lunch at a restaurant that day, he delighted them by telling amusing stories about some of his clients and the mishaps he had suffered over his long gardening career. This tall, thin, elegant man, sometimes accused of haughtiness, had the men in an uproar with his dry humor, at his own expense. They particularly appreciated the story of how he had slaved with strings and sticks and very little assistance to plant a large grouping of azaleas for a very grand American client, only to have all his work pulled up as soon as her luncheon guests left the estate. The pleasure he derived from working with men who knew what they were doing was boundless. He would ask them technical and practical questions and jotted down their replies. He was constantly learning. Often he would show them a sketch, anxious to see if they thought his ideas would work.

Most of the gardens that Page designed in England were flower gardens. He often used hedgework for their basic structure and chose plantings typical of English cottage gardens, but set them out in formal patterns that might be called French designs in miniature. An

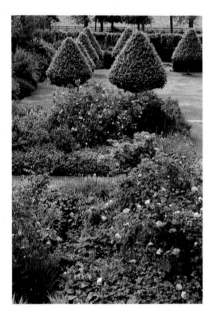

Below At Little Mynthurst Farm, Page contrasted the profusion of flowers in this walled garden with the clipped hornbeam trees growing in geometric formation in the background.

Following pages Russell Page provided extensive plant lists for Little Mynthurst Farm. A corner is planted with rosa complicata, *Johnson's blue geranium, and* stachys macrantha robusta.

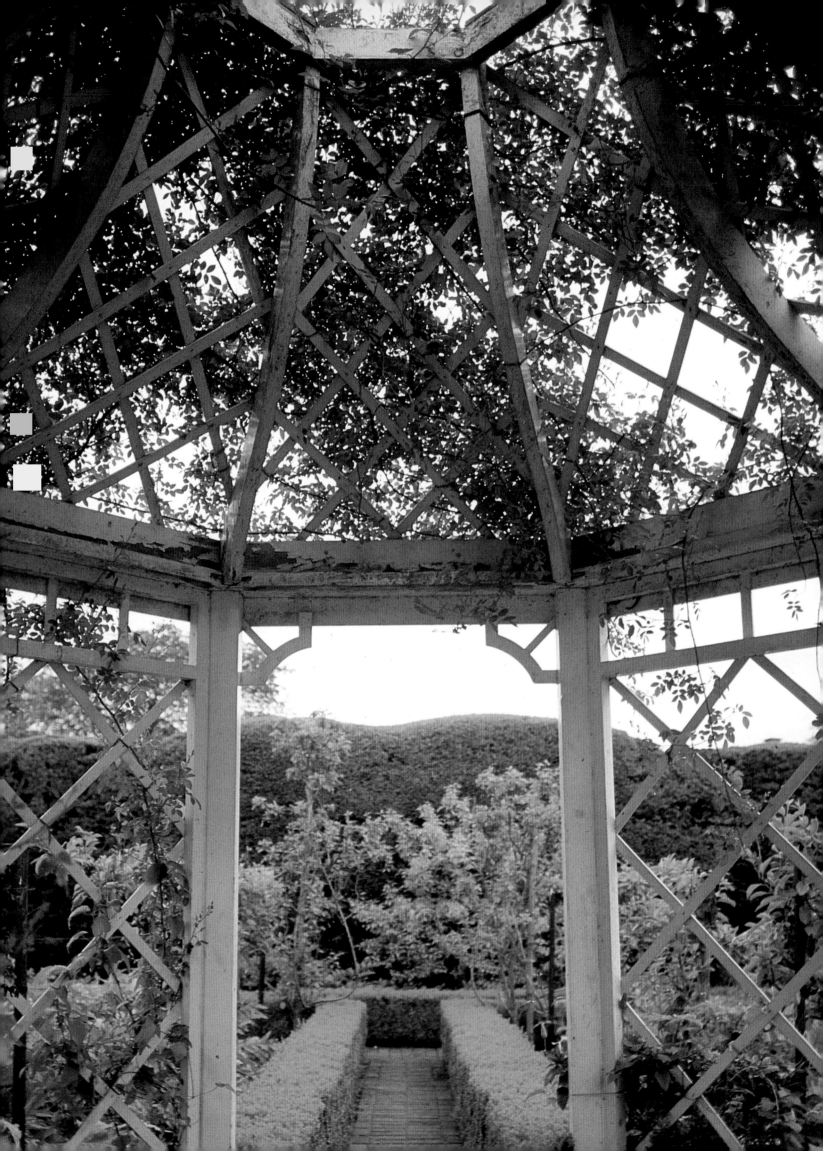

excellent example of such a garden is the small one he did in 1955 for Mrs. Reginald Fellows, an eccentric lady who collected only black animals—cattle, swans, and horses—on her estate in Berkshire. She lived in a cottage on the grounds, somewhat removed from the large main house where her children and her guests were put up. She made neo-gothic door and window frames for the cottage to conform to the inner decoration, designed by Cecil Beaton, of blue and gold walls and a tigerskin-covered chaise longue. She asked Page to do a garden that would fit with the spirit of the house. Within high brick walls, he made a garden whose beds, he wrote, "are small and are intended for bedding-out with spring and summer flowers. Their simple repetitive pattern makes it easy to devise all kinds of planting in harmonizing or contrasting patterns."[2] Now, years later, the garden survives in a more

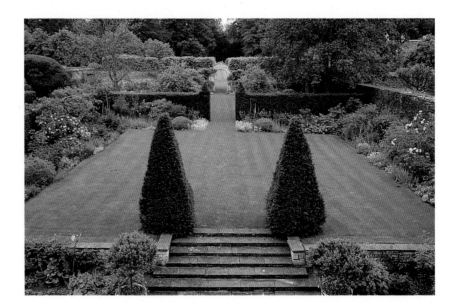

Opposite Russell Page, a good friend of Lady Caroline Somerset and her family, came often to work at the Cottage, her home in Badminton, and in fact is buried nearby. Over the years he designed a series of green rooms in the old Cotswold garden. He made a white wooden folly the centerpiece for the walled kitchen garden.

Right An air of decorative formality suffuses the grounds at Badminton. Two yew pyramids mark the entrance to the first of the enclosed gardens.

sober version, as Mrs. Fellows's niece has removed the central box divisions to allow for the sprawl of larger shrubs and plants. But its elegance and charm remain intact.

One of Russell Page's greatest joys upon returning to live in his native country was his rediscovery of English gardens and gardeners, with their lavish use of flowers. They filled him with enthusiasm, best demonstrated in his own words:

Based in London I had the opportunity of making an English garden from time to time. To garden here is a source of refreshment. Gardens here are a part of life, as in no other country except, perhaps, Japan. An eccentric maritime climate has produced an almost unique relationship between soil, plants, animals and people—there is an alchemy which links them in an odd taken for granted harmony. Inevitably I meet devoted and

first class gardeners the world over, but they are exceptional in their surroundings. Here, in this country, wherever I go, from the grandest to the most modest garden I meet with a sensitivity towards and awareness of plant life which even though expressed in a million different ways, enthusiastic, intellectual, snobbish, sentimental, scientific, brilliant or seemingly plain still reflects this hidden relationship between humans and plants.[3]

Page found not only a profusion of plants awaiting him in England, but also a good number of his friends. Lord and Lady Bernstein, for

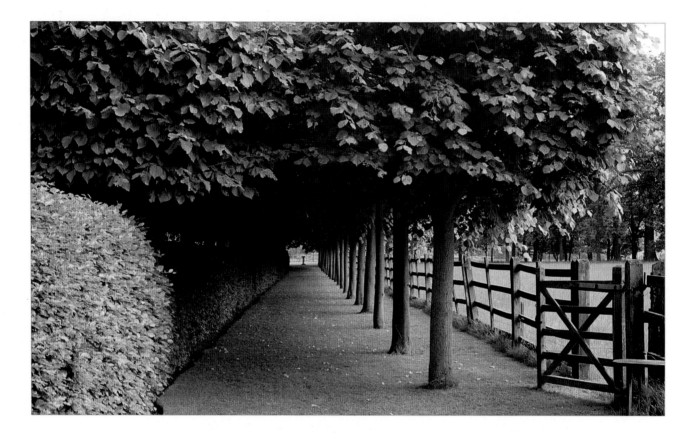

instance, gave him an opportunity to garden and fiddle at his leisure at Coppings Farm, their country house. Over the years he stayed there many weekends, arranging plantings in the heavy clay soil. He called it "working in the Kent vernacular."[4] He also did a garden for them in Barbados, where he spent several Christmas holidays, and traveled with them to Israel. There he became a friend of Jerusalem's mayor, Teddy Kollek, to whom he offered advice about what to plant around the walls of the city and how to make the surroundings green. In December 1973 he sent Kollek "A Short and Random List of Plants Suitable for the Jerusalem Climate" and remained available to counsel and encourage the beautification of this ancient city.

Page's interest in roses, especially the old-fashioned ones, was

At Coppings Farm, the country house of Lord and Lady Bernstein, pleached linden trees form a shaded tunnel between a fence and a hornbeam hedge.

reawakened at Owley, the Kentish farmhouse of Mr. and Mrs. Chester Beatty. In the twenty years he had spent in France and on the Continent he had been frustrated in his attempt to design with roses. Few varieties were available there, and Page had had to rely mainly on the French rose grower Meilland's limited, though excellent, list. The choice of roses obtainable in England was richly stimulating. And Mrs. Beatty loved the flower so much that Page was free to transform most of her property into a rose garden. He used island beds of old-fashioned roses, mixed with flowering shrubs, to create a sense of space and an illusion of distance from the house.

One of Russell Page's favorite places in England was the Cottage at Badminton, the home of Lady Caroline, Lord Bath's eldest daughter, and her husband, now the duke of Beaufort, who were among his closest friends. Theirs was an old Cotswold garden with stone walls and ancient hedges of box and yew, to which Page brought elegance and charm. Page's first plans for the garden were made in 1965, the last in 1984. During that time, he added new paths, archways, and gates to make vistas and suggest space. Using cordoned apple trees, box edging, and a central trellised gazebo, he formalized the vegetable garden. The end result of his twenty years of work is a semiformal English garden on an intimate scale.

There are a number of similarities between these small English gardens—Coppings Farm, Owley, Badminton—and the ones he did around the same time across the Channel along the Normandy coast—Meautry and Varaville. A certain cross-pollination of ideas is evident in his work of that period. For example, pleached linden allées, clipped trees, and an abundance of flowers recur in many of his designs. Each is used differently, however, in the context of a particular place and adapted to the life and interest of the individual owner.

It was Easter 1966 that I first met Russell Page. We were introduced at lunch at the Haras de Meautry in Normandy, where he had designed a simple garden plan for Baron and Baroness Guy de Rothschild. Some years later, he landscaped the pool and pool house areas and made a *potager* (vegetable garden) and a cutting garden for roses there. We became friends at sight, and after coffee I persuaded him to drive with me to the stud farm my husband and I had recently bought at Varaville, on the other side of Deauville. He was enchanted by the poetry of the place: an early eighteenth-century stable yard; the vague outlines of the original château, which had burned down in 1937, just visible in the long grass; the stone-walled kitchen garden and loose shrubs of rugosa roses growing wild. He picked a rose, sat down on a low wall and began to sketch the house he imagined for us on the back of an envelope.

*A*BOVE *A columnar beech tree seems to stand guard next to the Kentish oasthouse at Coppings Farm.*

*F*OLLOWING PAGES *At Owley, a farmhouse in Kent, Russell Page designed a miniature knot garden with roses at the foot of an oasthouse. The current owner of the house replanted each bed with a different white or silver-leaved plant, such as lavender and lamb's-ears, a change Page would have approved. He recommended this type of formal layout for cutting gardens, with each bed containing a different kind of flower.*

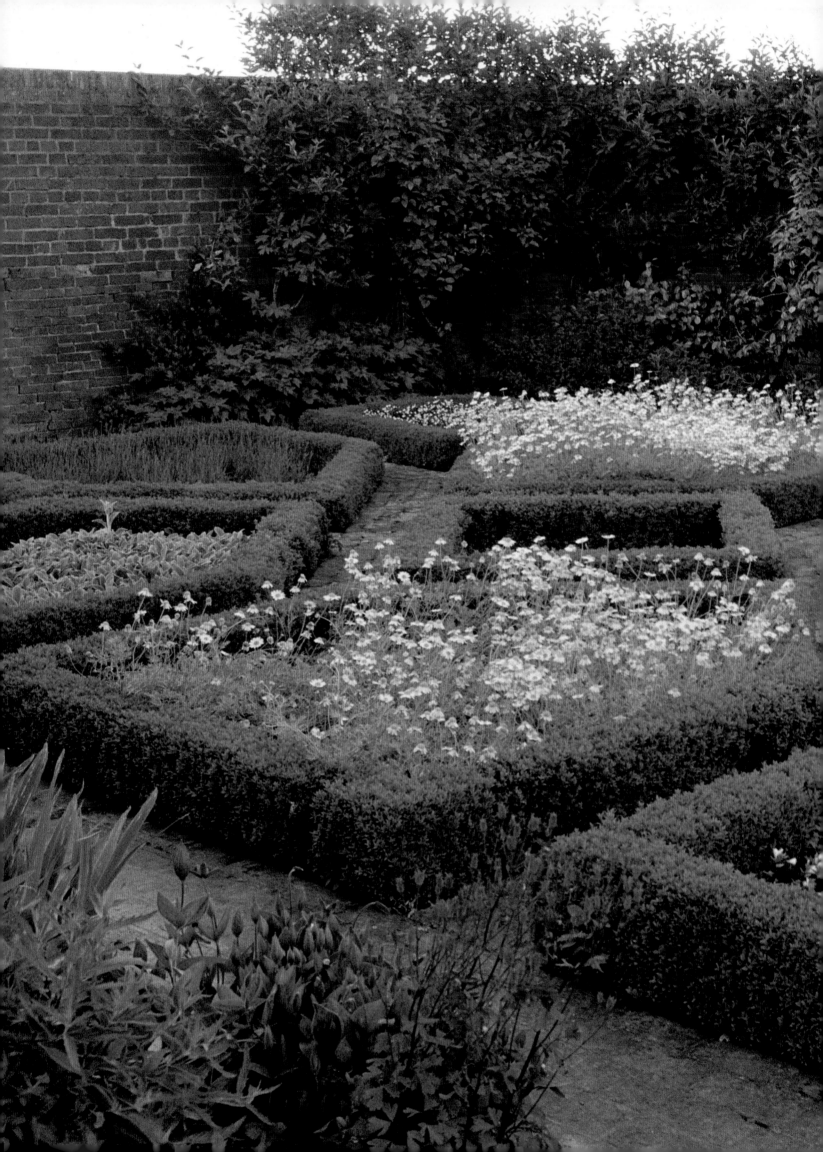

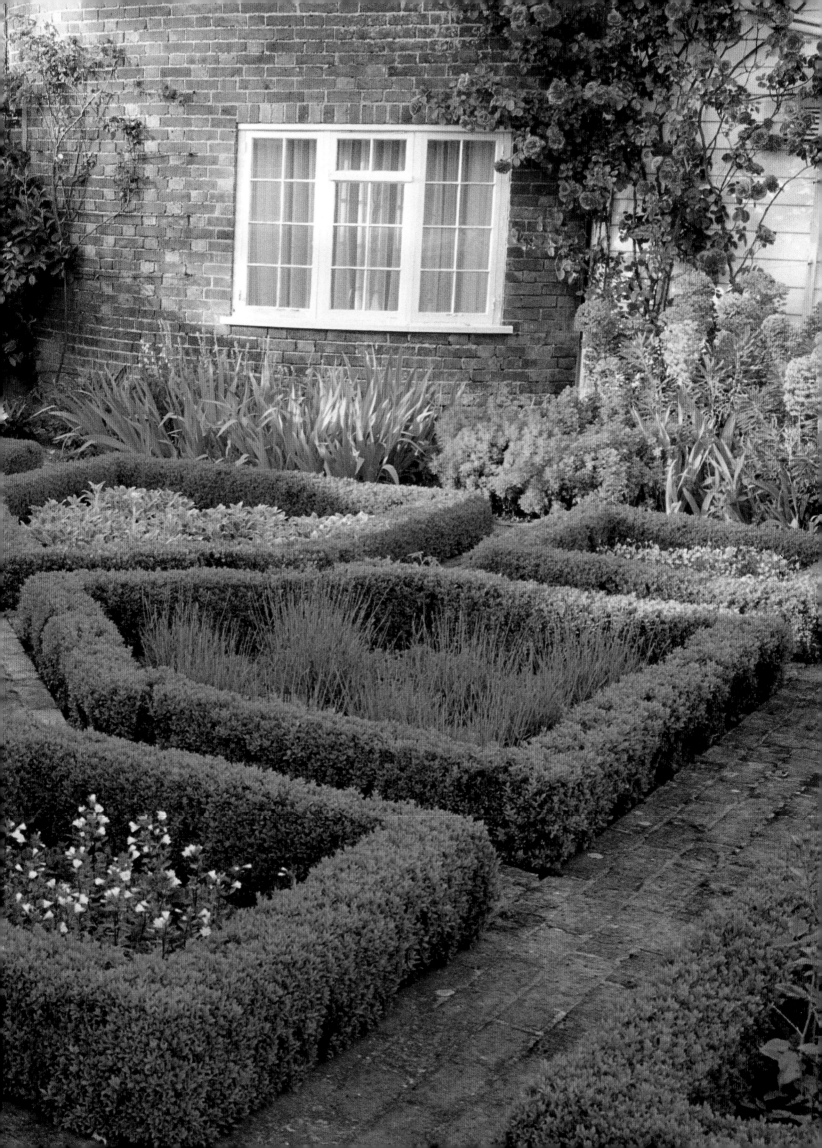

The house he had drawn didn't materialize, however, as we were determined to build a modern structure, which was a rare sight in this part of Normandy. But I did have my heart set on having Russell make the garden. For a while, the two projects appeared incompatible. He found the style of house we had chosen "irrelevant" and hated its location on a mound of earth at the end of a walled kitchen garden.

LEFT, ABOVE At the Haras de Varaville Russell Page retained a rounded clipped yew, the survivor of a pair that had stood in front of the former château, to serve as a starting point for his planting of evergreen shrubs and box hedges near the house.

LEFT, BELOW The south lawn, seen from the terrace of the Varaville house, is surrounded by spring-flowering shrubs and trees chosen by Page for their white and pink blossoms.

He distrusted our American-born architect and only took on the project in 1967 after I told him our friendship would not suffer from his refusal. His letter from London accompanying the first rough plans was a masterpiece of understatement: "I must say though it may be a very nice house it really does not seem to take the site into account at all—half of it on a mound and the mound sliced off sheer in the middle of the South side—how can one make it sit down and have a convincing garden round it?"[5]

But even here, as he had before, he was able to take the structural disadvantages and turn them into the strongest, possibly the most

successful, elements of the design. He offered various planting suggestions for the slope at the end of the elevated house to settle the area down. His first thought was to use horizontal junipers. "They will look like a storm-tossed sea," he assured me. I resisted this suggestion, and eventually he decided that the slope should be planted with an assortment of plants and shrubs and a few of the dark evergreens on the north side of the slope.

The care Russell took over the details and placing of the plantings was infinite, though it was often done by correspondence. I received many long, handwritten lists of planting suggestions for the garden: lists of annuals, with their colors and sizes; bulb lists; lists of trees known for their autumn colors; lists of trees for spring. Even marked-up catalogues arrived to help me choose, to help "get me going."

RIGHT A slate walk descends from the terrace of the house at Varaville to join a sandy path that forks left to the wild garden and right to the spring and summer garden. A young magnolia grows in the triangle formed by the intersection of the paths.

FOLLOWING PAGES Page underplanted a grove of mature chestnut trees on the Varaville property with spring bulbs and flowers that thrive in shade.

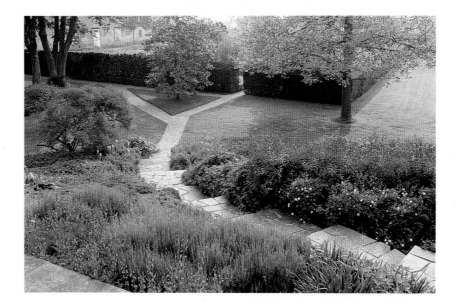

At the time, I had no idea of the kaleidoscopic nature of his life, or of how, as he wrote, "Different countries, different places, different scenes succeeded each other in a bewildering and evershifting series of superimposed patterns and pictures."[6] He often flew to Holland, where we had our family home, to spend a few days with me touring museums and horticultural nurseries at Boskoop and discussing the garden-to-be at Varaville. He showed me plants and shrubs he thought I would appreciate, then sometimes we drove across the Belgian border to have tea with his good friends the de Belders, who were renowned botanists. There also my garden was often the subject of our conversation. Soon, though, Russell was ready to board a plane to see another client, in Rome or Milan or Barcelona or New York.

Gardens and gardeners were not common in Normandy, nor was there much variety of plant material available in France in the late 1960s. We had to travel to Belgium, Holland, and England to find and order the plants and trees that we wanted for Varaville. During this

period, I was reading several gardening books and becoming very enthusiastic about planting all sorts of new flowers and shrubs in the garden. Occasionally, I would meet Russell in London, and we would drive off in his Mini to visit and revisit gardens such as the one at Hidcote, his favorite, and Sissinghurst. We even spent a weekend at Job's Mill with Lord and Lady Bath so that he could show me Longleat, which he hoped would give me ideas for our family castle in Holland, recently opened to tourists.

The main problem Russell Page faced at Varaville was how to link a modern stone-and-glass house to the eighteenth-century stables, walled kitchen garden, and flat pastures of the countryside. The first decision he made was to keep the walled kitchen garden area but to remove the wall nearest the house to "weld loose shapes to formal

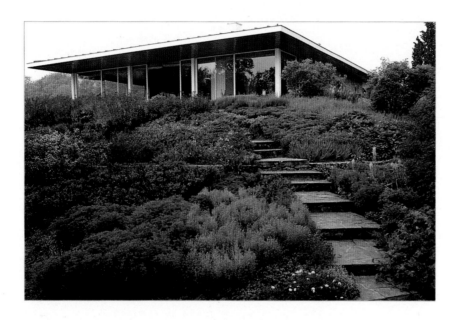

ones."[7] He carefully established his proportions within the area and paced out the series of yew hedges to be planted parallel to the remaining walls. I received a series of letters giving instructions about the partially crumbling walls. "If the North wall is a shade crooked, as I suspect it may be, don't let them tear it all down to straighten it—it really doesn't matter—a bit of irregularity is not a bad thing."[8] Whenever he couldn't make the trip over during the two years of building the house and planning the garden he sent endless ideas, lists of plants, and questions about what I wanted.

The yew hedge parallel to the back west wall, which opened in the center of the garden, made the strong horizontal line he considered essential to place foreground and background in their proper places. The hedges masked a series of compartments, separate garden rooms on either side of the central lawn, one leading into the next. He was convinced that I would need peace and mystery in the garden, both

LEFT Varaville's modern house is set on a man-made knoll. Page covered the slope with small shrubs in contrasting heights and textures to soften the severe lines of the architecture.

OPPOSITE, ABOVE Page created a large green room with yew hedges, the tops of which he clipped to echo the roofline of the Varaville stable buildings, and added two yew pyramids for height. Inside, the garden is thickly planted with Iceberg roses, Page's favorite floribunda.

OPPOSITE, BELOW Page designed twenty-four box-edged squares alongside Varaville's western lawn and filled them with bulbs for a solid color display in spring and summer. Four clipped hornbeam cubes in the middle add vertical emphasis.

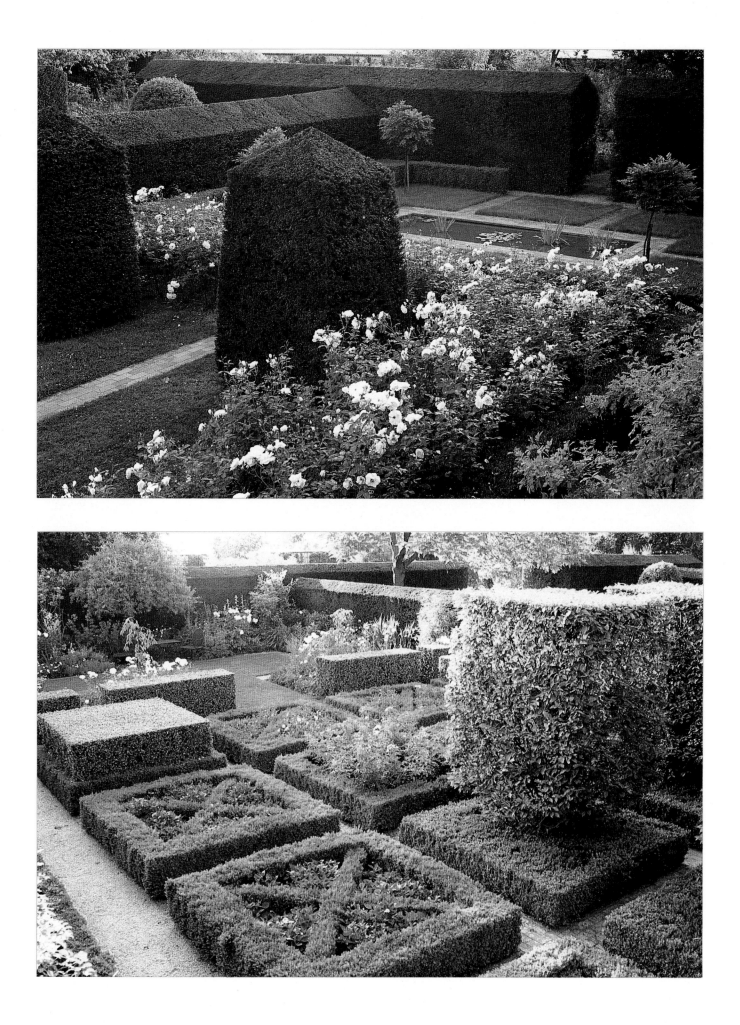

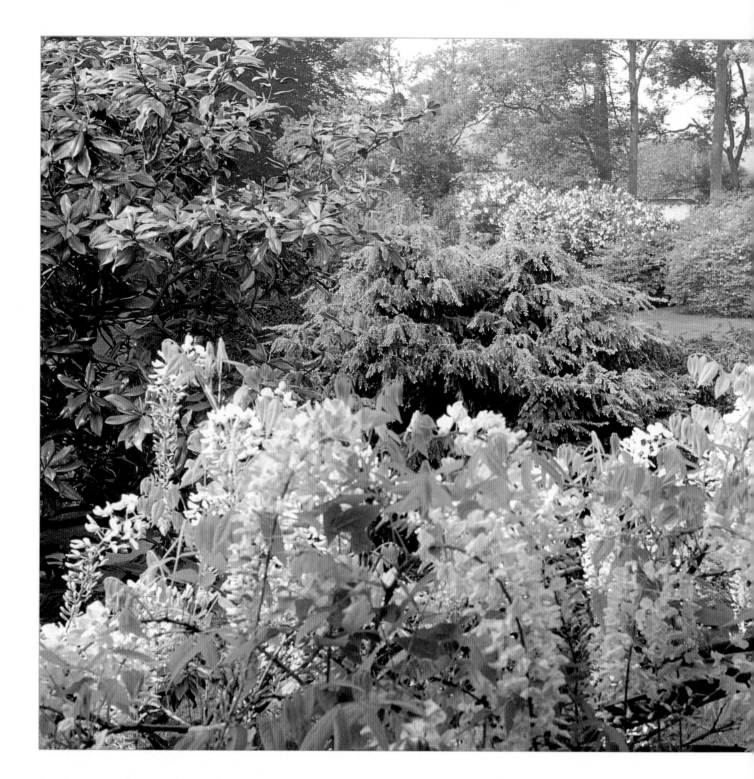

ABOVE White-flowering wisteria cloaks the balustrade of the house's upper terrace, which has a view toward the shrub garden and Varaville's old stable buildings.

hard to come by in a house full of children. These stone- and yew-walled rooms were designed with small axial openings; there was no way to see the whole of one garden from the next, no way to see the inner gardens from the terrace or house.

By the last week of March 1968 the house walls were up, and we could begin planting the garden. M. Prevosteau, a French friend of Page, provided the labor and many of the plants. The three of us, along with some workmen, arrived at Varaville and worked for three days. We followed orders as Russell changed the hedge alignments; placed

the plants on the mound by hand and then replaced them; traced the shrub islands on the south lawn; checked the depth of the holes dug; and saw that the roots were properly unballed and pruned. All these tasks were carried out under an incessant, cold Normandy drizzle in heavy mud. Russell was constantly rushing back to the terrace next to the house to get a long view; then shouting his orders and, often finding us slow, plunging back down the slope to do it himself.

At least ten days every subsequent August, Russell joined me at Varaville. We would discuss the garden, adding and subtracting and refining the plantings, particularly those on the slope, to gain more foliage contrast. Mainly, though, we gardened together, his greatest pleasure, with music pouring from the house.

In 1972 Russell Page stayed often at Varaville while making the

garden of a nearby manor house. Its fifteenth-century house was perched above gentle hills and apple orchards of Normandy's Pays d'Auge. The owner, also a friend of Page, was an admirer of Lawrence Johnstone's garden at Hidcote. With this in mind and a desire to keep the garden from interfering with the lovely view, Page designed seven linked and rather closed garden rooms around the house. The lower corner terrace garden is the only one that looks out over the country-side. Here, Page used lavender and soft pink roses; now they have been replaced by *Limonium maritima*, lavender, and other silver-leaved plants, but the owner has retained the geometrical patterns. A strong structural plan and sound design give this garden its quality of serene refinement.

Back in England Page began to do some landscaping for John Aspinall, a celebrated gambler and animal collector, at Howletts, his estate near Canterbury, in 1968. Page's first changes necessitated a

RIGHT An informal garden room at the end of the garden at Varaville is filled with islands of acanthus, roses, and peonies underneath flowering cherries, crabapples, and 'Paul's Scarlet' hawthorns.

FOLLOWING PAGES A willow-leaved pear tree shades an intimate sitting area in Varaville's summer garden, which is planted with camassias, irises, and lupines.

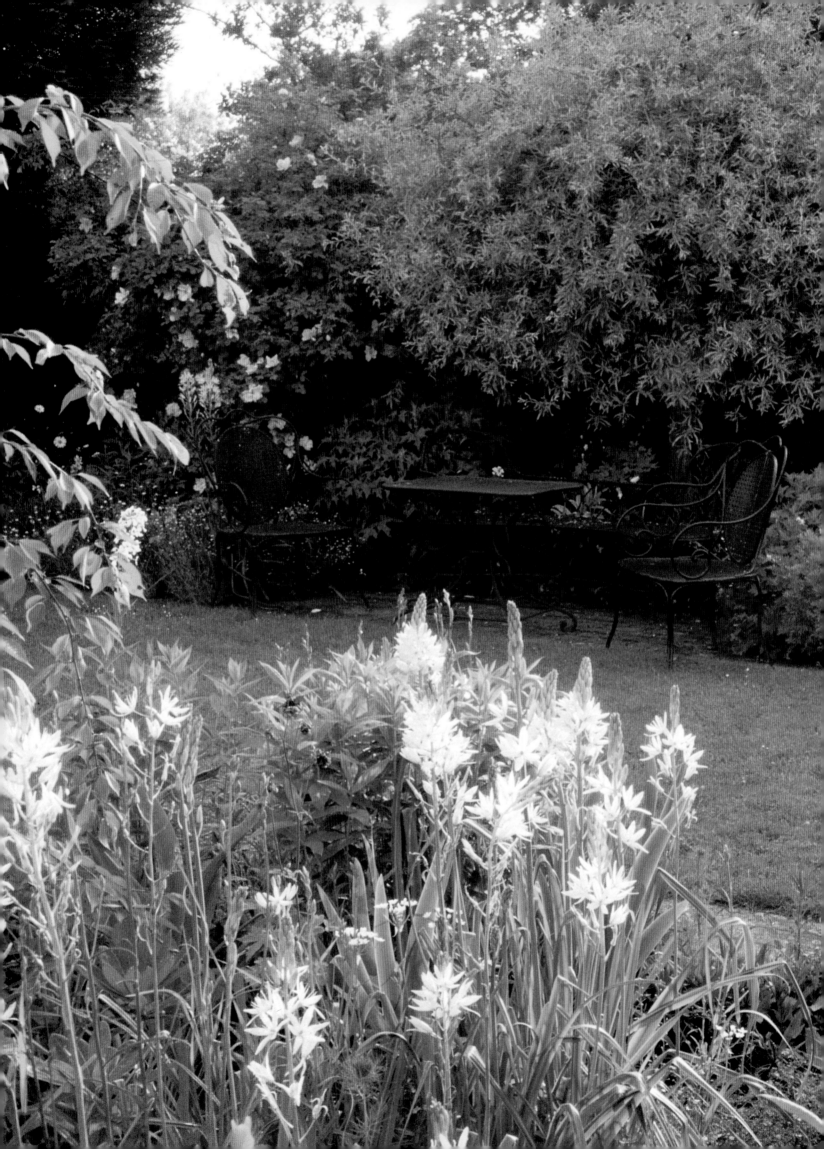

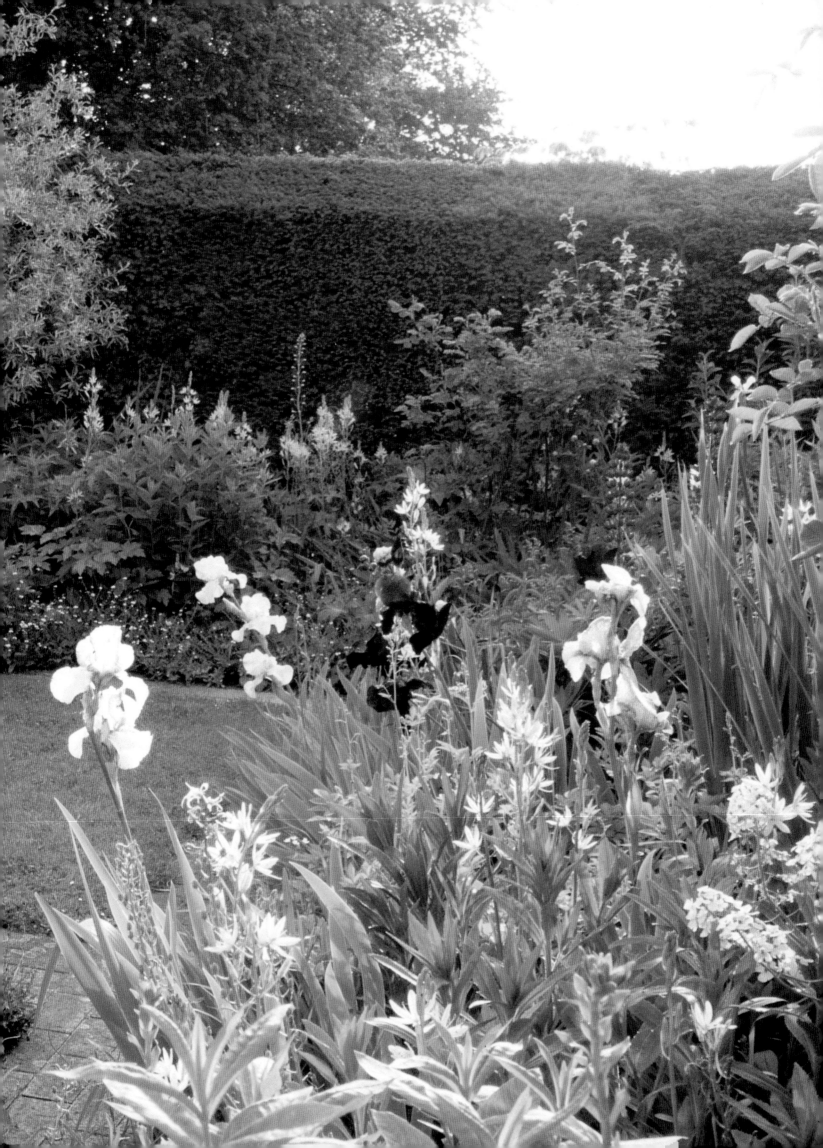

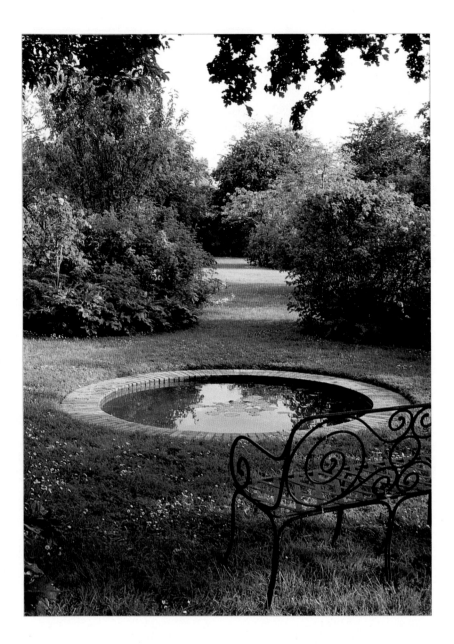

ruthless rearrangement of driveway and gardens, extending the new garden from the house "in a simple but rather architectural way as much as possible in a Jane Austen-ish or Reptonian manner."[9] When Aspinall's animal collection grew from two Himalayan bears and a tigress to include gorillas, leopards, rhinos, hoof stock, and eventually African elephants, Page restructured the park to provide a place for the private zoo.

John Aspinall eventually began to search nearby for a larger estate so that he could open a public animal park. He found and acquired Port Lympne, Sir Philip Sassoon's three-hundred-acre property. Instinctively, he felt that Page must have known this place in its days of glory and would be the ideal person to restore the garden there. In fact, Page had known it well, had often stayed there, and had written an article on this exotic place in the 1930s and described it in his book, *The Education of a Gardener.*

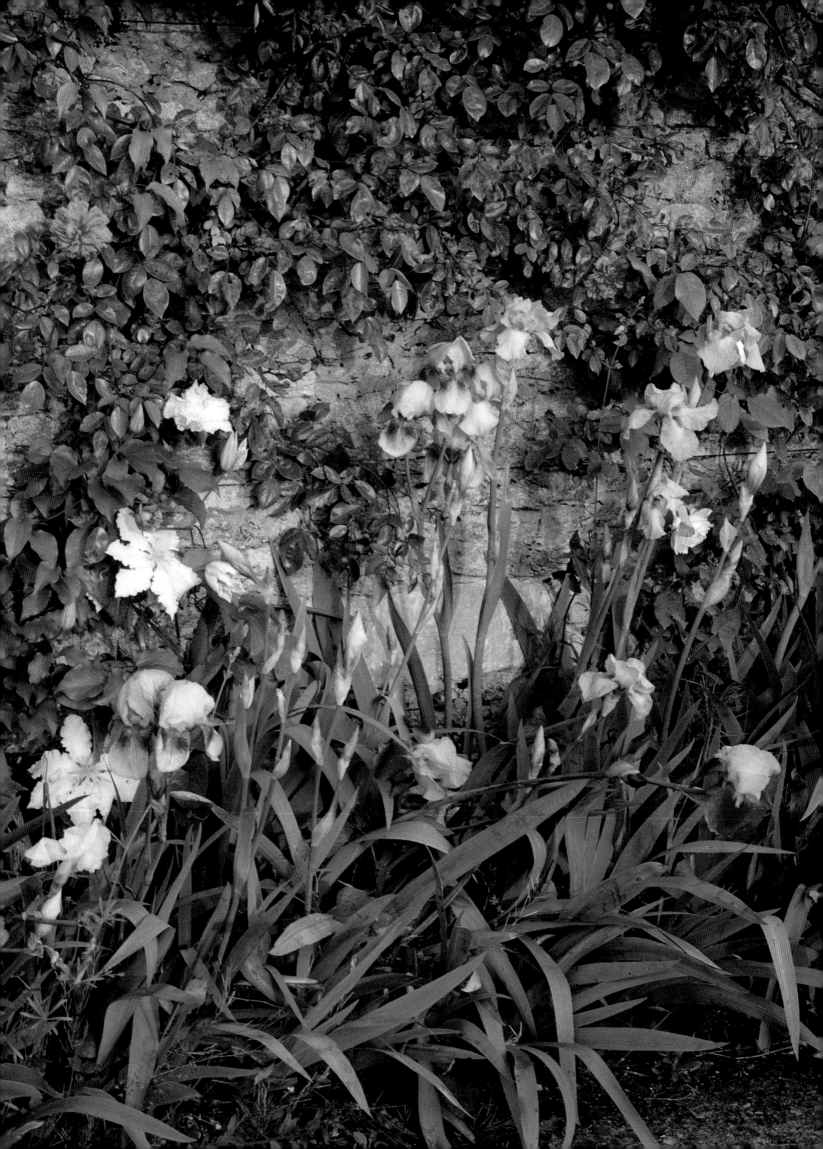

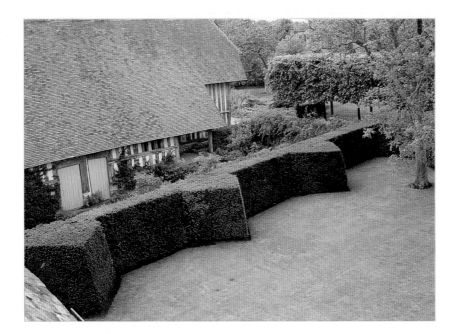

LEFT *Russell Page drew up a master plan for a garden in Normandy that involved reshaping the terrain and creating several enclosures. Hedges not only form the bones of the garden but serve as windbreaks as well. A buttressed hedge flanks the front lawn.*

BELOW *In the same Normandy garden a seemingly haphazard grouping of such flowers as goldenrod, phlox, roses, and hollyhocks composes a jardin de curé,* to the side of the little blue parterre (opposite page) and much in contrast to it.*

OPPOSITE *Russell Page designed this parterre for the same garden at the foot of a barn containing an old cider press. The flower garden is shown here in May, when its basic design is fully visible, and in August,* FOLLOWING PAGES, *when it is at its peak. The owner chose the plantings of lavender and* Limonium maritima.

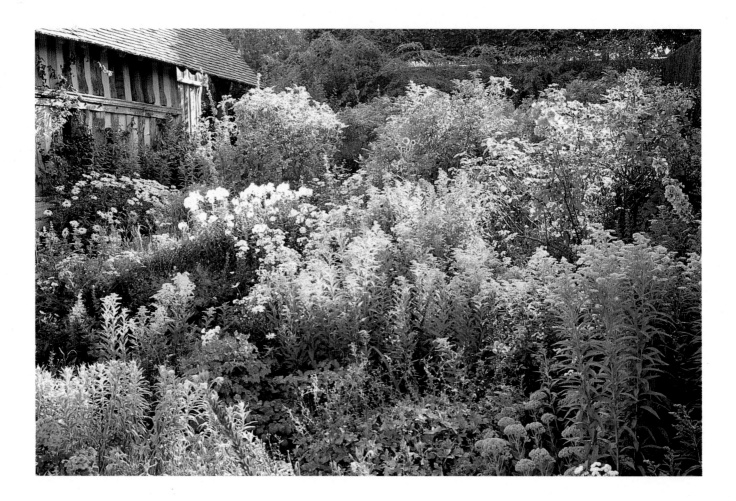

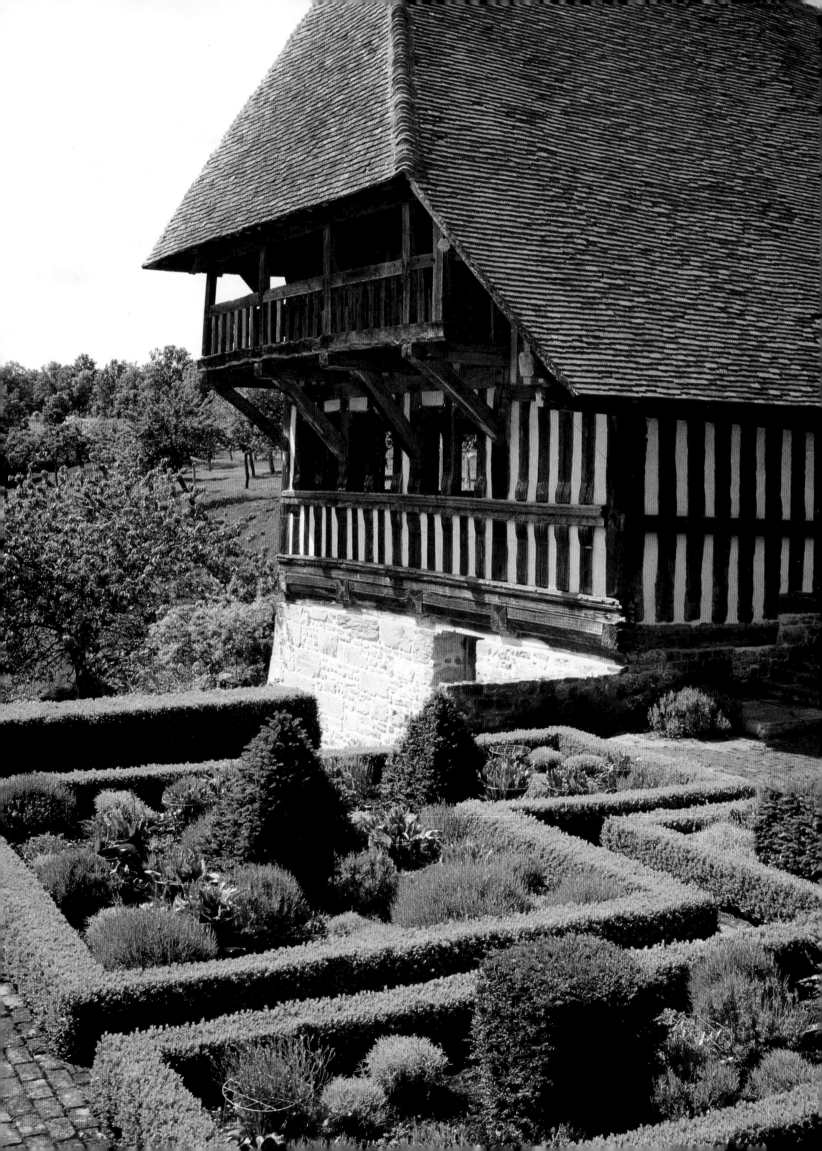

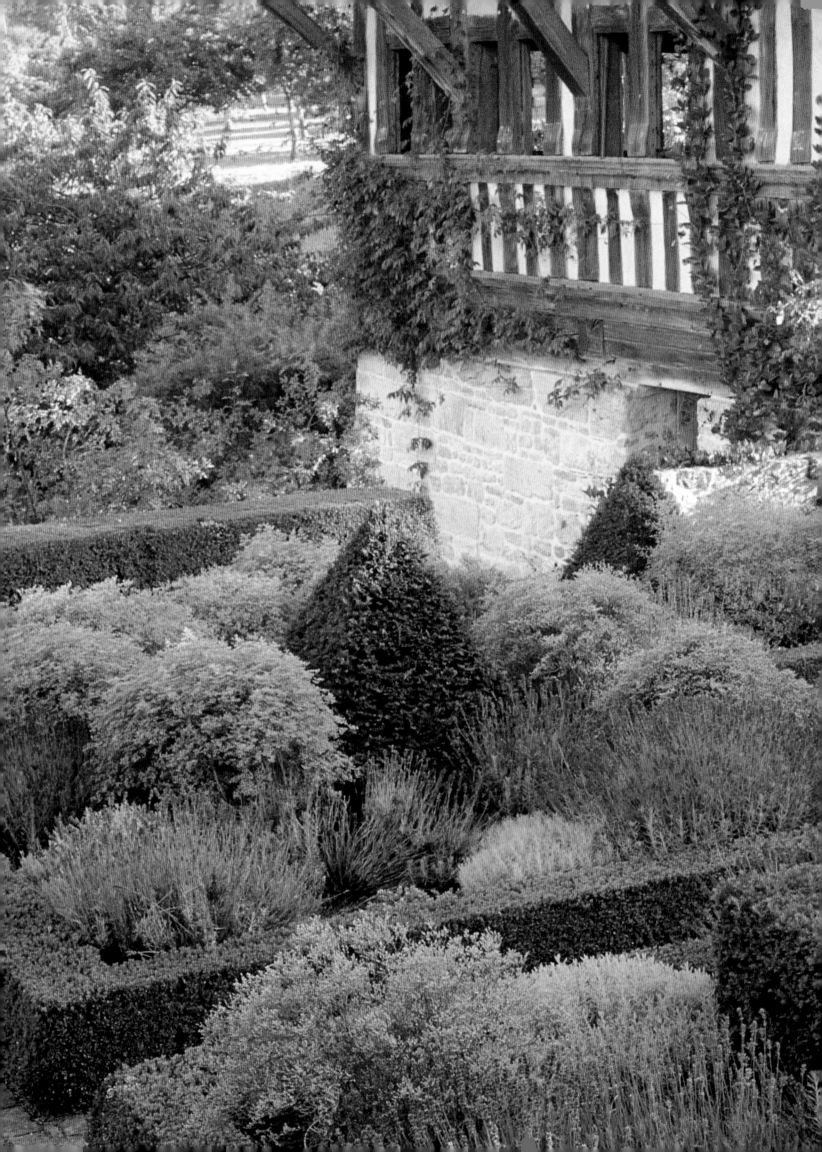

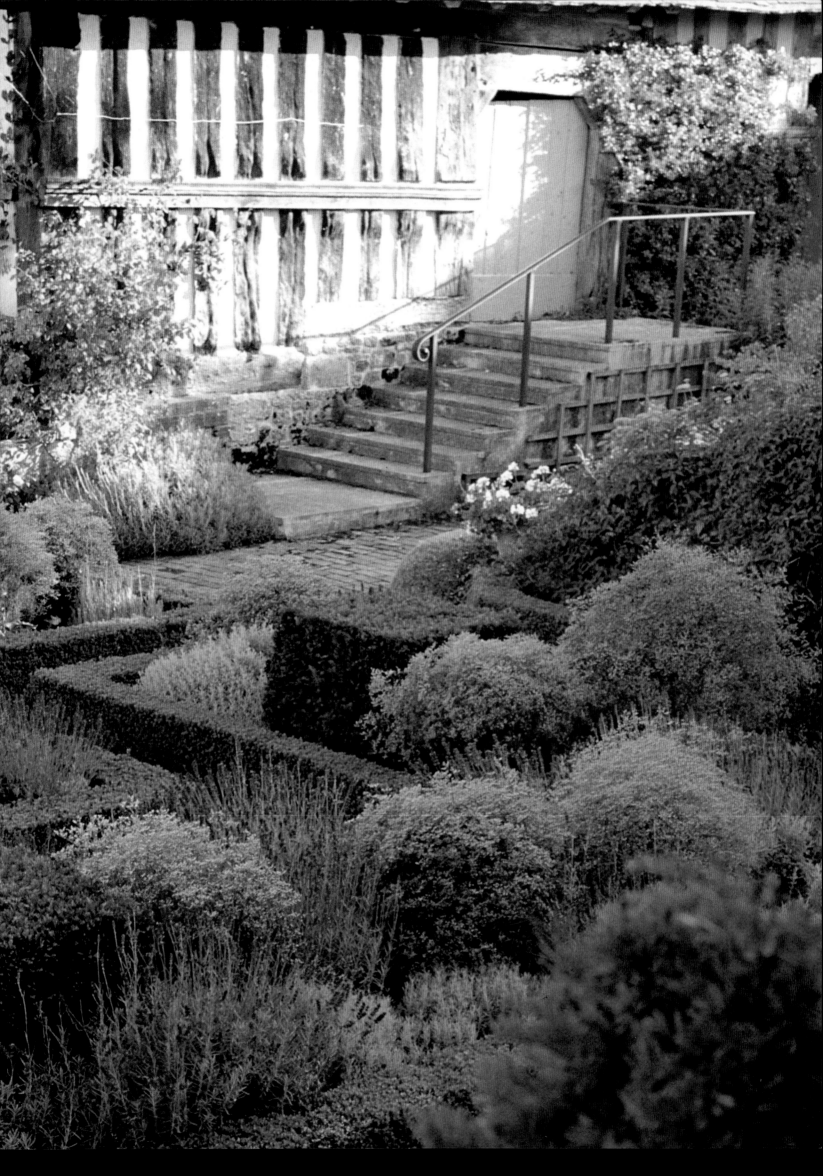

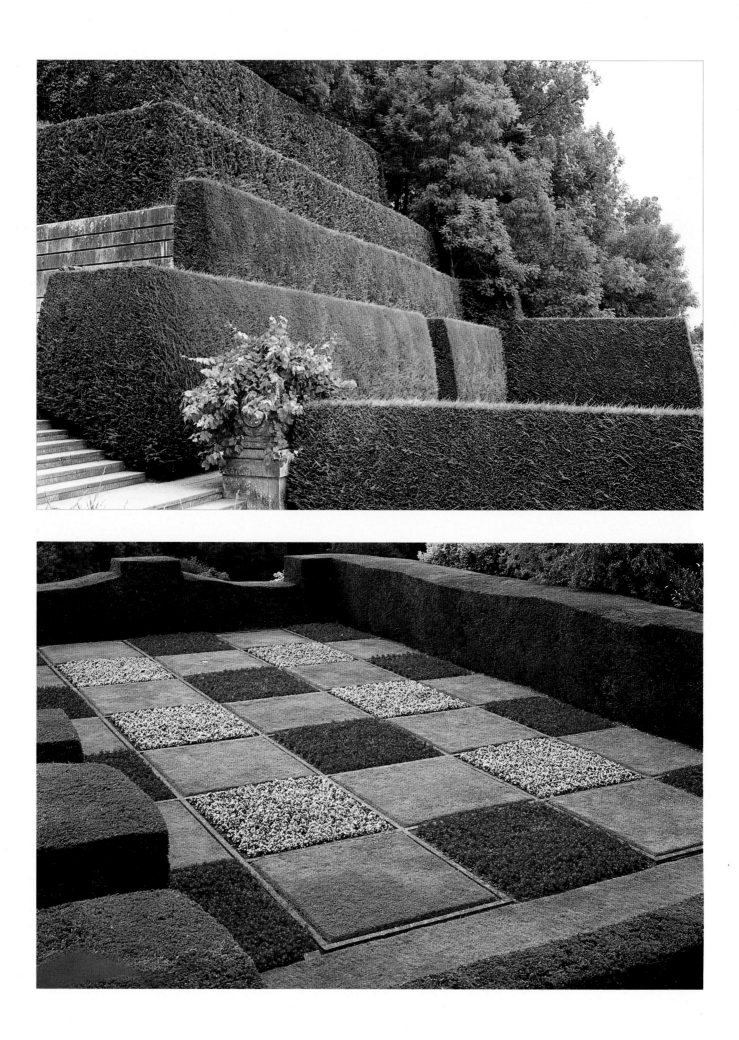

Page was delighted when Aspinall offered him the opportunity to redo the gardens, not for guests this time, but for the public. He accepted Aspinall's challenge to undertake a complete reconstruction of these vast gardens, with a fuller, more varied planting plan. This reconstruction is the only one on its scale he attempted. It stretched his technical capacities, as well as his memory of what had been planted before; it certainly differed from his usual farflung work. Nonetheless, Page was convinced that the gardens could be made more beautiful than before, as the trees, originally planted between the two world wars, were now in their maturity.

The key to the gardens facing south on a very steep hillside surrounding the property's Cape-Dutch house is a boldness in color, texture, and scale seldom seen in other gardens. Page replanted the

Opposite, above Russell Page refurbished the monumental hedges along the grand Trojan stairway, using Cypressus leylandii.

Opposite, below Gigantic yew hedges enclose the chessboard garden at Port Lympne, Aspinalls Park in England, which is now open to the public. The squares of turf alternate with carpet beds of red begonias. A counterpoint to this garden, lying on the other side of the front lawn, is fashioned in an equally bold pattern of stripes.

Right Page conceived Port Lympne's shrub border to replace one of the most labor-intensive flower borders in England. It now contains about seventy different varieties of shrubs in colors progressing along the pathway from yellow to red to blue.

various sections, or compartments—the clock garden, the great Trojan stairway of 125 steps, the chessboard garden, and the long dahlia border—with blocks of solid colors. He used broader effects and bolder plantings in the long borders, reduced the varieties used, and added great clumps of roses and many flowering shrubs to underline this dramatic composition. Page's reconstruction of this formal garden, which is laid out in the grand manner of the eighteenth century, is saved from dullness and rigidity by its gigantic scale and the opulent colors of the nineteenth century. It is now stronger and finer than it ever was.

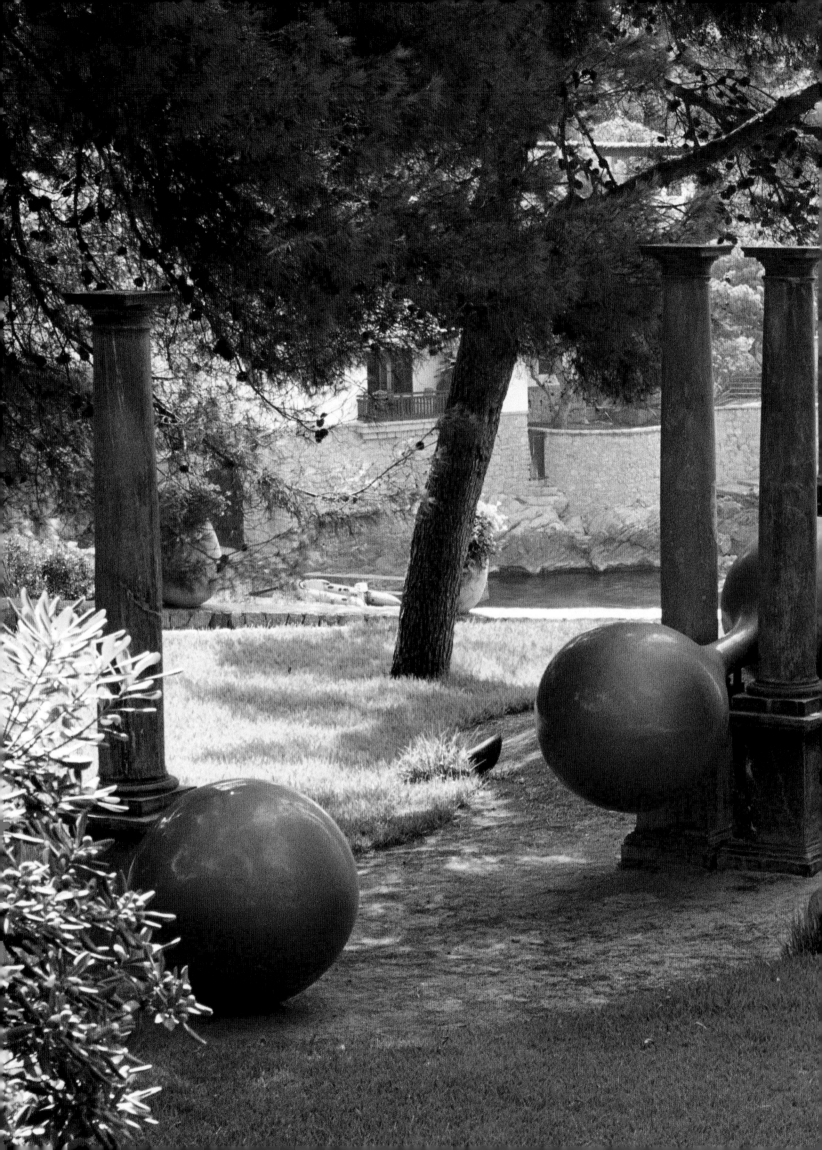

The Moorish Influence

Islamic culture had cast a spell on Russell Page in the early 1930s, when he was searching for a deeper meaning in his life as well as in his art. It was then that he met George Gurdjieff, a Greco-Armenian mystic and philosopher, who became both his guide and teacher. Their relationship, plus time spent working for the British government in Egypt, Ceylon, and India during the war years, helped deepen Page's interest in the ways of Islam. In addition, those travels exposed him, for the first time, to a non-European view of life, aspects of which he found quite attractive. He saw, for example, that the pleasures of silence went hand in hand with a certain mysticism. These experiences were to influence his approach to garden design and are best revealed in the work he did in Spain. ❧ The typical Islamic garden is set in an enclosed space, a courtyard of white marble; it is quiet, except for the sound of water, emanating from a single fountain jet or running under flagstone paths. Calm is emphasized by order: Trees are aligned and geometric patterns prevail. Such an atmosphere appealed to Page's deeply private nature. He once said, "Islamic art and Islamic gardens, in particular, taught me a more subtle geometry and how to use it to make a very basic and apparently simple pattern and forms and then to add all the luxuriance of living plants to make a special kind of world whose visual impact is unique."[1] ❧ The Moorish gardens that affected and influenced him the most were the Alhambra and Generalife, in Granada, capital of the last Islamic kingdom in Spain. Although separated by a few hundred yards, they are virtually one. The former is a succession of four courtyards; the latter is a series of small gardens set in narrow terraces. Page had studied and written about this complex of gardens as a young man and it had always haunted him. He considered it a place that revealed itself slowly, where architecture, geometry, and natural growth—the greenery of orange, jasmine, and myrtle—were interwoven and "pushed to the extreme limits of subtlety and refinement."[2] ❧ Russell Page first went to Spain in the 1960s to make a small garden in Madrid. Then he traveled on to Majorca to rework a garden on the rocky southeastern Mediterranean coast for banker Don Bartolomeo March. Since this project was to busy him for over fifteen years Page

*A*BOVE *Russell Page trained cypress trees to form an archway over the driveway at the entrance of Sa Torre Cega, Don Bartolomeo March's estate in Majorca.*

*O*PPOSITE *At Page's suggestion, Don Bartolomeo adorned the gardens of Sa Torre Cega with a fine collection of sculpture. A bronze insect clings to the rock among cordylines, aloes, and agaves along the western drive.*

had the opportunity to revisit the Alhambra many times and also to become acquainted with the small Moorish gardens in the villages at the foothills of the Sierra Nevada. Page felt free to experiment with this other style of garden architecture in Spain. He believed that this older, more refined tradition was the starting point for all European gardens.

Sa Torre Cega, Don Bartolomeo March's hilltop property at Calaratjada in Majorca, consists of some thirty-six rocky acres that rise sharply from the sea. In 1910 the owner's father had replaced a lighthouse at the top of the knoll with a high, massive square house. A monumental flight of stairs leads from the main terrace of the house to wrought-iron entrance gates down below in a dauntingly straight axis. When Page arrived there in 1964 a wide asphalt drive, edged with pointed stones and scarlet geraniums, wound through Aleppo pines and palmetto shrubs and there was but little garden. The first phase of his work involved modifying the existing features. He narrowed the roads throughout the estate and raised the concrete-edged beds that were placed on either side of the main drive. These he planted with *Magnolia grandiflora* and deep blue agapanthus. At the bottom of the grand staircase, he added a balustraded terrace in an attempt to shorten the overpowering main axis. He softened the awkward uphill slope of the drive below it by a series of slender cypress trees, which now form arches over the road. To the left of the entrance, the motif of the green archway is extended by a pergola covered in *Bignonia ricasoleana,* which Page copied from the one he had seen in the garden of the Alfabia, near Palma. On the opposite side of the entrance stands a traditional Valencian *hivernero,* a high wooden structure of trelliswork; its vaulted roof thatched with heather to protect young palms and give delicate semi-shade to green plants and grateful guests.

Since the estate covered a dense pine-covered hillside, it was impossible to see more than a small part of it from any one point. Page used and intensified this situation to make a collection of hidden gardens for different kinds of planting. On the western hillside, descending from the house, he had clearings cut into the woods and connected them by stepped paths that wound through a variety of natural plantings. A path leads to four terraces below, which are centered by a staircase lined with clipped Italian cypress trees. These terraces he treated formally, breaking each level with a series of small beds worked out in the Moorish geometry of simple lozenge patterns. Each bed is surrounded by eighteen-inch paths paved with alternating squares of white pebbles and pinkish-yellow limestone. The beds are filled with a profusion of annuals for summer color. During the first years Page planted masses of blue and mauve petunias on one level and 'Blue Mink' ageratums and pale yellow marigolds on another. The

severity of the upper three terraces is relieved by blue plumbago and yellow lantana cascading from retaining walls. Trees and shrubs shelter and isolate this part of the garden, which does not have a view, from the rest of the hillside.

Page first treated the bottom terrace as a formal labyrinth made of eight-foot-high cypress hedges and clipped bitter orange trees around either side of a rectangular pool. But the cypress hedge did poorly and Page replaced it by two additional flanking pools filled with water lilies and inhabited by enchanting emerald-green frogs. Henry Moore's *Large Totem Head* replaced the fountain jet in the central pool.

Page had the estate's eastern hillside thinned of growth and then planted with the owner's large collection of bougainvillaea. Seventeen different varieties out of a possible forty-four were acclimatized and

Russell Page made a natural looking habitat of native grasses, bamboos, and yuccas for Francisco Otero Besteiro's black-basalt rhinoceros, one of several animals by the sculptor at Sa Torre Cega.

planted here in different ways: Some were trained flat as ground covers, others were grown and shaped into huge self-supporting bushes, while others were allowed to cascade through the pines. Don Bartolomeo's enthusiasm grew with each new garden; "Let's double it," he would urge. Two acres of bougainvillaea seemed quite enough to Page, who had given great care to proportion, color, and texture in this area, and was frankly appalled as well as bored by such excess. Eventually he suggested to Don Bartolomeo that it might be interesting to display some sculptures in the garden.

Thus evolved the idea of placing a giant naïf sculpture of a chimpanzee holding a dove in the most botanically interesting site on the property, an area adjacent to the bougainvillaea garden. Page had already planted this garden with a mixture of different native grasses and bamboos as well as assorted yuccas, including *Yucca filamentosa* and *Y. gloriosa*, sago palms, and other indigenous plants and exotics

in order to add different tones and mixtures of green to his composition. He also created a small waterfall there by boring holes into the reddish-brown limestone of the substructure. A rhinoceros, a tortoise, and a bull sculpted in black basalt by Francisco Otero Besteiro loom half-hidden in this contrived wilderness.

March's gradual acquisition of sculpture brought a new dimension to the landscaping of the estate, and Page's role is perhaps prophetic of his last major project, the PepsiCo headquarters sculpture garden in New York State. "I found it interesting to site individual pieces so that they would enhance and be enhanced by the garden harmonies I had been trying to compose,"[3] he said of the work. Sculpture was placed in many locations—near the sea, under the Aleppo pines in front of the house, and on the broad main terrace, where Page had

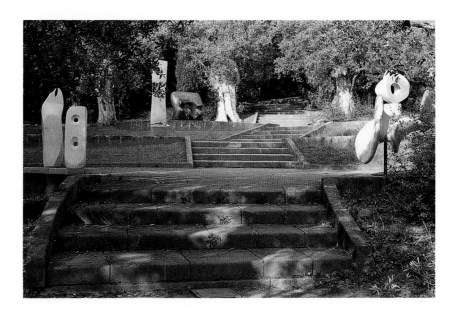

Opposite, ABOVE *Page suggested a woodland setting at Sa Torre Cega for the starlike sphere* Dode Caedro *by Eusebio Sempere.*

Opposite, BELOW *Page chose annuals, such as marigolds, petunias, and ageratums, to fill a lozenge-patterned terrace on Sa Torre Cega's western hillside with summer color.*

Right Russell Page constructed three oval terraces linked by low marble steps for smaller pieces by Chillida, Lipchitz, and Moore. He enclosed the area with ancient, transplanted olive trees.

Following pages Geometric hedges, designed by Page near the entrance to the house at Sa Torre Cega, frame La Higuera, *Juli Guasp's whimsical fig tree.*

earlier installed formal raised pools for lotus and water lilies and softened the contours of the harsh white flat stonework with clipped cypress hedges and three-tiered octagonal beds. Juli Guasp's silvered-bronze fig tree, *La Higuera*, faces the stairs, and Xavier Corbero's weeping bronze column *Fuente* occupies the center of the far terrace. Together Corbero and Page decided to place seven gray marble columns, part of the sculptor's composition of gilded spheres, above the small bay.

The positioning of smaller pieces of abstract sculpture posed a particular problem for Page. If they were set among the strong verticals of the pines, they would have been dwarfed by the trees; but if they were placed on a flat plane, they would have looked like teacups on a tray. He decided, he explained, "to set them in groups where their spatial relationships would set up an invisible geometry of tensions, criss-cross in the no longer empty air."[4] He chose to exhibit them in

The Moorish Influence 153

groups on a small bare hillside area near the kitchen garden. There Page constructed three oval, interlocking terraces, on different levels, surrounded by two oval rings of ancient olive trees transplanted from a nearby farm. Pruned hard back, they have all survived and make soft, rounded silvery-gray walls framing the elaborately calculated relationships between individual pieces by Jacques Lipchitz, Chillida, Moore, and others.

Page later remembered that the inspiration for these curving ovals on changes of level came from a chance visit some months before to the ruins of a Neolithic village near the neighboring town of Arta:

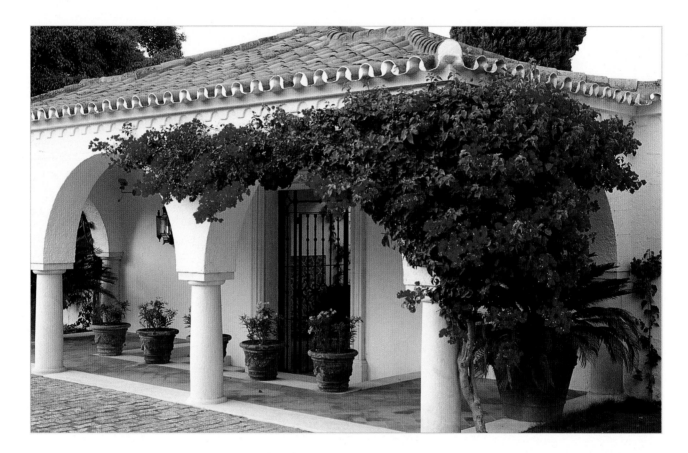

"These ruins spelt out a pulsing rhythm suggesting not in this case tranquility but harmony strong enough to have made its mark on a twentieth century sculpture garden."[5]

While making the gardens of Sa Torre Cega Page was also involved in a number of other projects: He did three small villa gardens in southern Spain at Motril, as well as the landscaping for numerous properties on a luxurious residential estate at Sotogrande, near Gibraltar. In Marbella he devised a swimming-pool setting for his friends Baron and Baroness Guy de Rothschild and sketched a small garden for Madame Ortiz-Linares y Patino. It was during this busy period that he also became friends with a charming American woman from

When Don Jaime Ortiz-Patino decided to build a house in Sotogrande, in the south of Spain, he hired Russell Page to plan the grounds. The entrance porch is covered by drought-loving bougainvillaea.

Georgia, Mary Melian, whose husband was one of the Spanish founders of the consortium that developed Sotogrande.

An excellent gardener herself, Mary Melian drove Page around the wild and simple countryside and over the wooded hills as far as Sevilla. He asked her endless questions about the names and nature of the plant life of southern Andalusia. His joy at finding plants he knew well—dwarf gorse, low-growing *Lithospermum,* and many varieties of cistus—was infectious. He noted that the climate, warmer and drier than that of the Côte d'Azur, would support properly sheltered umbrella pines and wind-tolerant oleanders. Mary Melian, for whom

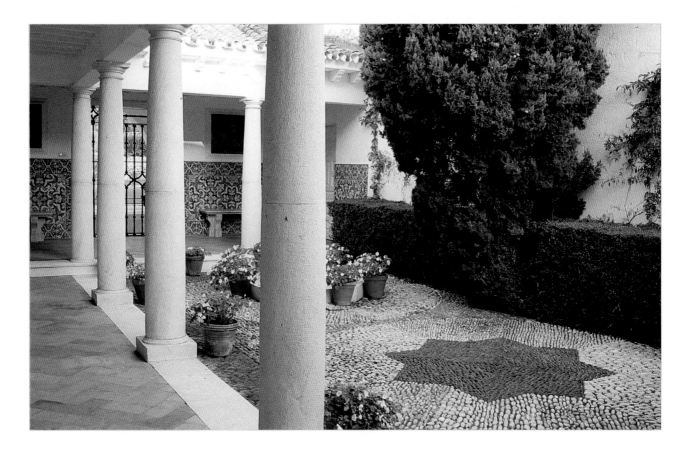

The pebbled Spanish entrance courtyard inside the Ortiz-Patino residence harbors an asymmetrical cypress hedge, cypress tree, and potted flowers.

he generously designed a formal rose garden, found him unique. He never imposed his knowledge, he would just unassumingly suggest a better plant variety, and only when asked did he recommend a better placement for her pool house.

Not long afterward, Don Jaime Ortiz-Patino, whose town garden Page had previously designed near Geneva, also decided to build a villa at Sotogrande. The architect Jacques Regnault was to do the house, and Page was asked to design the gardens. The problems Page encountered at this site were drastically different from those he had faced at March's estate on Majorca. Here the terrain was flat and sandwiched between a golf course and an imposed series of roads. Mr.

Ortiz very wisely involved Page in the preliminary planning of all the premises. Page had seen at Mrs. Melian's house the sheltering role that patios could play in a composition. As a consequence, he persuaded Regnault to revise the original plans he had drawn up for the Ortiz-Patino project and then helped him to redesign the buildings around inner and outside patios. He said of this collaboration:

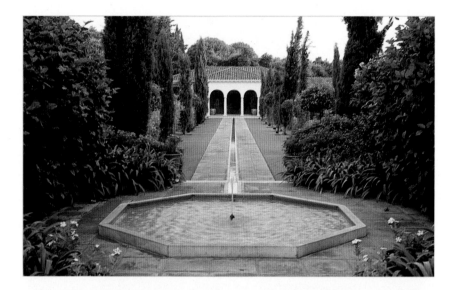

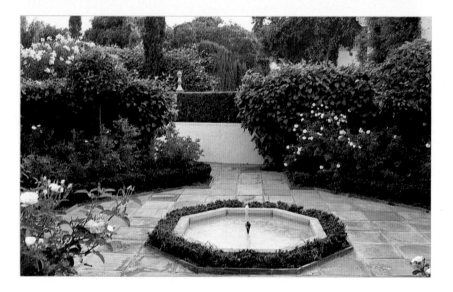

LEFT, ABOVE Page delineated the main axis of Ortiz-Patino's property with a long, narrow water channel that connects an octagonal Alhambresque fountain with a pavilion at the far end.

LEFT, BELOW The octagon is a recurrent motif on the Ortiz-Patino estate. It reappears in the lush little courtyard of the guest quarters, where roses and white ageratums grow in box-edged foundation beds designed by Page.

OPPOSITE, ABOVE Page chose to border Ortiz-Patino's tennis court with a low wall covered in plumbago. He also designed the viewing platform, built of dark green wooden trelliswork and blue-and-white local tiles.

OPPOSITE, BELOW The loggia at the end of Ortiz-Patino's living-room wing looks out on the neighboring golf course dotted with cork oaks.

FOLLOWING PAGES A luxuriant hedge of oleander and yellow and mauve lantanas separates the narrow main axis of the Ortiz-Patino property from the golf course.

I much enjoyed designing a house where each room had its own patio. The main one outside the living room has a sixty foot long pool and the flanking buildings are covered with espaliered lemon trees and pale blue plumbago. Another has huge plants of *Strelitzia, Angasta,* flanking square raised pools set about with ginger lilies, *Hedychium, Clivia imantophylla* and violets. The walls of still another are dotted with a begonia, whose white flowers have such a crimson purple blotch, and a single tree of *Koelreuteria* gives shade and yellow blossom in July.[6]

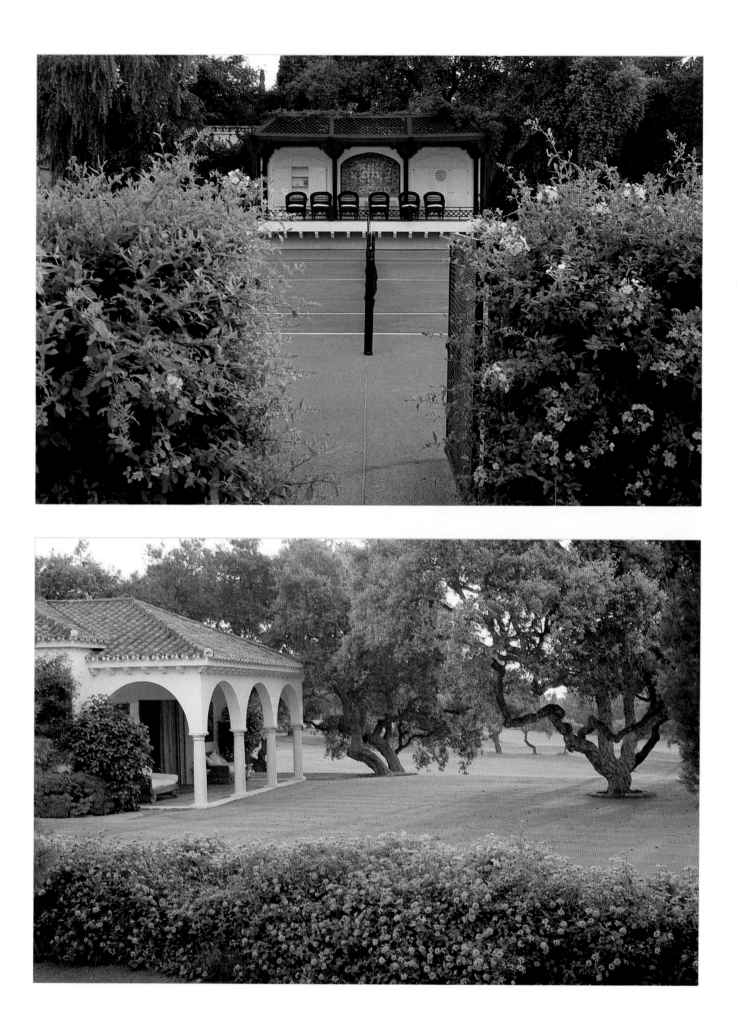

Mr. Ortiz was a keen sportsman and he wanted to have certain recreational facilities on the grounds where he lived. One of a landscape designer's tasks is of course to accommodate the proprietor's needs and preferences. At this point in his career, Page was such an accomplished and mature craftsman that he was able to take on almost any difficult site or problem. The Ortiz property is a long and rather

narrow strip of land, yet Page managed to fit a large house and service wing, an office complex built like a Moorish casino, a house for guests and children, a tennis court, a swimming pool, garages, and garden pavilions into this oddly shaped space. His idea was to combine the recreational areas with the ancient traditional Spanish courtyard gardens. It was a daring and, as it turns out, inspired decision, providing Mr. Ortiz with a modern paradise of his own. Only someone of Page's caliber could bring off such a complicated undertaking so successfully.

Left, above Russell Page advised Alfonso Zobel, a young architect, on the pool at the heart of his residence in Sotogrande and placed vertical accents outside the green hedge, with which he defined the swimming pool area.

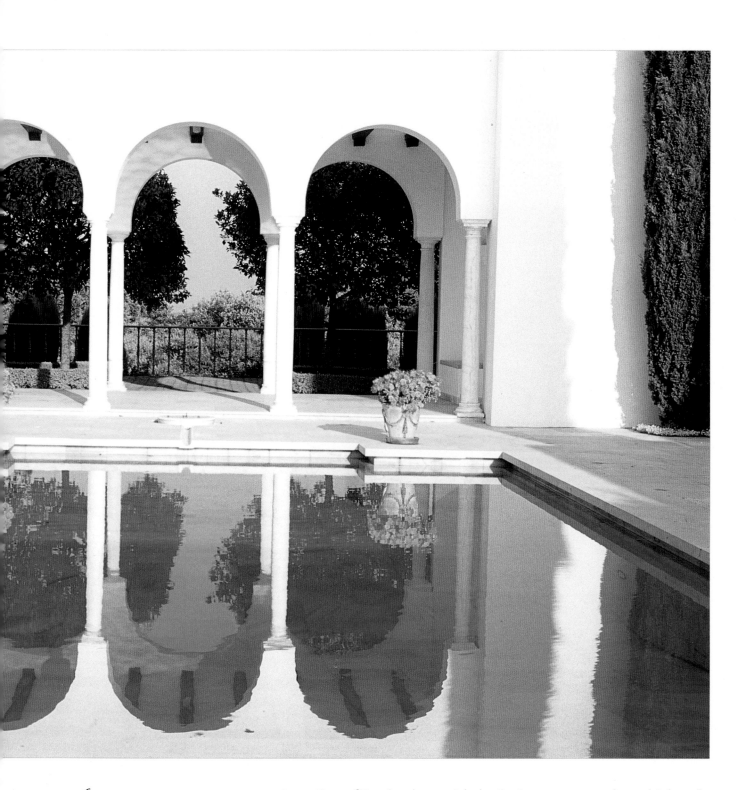

ABOVE AND OPPOSITE, BELOW Page was a genius at correcting problems with the terrain of a site, such as the steep drop behind Zobel's house. He cleverly disguised the slope with a planting of cypress trees, only the tops of which are visible through the arches.

Part of Page's success with the Ortiz property was due to his lengthy study of the Alhambra, with its extraordinary flow from one courtyard into another. Here he connected the buildings and gave sense to the architecturally imposed layout by designing a simple, but dramatic, small-scaled interpretation of the great garden at Granada. He centered a narrow water channel in the lawn-edged path between the large rectangular pool set in front of the casino and a small octagonal pool placed before the swimming pool on a slightly higher level. Various patios enclose small, protected gardens where sun and shade magically

alternate. The nearby "natural" golf course, with its ancient cork oaks, and the distant view of the sea were "borrowed" to become visually a part of the property. It is a brilliant realization.

In 1972 Page was delighted to help a talented young architect, Alfonso Zobel, with the landscaping of his nicely proportioned new house, also on the Sotogrande estate. The Moorish influence is evident

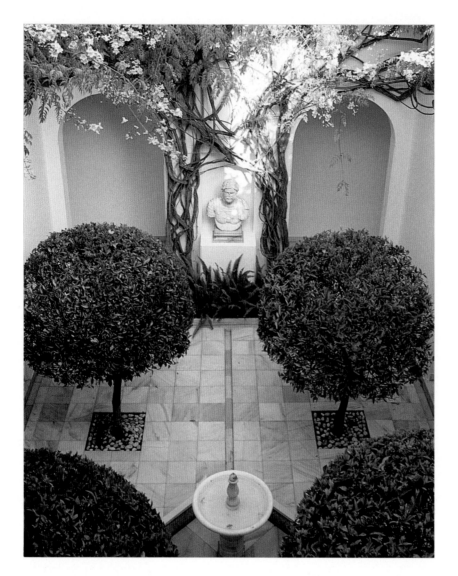

LEFT Page furnished a small Andalusian patio with four tangerine trees and a pale pink bignonia.

OPPOSITE Page planted a myrtle-edged rosebed opposite the entrance of Zobel's house to tie the property to the surrounding landscape.

in his design for its courtyard garden, with a body of water—a swimming pool—at the center. Page advised on its poolside plantings and the planning and furnishing of a small, white inner patio with four tangerine trees and an unusual pale pink *Bignonia.* On a slope behind the villa the Englishman created two terraces, the lower of which he covered with dense rows of cypress trees to disguise the slope's steep drop-off. Outside the villa's white-washed walls he made a myrtle-hedged rose garden on the entrance side and planted several trees to tie the walled-in property to the outside world, which included a neighboring golf course and a distant view of the sea.

More commissions in Spain quickly followed. Page was asked to compose other gardens for several new houses at Sotogrande. He also designed a beach club on the Mediterranean coast, which gave him the opportunity once again to exercise his talent for architecture. While work was in progress on all these projects, Page familiarized himself with the local architecture of white-washed walls, few and small windows, and shallow pitched roofs of Roman tiles, and he wrote that he enjoyed helping to design and build a hilltop village, designed round a central plaza with its fountain and shade trees and a shop or two.[7] This community of buildings, known as the Cortijo apartments,

is located near the Sotogrande golf course, Valderrama. An extensive undertaking, this project must have reminded him of the planting guide he made while in partnership with Geoffrey Jellicoe before the war for the village of Broadway in the Cotswolds. In both places he created a natural harmony of plants and trees. For this Spanish village it was done within the frame of ten large patios, avenues, and plazas. Every patio was given a different design, each with its own botanical theme. He could indulge himself in his choice of plants for shade and beauty. Unfortunately, the climate has not been kind to these carefully planned compositions; nevertheless, they remain a succinct summing up of the rich experience of Page's work in Andalusia.

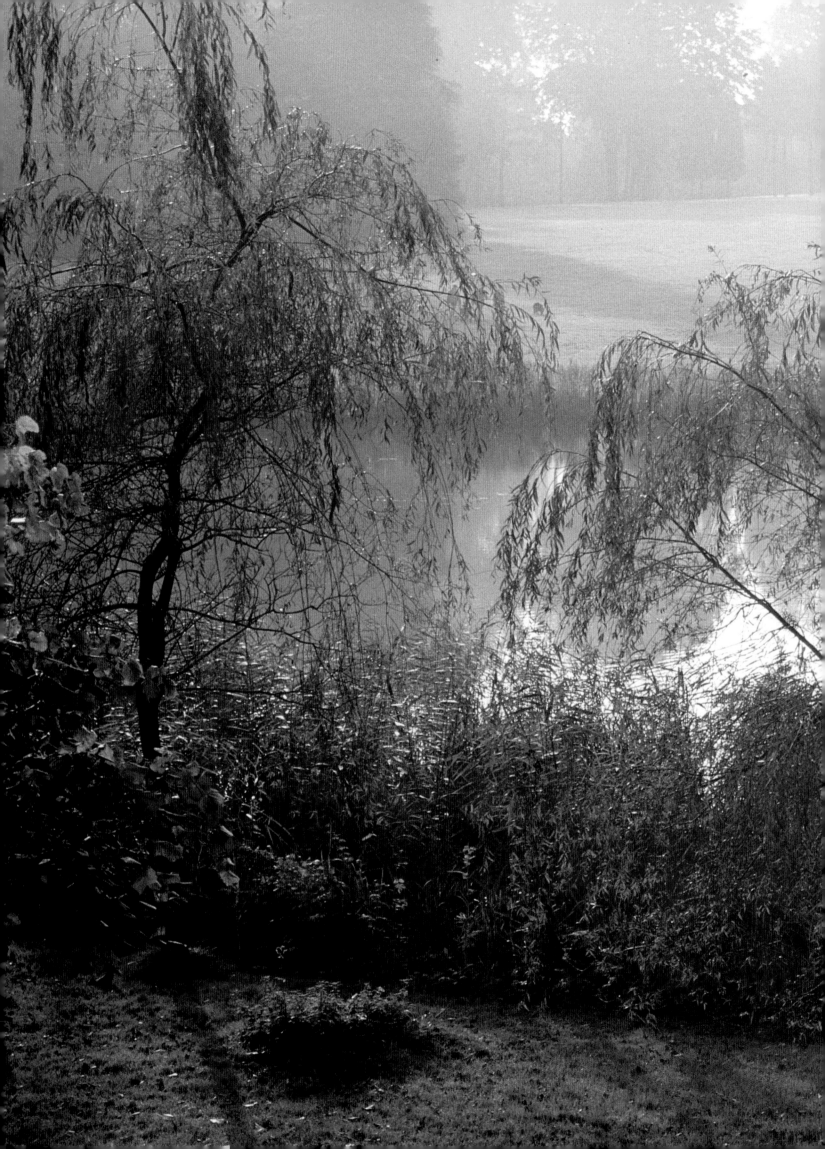

Chapter 7

Trees
and Water

ussell Page's passion for trees may have begun with the first one he remembered planting, a miniature blue-gray juniper that never grew more than ten inches high. Later, his career designing gardens in different countries and in different climates exposed him to a wide range of trees. He explained, "Gardeners are kindly company and if my knowledge of trees and the range that I use in my work has become so unduly extended over the years it is because of the time that great collectors have devoted to familiarising me with less common species and varieties."[1] In fact, it was primarily to Sir Harold Hillier and Robert de Belder, renowned experts on trees, that he owed his deepening interest. The former's *Manual of Trees and Shrubs* was for Page a bedside book, a bible, whereas Robert and Jelena de Belder's world-famous

*A*BOVE *So strong was Russell Page's instinct for the lay of the land, he was able to stake out the outline of this pond in a meadow at Hemelrijk, Robert and Jelena de Belder's arboretum in Belgium, unhesitatingly, in one go.*

*O*PPOSITE *Two* Rhododendron williamsianum *hybrids in shades of pink are among hundreds of different varieties of rhododendrons growing at Hemelrijk. Russell Page helped bring some order to the De Belders' collection.*

arboretum at Kalmthout, in Belgium, served as a visual lesson . ❧ Around 1950, Robert de Belder bought an old nursery garden for love of a *Stewartia* growing there. Since then he and his wife, Jelena, have crowded its forty acres with plants, cuttings, and seeds sent to them from botanical gardens and collectors throughout the world. Page wrote of it, "One's progress through the garden is slow for at every step there is something to learn and something to admire."[2] ❧ At the De Belders Page was both student and expert. Although basically a lonely man, with them Page felt part of both a worldwide network of plantsmen and a warm, united family. Even though Page became friends with many of his clients, they generally lacked detailed knowledge of his special field and did not and could not keep up with his growing interests. His frequent visits to Kalmthout, however, brought mutually exciting exchanges of specific information along with deep friendship. What he enjoyed most there was working with the De Belders in the garden, often by flashlight long after night had fallen. He mourned that "the days seem never long enough."[3] When the De Belders asked his advice, he was only too happy to suggest simplifications, such as open vistas and clearings, in the crowded labyrinth of shrubs and trees. The garden was bursting at the seams, so Page encouraged the De Belders to send the overflow to their nearby three-hundred-acre family property, Hemelrijk. He followed the planting of

their extraordinary botanical collections with fascination: some two hundred species of willows; a large collection of maples; and, particularly, a glade given over to all the species and hybrids of hydrangea that the De Belders had collected during field trips in China, the Himalayas, and Japan.

In the 1970s and early 1980s, Page returned to Hemelrijk annually,

PRECEDING PAGES Page often spent as much time coordinating the autumn colors of a garden as he did the spring and summer. At Hemelrijk, Japanese maples growing under a canopy of copper beeches display a harmony of colors in October.

LEFT, ABOVE Inspired plant association was one of Russell Page's instinctive talents. At the Kalmthout arboretum he let the pale blossoms of Rhododendron hybrids 'Adrian Kostner', 'Harvest Moon', and 'Dairy Maid' underscore the white trunks of birch trees.

LEFT, BELOW Page found the orchestration of Hemelrijk's rhododendron plantings an absorbing task. Yellow-flowering mollis azaleas are enhanced by the rusty shades of red-leaved maples.

OPPOSITE At Kalmthout a carpet of naturalized Montia sibirica adds magic to a group of katsura trees.

FOLLOWING PAGES At Kiluna Farm, Mrs. William Paley's property on Long Island, New York, Russell Page turned a large hollow formerly occupied by greenhouses into a magnificent scene of dogwoods and azaleas mirrored in an oval pool.

to help plant out more of the thousands of rhododendrons and azaleas waiting for a home. He wrote of them, "These with their huge range of colouring: whites, yellows, oranges, scarlets, crimson, mauves and purples are difficult to place and I have never seen it well done. Rhododendron fanatics seem content with any old mess of colour. Walking through most rhododendron collections appalls me. It is about as artistically interesting as leafing through a wallpaper catalogue."[4] Over the years, Page had given much thought to the problem of color combinations in a garden. He credited Gertrude Jekyll's

books and Norah Lindsay's expansive use of perennials as the main influences on the principles of color arrangements that he developed. Both women had worked with large patches of monochromatic colors, which they often bridged with white before breaking into another color range.

Page planted the flowering shrubs at Hemelrijk in loosely grouped promontories and bays, on a stretch three hundred yards long and about fifty feet wide, in the half-shade of beeches and oaks. Palest pinks shade into pale pinkish mauves, then into clear blue mauves before breaking into, for example, a grouping of the variety 'Sappho,'

which is white with a striking violet-black eye. Purples blend into crimsons, then a white break comes before the scarlets, and white again before a full range of oranges, yellows, and cream. Page explained, "In a more open situation I would think to plant groups of three or five of the same variety with regard to their eventual development as a large and solid clump and intersperse such clumps with evergreen trees."[5] Here, the semi-shade of trees softens the color scheme.

In the mid-1950s, Page applied his ideas on color in the garden to the planting of flowering shrubs at Kiluna Farm, the home of Mrs. William S. Paley, on Long Island, New York. It was the first American garden he designed. He began by placing an oval pool at the bottom

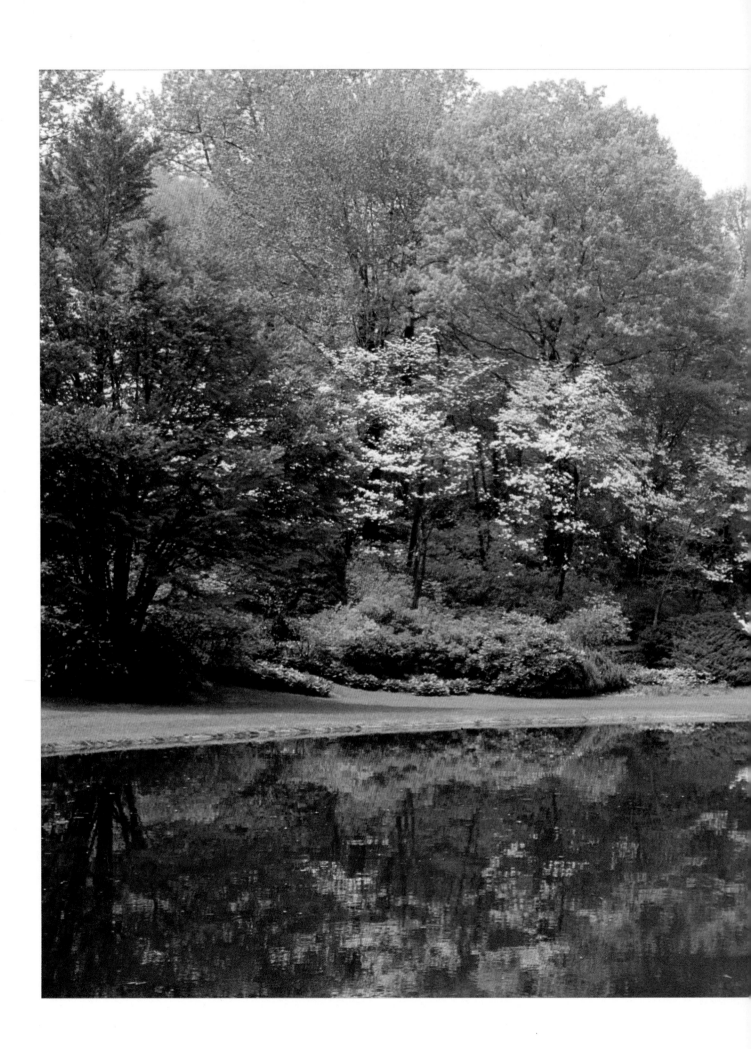

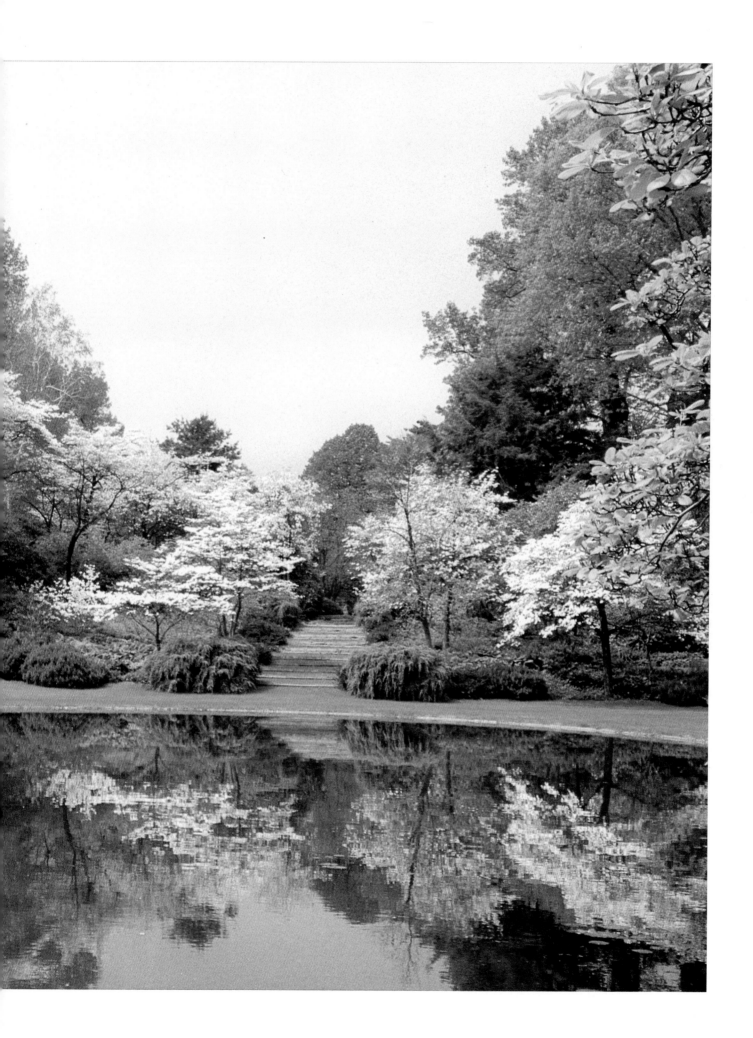

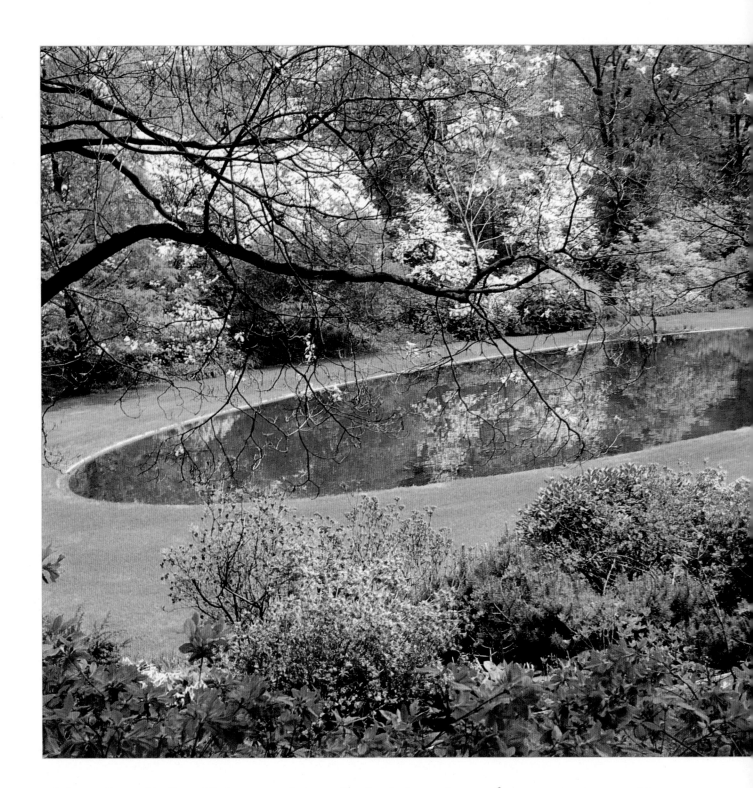

of a large elliptical hollow. Higher up on the ascending banks he made two woodland paths on two different levels, which run almost parallel to the outline of the pool. Then he planted the banks with flowering trees and a concentration of azaleas: Japanese evergreen species, mollis azaleas, Exbury hybrids, and the taller Ghents. They flower from April until July in a calculated harmony of pale, luminous colors.

Page's increasing knowledge of trees, as well as his innate sense of how and where to use them, helped to join his love of architecture to his botanical interests. For him, trees were living architecture that gave

ABOVE Placed in the center of the dell, Kiluna Farm's elliptical pool takes on different shapes depending on the point from which it is viewed.

OPPOSITE A sketch by Page of his design for Kiluna Farm shows the positioning of the oval garden in the main axis of the property. It is, however, invisible from the house.

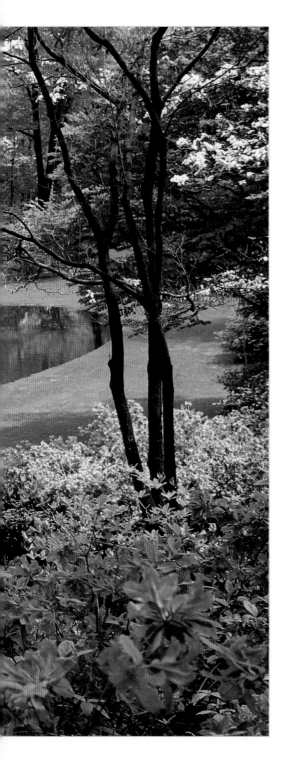

form to a garden. Water in the garden was also a source of endless fascination. Bey Corbally Stourton's earliest recollection of her brother Russell was of him sitting in a pool of water on their daily walk with a nanny and refusing to get up. The stream that cut its way through their property was a source of never-ending pleasure. "Russell dammed it and made waterfalls and diverted it in many directions," she remembered. "I was the bearer of stones, and many happy hours we spent together, building and rebuilding. Sometimes it was up to two and a half feet deep, sometimes just a muddy trickle. There is no doubt that this continual altering and remaking banks and heaving heavy stones enthralled Russell. The long summer days were passed in the rivulet."[6]

With time and travel Page's early obsession with water was

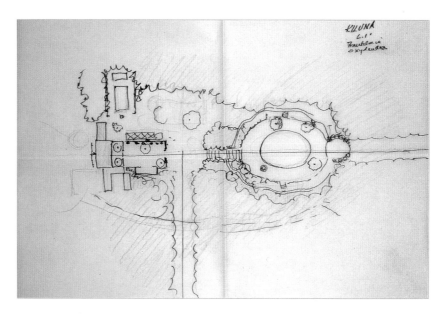

strengthened by insight and knowledge. He better understood its vital role on the earth when he flew over such places as Iran, India, and the delta of the Indus during the war years. A flight from Khartoum to Cairo, in particular, which took him over the Nile as it threaded its way through the vast desert, gave him a cosmic view of water as the life-giver. His study of Islam's four rivers of Paradise, symbols of irrigation, made him further aware of water's vitality and essence.

In England, his native land, Page observed the romantic relationship between water and the landscape; in France he learned how water can be used to formalize a garden. In the windswept low countries he saw how a pool of water mirrors sky, clouds, and trees and brings movement and density to what might otherwise be a dull landscape. And in Italy the beauty and magic of pools, fountains, and the cascading water stairs of Renaissance gardens exposed him to a culture's positive passion for running water. It is not surprising that

FOLLOWING PAGES At Kiluna Farm, Page planted brightly colored Kurume azaleas in the dappled shade of dogwoods, Amelanchier canadensis, *and magnolias.*

Page had planned to devote a good portion of his unfinished second book to the nature of water: its changing color, its mystical quality, its power, and its place in the garden.

Along with Page's appreciation for the role water plays in the world, he seems to have had an innate aesthetic sense for its position in the garden. When he decided that water, in the form of a pond, would enhance a site, he always traced it out on foot before incorporating it into the architectural plans. At Hemelrijk there was a piece of low meadowland that he felt would be the ideal setting for a pond, the surface of which would mirror the Flemish sky, and bring it down into

the landscape. Carrying a sack of one hundred wooden pegs, Page and Robert de Belder walked over the terrain one Sunday afternoon. Page placed the pegs in the ground to mark the outline of the pond. He never looked back at the pattern he had imposed until they returned to the starting point. His instinctive feel for the land was so precise that not one peg was ever changed. Three months later Hemelrijk's four-acre pond was accepted by migrant geese and ducks as if it had always existed there.

Page employed the same method when he designed and traced a small pond for Baron Guy de Rothschild at Ferrière, near Paris, a huge château and park designed and landscaped in the 1860s by Sir Joseph Paxton, the architect of the Crystal Palace in London. Baron Rothschild

asked Page to make a park and pond on a thirty-acre area within a larger park; to create a smaller world around a quite small house that he called "a modern petit trianon for a Second Empire Versailles."[7] First Page planted trees to enclose the area and mark the transition from large-scale planting to a more modest and more interesting botanical collection. "Getting the pond right" was a preoccupation for Page. He often asked me to drive him along some of the quiet canals in Holland just to find the proper plant edging for it, which was apparently unobtainable around Paris. Page used the same approach as at Ferrière and at the de Belders' in the late 1970s when making a new lake, at a seventeenth-century château near Dieppe. Here he traced the curving contour of the lake on foot, this time with a large bag of talcum powder, pierced at the bottom, instead of pegs.

Opposite For close-up viewing of the shrubs and their underplanting of scillas, lilies of the valley, hostas, and various wild flowers, Page cut two paths into Kiluna Farm's surrounding woodland that roughly follow the oval shape of the pool.

Right After the pink and crimson display of Kurume azaleas Kiluna Farm's spring palette turns to the yellows and oranges of Exbury azaleas. Ornamental rhubarb and alpine strawberries are mixed with daylilies underneath the shrubs.

With experience Page became increasingly adept at using his instinctive feel for manipulating water and land to solve landscape problems. In the late 1960s at the Baron de Villegas estate on the fringe of Brussels, Page was able to turn the apparent defects of the site—in this case, a swampy valley planted with Canadian poplars—to great advantage. He explains his plan of action in developing the garden:

It seemed to me that the first thing to be done was to clear this valley completely of its rubbishy trees. Once these had been felled and all the undergrowth, rotten logs and stumps had gone and it was a whole winter's work, we had a very different open view across to the fields beyond. At the head of the valley on the boundary there was a spring which seeping through various ditches fed the existing small lake . . . it was, I suppose a relatively major work . . . this neglected patch cut through the middle of

the property, but no amount of clever planting could have solved the problem of giving unity to the estate.[8]

Page completely reorganized the entire landscape by devising a new system of stream and lakes. He and the Villegas, guided by their own knowledge and counseled and encouraged by the de Belders, began to

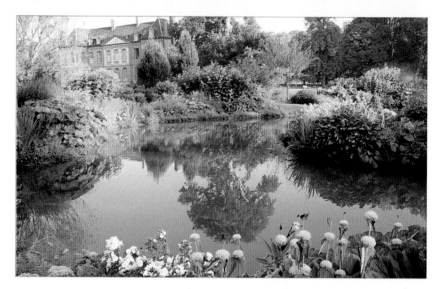

LEFT, ABOVE *At the estate of Count de Villegas near Brussels, Russell Page devised an extensive system of streams and lakes, which serves as the setting for a sophisticated tree collection. The striking foliage of gunneras, growing at the edge of one of the three ponds beneath the golden leaves of beech trees, lasts well into the fall.*

LEFT, BELOW *The terrain surrounding this tranquil pond designed by Page in a Normandy garden is richly furnished with bog plants, such as rhubarb, rodgersia, astilbes, daylilies, phlox, phlomis, lythrum, and many other treasures.*

OPPOSITE *Russell Page designed and planted this pond for the baron and baroness Guy de Rothschild at the domaine de Ferrire, a château surrounded by a vast park laid out by Joseph Paxton in the 19th century. Page planted the pond's island and banks with native plants he collected in the surrounding countryside.*

form a pictorially and botanically interesting collection of trees in the newly arranged valley and in the level meadowland between the local road and château. The trees included taxodiums, metasequoias, autumn-coloring katsura trees, and aronia, then a few libocedruses and *Chamaecyparis pottenni* as vertical evergreen accents. They planted a small collection of willow cuttings near the new lake, and these grew incredibly fast.

In 1953 Page was commissioned to rearrange and enlarge the grounds of the Villar Perosa, the country home of Signor Giovanni

Agnelli, the head of Fiat, and his wife, Donna Marella, set on a plateau in the foothills of the Alps. It was immediately obvious to Page that room would have to be made in the overcrowded, overplanted nineteenth-century garden to open the site to the landscape. Contrary to his usual experience, Page found that changing the garden was far more difficult than designing one from scratch. Problems were delicate and involved a struggle. Each spruce, each monkey puzzle had been planted either by a garden-loving grandmother or else jammed into the existent spaces between box parterres and white marbled statuary by the family gardener who had reigned supreme for fifty years.

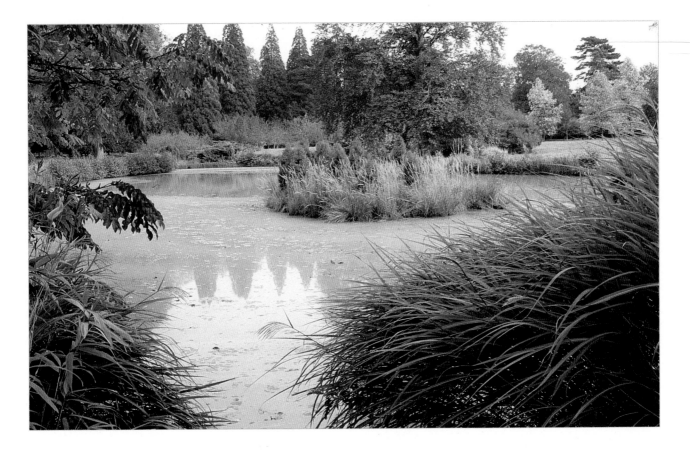

Initially Signora Agnelli was reluctant to change even a leaf in the garden and at times she grew exasperated by Page's ruthless extermination of family relics. But she was, nevertheless, quite excited by his plans to create a park. Her photographer's eye, innate sense of beauty, and her growing interest in gardening were stirred and stimulated, particularly by Page's ideas for the narrow ravine that runs down the garden next to the villa. The ravine joins a steep valley, at the bottom of which was a rocky stream. Page saw here an opportunity to design a simple, large-scale water garden.

First he tackled the ravine, putting in plants, such as rhododendrons, magnolias, and Exbury azaleas, that would do well in a moist, shady, sharply drained position. Since the valley ran rapidly downhill, he

decided to build a succession of dams, with the largest one hidden higher up in the valley, to control the flow of water. The position of this high dam allowed the water to cascade evenly over a series of eleven ponds, varying in length from twenty to fifty feet, that he designed.

Page described some of his planting choices in an article: "Edges [of the stream] are planted with drifts of Japanese iris, Japanese anemones, phlox, which like moist position, astilbes, spireas and ferns—wild rhubarb and gunnera make accents of giant foliage, and many varieties of hostas and other foliage plants are used as foils for more highly coloured flowers."[9] Page added clumps of flowering shrubs,

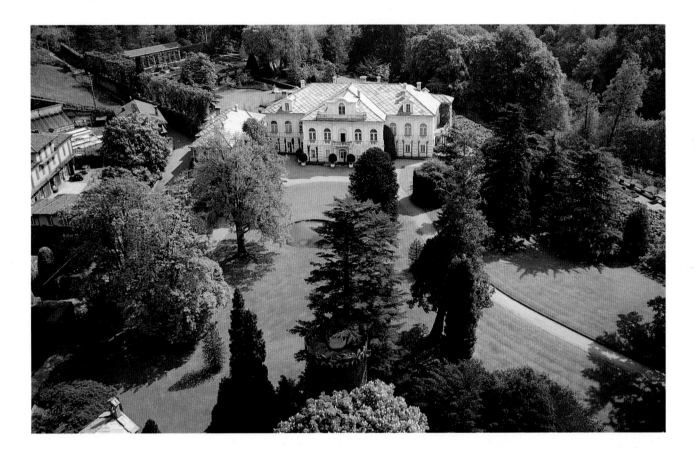

Opposite The steep valley running alongside Villar Perosa, the country home of Mr. and Mrs. Giovanni Agnelli, half conceals one of Russell Page's chefs d'oeuvre, a woodland garden with a string of eleven ponds.

Above The Villa Agnelli in Villar Perosa is surrounded by nineteenth-century plantings of trees, some of which Russell Page eliminated to create more space and light in the garden.

including *Rosa moyesi,* and *Rose hugonis,* groups of *Viburnum tomentosum mariesii,* and magnolias, to the low-growing groups of plants on the dry, stony slopes. He had the higher banks cleaned and thickly planted with silver birches, Scotch firs, beeches, and hornbeams. He dotted the floor of the valley with groups of Japanese cherries, *Robinia hispida, Taxodium distichum,* some trees for spring effect, and maples, sumacs, and Katsuras for autumn color. All this planting went slowly, especially when the first year's work was swept away by a summer cloudburst. Many of the plants were slow to acclimatize to the wild extremities of the climate.

All of Page's hard work paid off, however. Each group of shrubs has a steadying effect on the downward slope of land and the flow of water.

*R*IGHT *Page placed a small formal pool in front of Villar Perosa between the old specimen trees to break up the lawn. When the male* Araucaria araucana *to the left of it began to droop, Page advised planting a female behind it, which apparently revived the tired monkey puzzle tree immediately.*

*O*PPOSITE *This footbridge, which connects the woodland with the formal garden of Villar Perosa, was an important focal point for Page. He rebuilt it with white Chinese latticework, recalling the Chinoiseries of the villa's interiors.*

*B*ELOW *A last stretch of formal hedge lines the path from the bridge to the naturalized woods.*

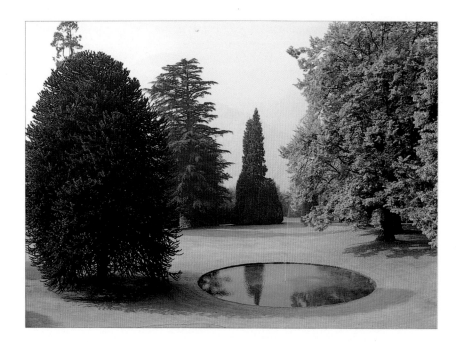

*F*OLLOWING PAGES, LEFT *Only two of the eleven ponds Page designed are visible from any one point at Villar Perosa. Each of the ponds has a different bankside planting. A patch of purple alpine asters grows alongside one pond.* RIGHT, ABOVE *Creeping cotoneaster covers the dam between two of Villar Perosa's ponds. Phlox and ferns have become naturalized .* RIGHT, BELOW *Various species of red-berried cotoneasters compose the planting along one of the lower ponds.*

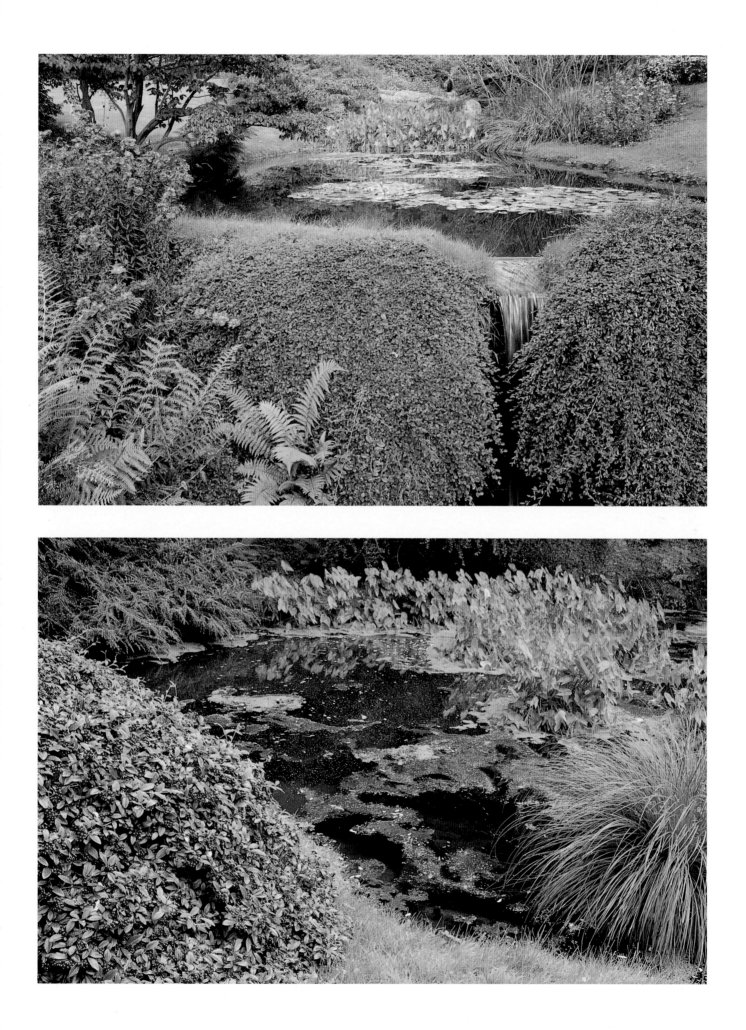

The trees in the valley provide variations of light and shade, while the hillside birches and firs link the overall composition to the mountainous countryside. The key to this composed landscape is the ever-present sound of water.

In 1969 Page returned to northern Italy to work on Count Brandolini d'Adda's country seat at Vistorta, in the Friuli region, near the Yugoslav border. By this time the count had already restored and redecorated the house in the style of the 1830s, the time that it had been built. A Turgenev enthusiast, he wanted a romantic park to comple-

Above A lofty, glassed-in loggia sets a romantic tone for Count Brandolini's country seat in Vistorta, north of Venice. Jasmine covers the villa's outside walls, and shrubs grow along its foundation.

ment it, but one without the usual excesses of the nineteenth century. Again Page saw the solution in water and placed lakes and ponds and trees on the estate in rounded, curving shapes. He used a stream both to make and feed three large ponds. He successfully created a green illusion in this flat land, not far from the violet-blue Dolomites. Page and the count spent hours walking and staking and studying the

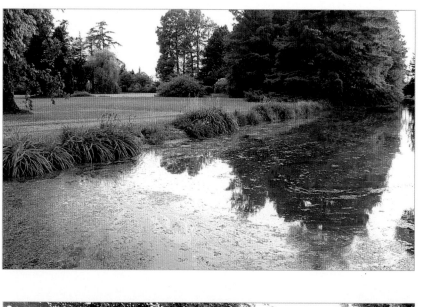

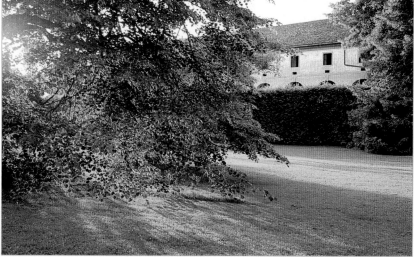

Right, above and below Vistorta's generous proportions extend to the farm buildings, the ample lawns, and three stream-fed ponds created by Page. A fifteen-foot-high hornbeam hedge sets the farm buildings apart from the manor house.

terrain together. They carefully preserved the best of the existing trees, while planting a variety of specimen trees and assuring the protection of a shelter belt around the park. The result is an elegant English park, seen through the inverted telescope of nineteenth-century Russian country life, set in Italy.

Like other gardens Page did in Italy, this elegant park is the result of a fruitful collaboration between the designer and his client. Page had wanted to install a rose parterre in front of the house, but the count graciously declined, preferring to retain a simpler appearance. Both

*A*BOVE *One of the ponds designed by Page, bordered by a row of conifers, is seen here from an upper story of Count Brandolini's villa. Ancient linden trees grow in front of the house.*

understood the importance of preserving the house as the central element in a complex of architecturally similar farm buildings. They therefore placed the rose garden to the side of the house, parallel to an existing canal, which Page enlarged when making the new ponds. A fifteen-foot-high double hornbeam hedge separates this area from the other buildings and the activities of the working farm. Such details show Page's adeptness at combining the elegant with the practical. The scale of the hedge is also in keeping with the large buildings on the estate, including a high and spacious loggia at the far end of the house, which the count had glassed in and covered with climbing plants within and without to create a cool winter garden.

Perhaps the most noteworthy quality of this park, with its misty Venetian light, its lawns, ponds, and trees, is the absence of formality. The park marks a transition in Page's work from a formal use of water and trees to a freer, looser, more natural landscaping, which also meant a liberation from his usual classical designs.

RIGHT, ABOVE The bold foliage of gunnera plants, edging the pond near the entrance to Vistorta's garden, has the size and substance necessary to maintain the scale of the surrounding trees and buildings.

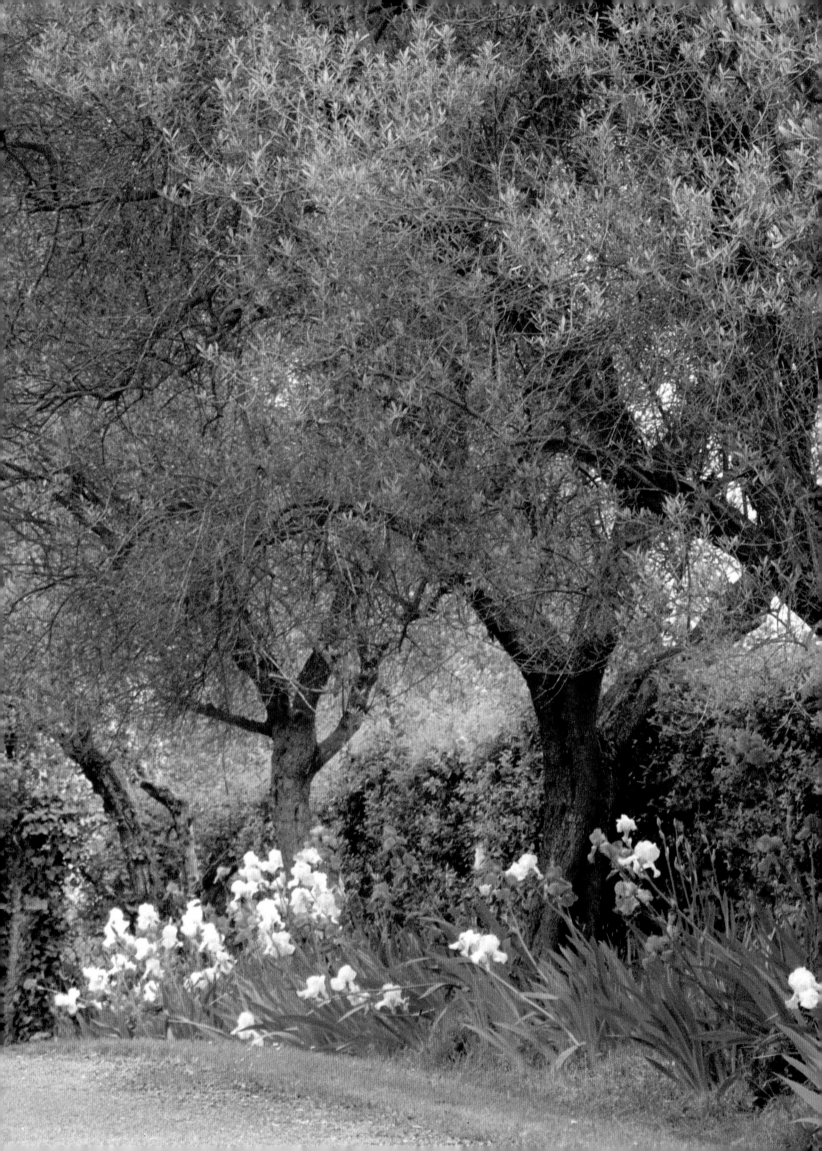

Southern Italy

Some of the happiest and most satisfying moments of Russell Page's professional career were spent designing gardens in southern Italy. The combination of mild climate and congenial clients, who were also enthusiastic gardeners, provided ideal working conditions. Three of Page's southern Italian gardens—La Mortella, San Liberato, and Tor San Lorenzo—particularly pleased him. Each has a distinct character that is the result of Page's respect for the nature of the individual site and the owner's devotion to the garden's creation and continuation.

In the 1950s, the eminent composer Sir William Walton and his wife, Susanna, asked Page to create a garden for a new house they were building on the island of Ischia, off Naples. Page also advised them about the positioning of their house, which they called La Mortella. In his unpublished writings, Page described his initial work at La Mortella, as well as his return twenty years later to plan new arrangements: ❧ "The land was a narrow gulley and a hillside so steep as to be almost a cliff thickly covered with the dark greens of *Quercus ilex Alaternus* and common myrtle, and the gulley at its foot was a dry weedy hollow strewn with huge and beautiful weathered chunks of lava spewed out at some period by Nepomeo, the now quiescent volcano whose jagged crater rises steeply a mile away. ❧ "In those days Ischia had little water but the soil in the gulley was good, so I designed a simple framework for a garden in which plants, Mediterranean, Californian, South African and Australian might be expected to flourish in near xerophytic 'maquis' conditions. ❧ "The house was to be backed against the cliff, its entrance perhaps twenty foot above the floor of the gulley, where lay three huge rocks in a spatial relationship that might have been set out by a Zen master in Kyoto. To accentuate this relationship I designed a more or less eggshaped pool planted now with water lilies and nelumbriums for eventually water was brought from the mainland to the island and where I had hoped at best for lavenders, myrtles and cistus, now tree ferns and camellias, tulip trees, hydrangeas, jacarandas and tree-sized daturas grow tall between the cliffs which draw them up and make shade for plants and ferns of many kinds which like semi-shade.

ABOVE At La Mortella, the home of Sir William and Lady Walton on the volcanic island of Ischia, Russell Page helped create an unusual garden in a secluded gully where the rocks, sometimes purposely exposed, were part of the inspiration.

OPPOSITE Page designed a small round fountain fed by a narrow channel at the far end of the garden at La Mortella. Its jet splashes water onto the calla lilies and strelitzias nearby.

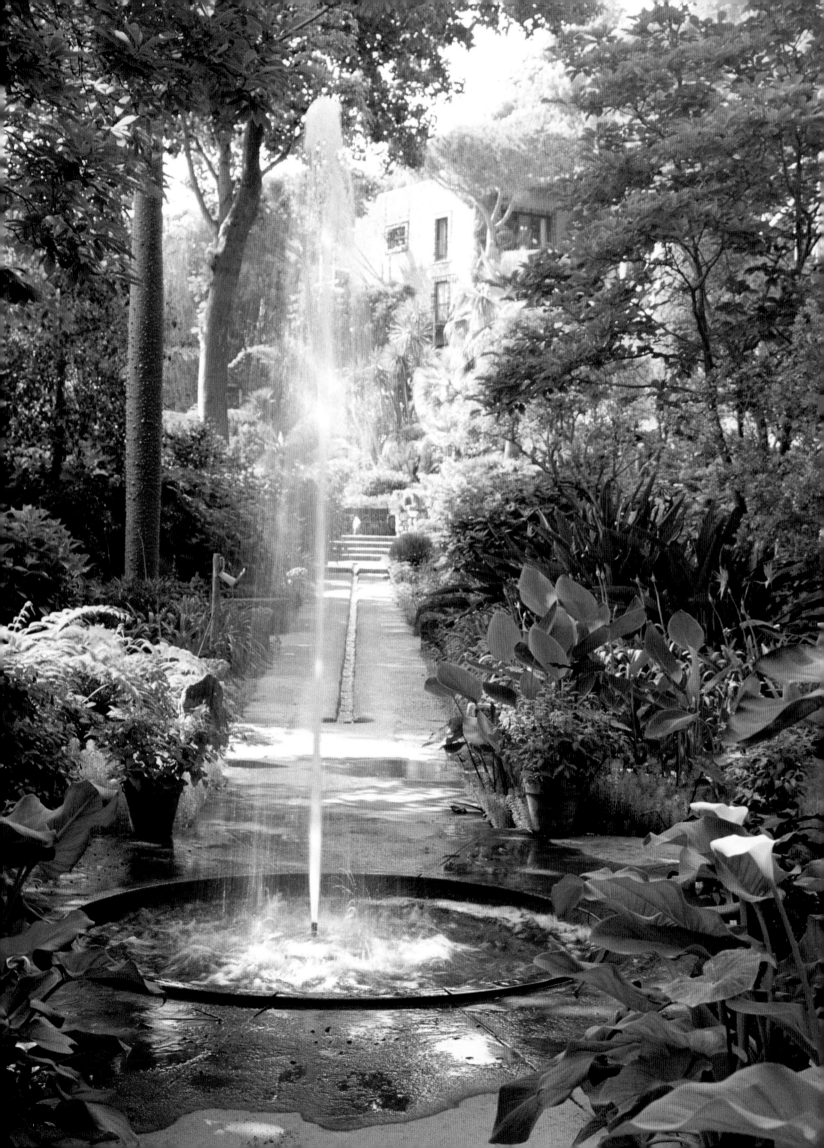

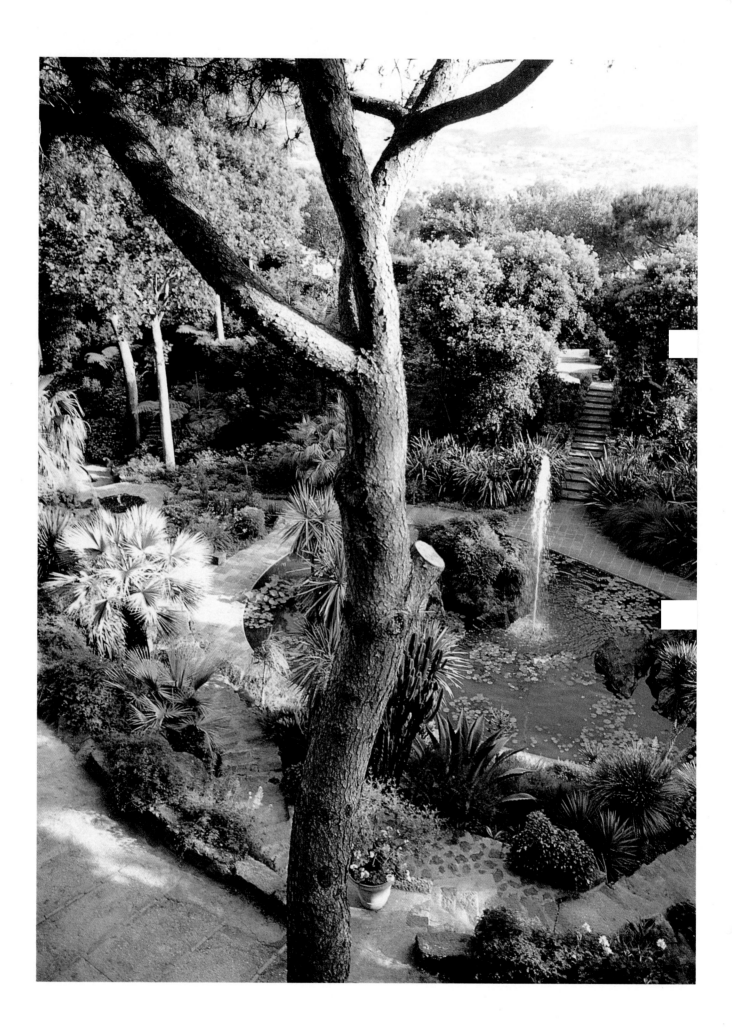

The plan is simple—the main terrace of the house is on the third floor and may be seventy feet above the pool which is the main feature of the garden. Beyond it a narrow and long flight of shallow steps framed by myrtle leads up to a small fountain jet which is the central point of a small garden devoted to camellias. These in turn are underplanted with *Hippeastrum* and the high

*O*PPOSITE *In the floor of La Mortella's narrow valley Page built an egg-shaped pool around three lava rocks. Several paths and steps radiate from the pool area to other sections and levels of the garden.*

*R*IGHT *Ischia's steep, rocky hillsides with rapid drainage provide the habitat for palm trees and succulents at La Mortella, all of which were planted when very young, to enable them to gain a strong foothold in the difficult terrain.*

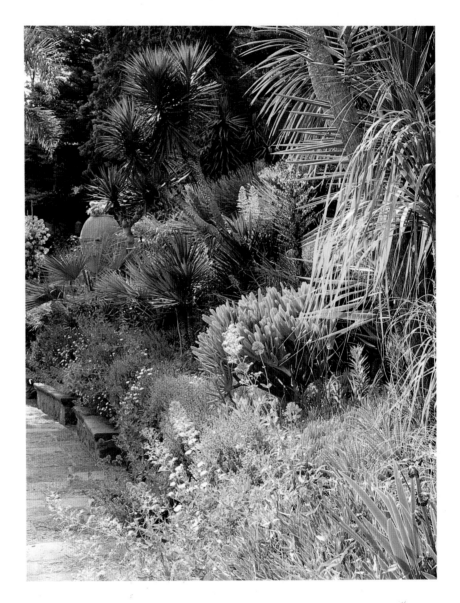

wooden trellis which limits this small terrace and is the garden boundary is espaliered too with camellias.

Steps and paths and dry walling, all cut from rocks on the property make sunny terraces and greatly curving paths and flights of steps leading up the base of the house. The planting here changes to Yuccas, Agaves, Strelitzias, *Russellia, Echeveria* and many other succulents, large and small. Here, too, are *Convolvulus mauritanicus, C. cneorum, Nierembergias* and *sedums.* To one side a little wooden hut which hides the fountains'

pumps is covered with *Mandevilla suaveolens,* white and intensely fragrant against *Araucaria excelsa,* and an equally tall *Cupressus Arizonica glauca.* The cypresses I placed to give vertical accents have all succumbed to the disease which has decimated Italy's most characteristic trees. We have still superb plants of *Magnolia grandiflora,* Umbrella Pines and a forty foot jacaranda above huge bushes of white datura and blue white lace cap hydrangeas set in drifts of agapanthus, the main glory of this garden in June.

Ischia bubbles with radio-active springs and plants grow with a vigour and speed, *Liriodendron tulipifera* has reached fifty foot in barely twenty years, that I have not found elsewhere in Europe except around the northern Italian lakes and the huge circular crater of an extinct volcano which is now Lake Bracciano, twenty miles north of Rome.

From the back of the house a tiny funicular takes you two at a time, under a little awning up the precipitous hillside to its crest where is a swimming pool heated by solar energy and a plateau looking out eastward over Posilipo, Cape Misenum and Vesuvius.

This is a garden of controlled disorder. Plants flourish exceedingly, beds are lightly forked but not dug over. Various begonias, ferns, iris, kaempferi seed themselves about—putting in a new plant means sacrificing some of the flourishing and heterogenous ground cover. . . . Plants decide to grow and thrive in the most unexpected combustions. A frail wooden toolshed is a scaffolding for a mound of *Mandevilla,* jasmine. Sambac reaches up to a covered terrace thirty foot above the ground on which a large stone bowl harbours the crimson and yellow of *Gloriosa rothschildeana* scrambling through a night-blooming cereus, twelve foot high.[1]

Page returned to Italy in the 1960s to design some gardens around Rome. While there he had time to visit and study such great classical Renaissance gardens as the Villa di Papa Giulio in Rome; the Palazzo Farnese in Caprarola; the Villa Aldobrandini in Frascati; and his personal favorite, the Villa Lante near Viterbo. He also discovered the Campagna, the countryside of the Lazio region around Rome, which was dotted with Etruscan remains and medieval hill towns.

English gardening was very much in vogue in Italy at that time. Many old Roman families were familiar with the style of Gertrude Jekyll and wanted their gardens to reflect her principles. Much of Page's work there became an absorbing exercise in interpreting his own English gardening heritage against the Mediterranean backdrop

of olives, cypresses, and umbrella pines. The jobs he took were varied: He designed roof gardens for the Agnellis and for his friend Frederico Forquet; the courtyard at the Palazzo Colonna; and a farmhouse garden for the Duchess Salviati. Outstanding among his southern Italian projects are gardens he created at San Liberato on the Lago di Bracciano and at Tor San Lorenzo near Anzio.

San Liberato, the estate of a noted Italian art historian, Count Sanminiatelli, is set on a ledge, in a half circle carved from a hillside covered with chestnut trees. It had once been the site of a small Roman market town, but by the time the count and his wife had chosen to

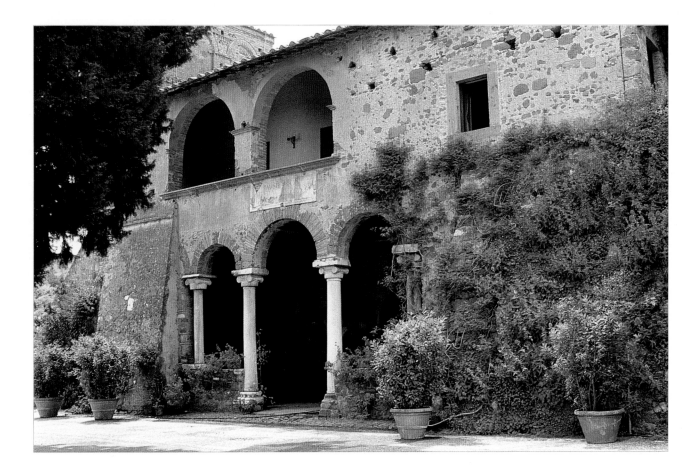

Count Sanminiatelli hired Russell Page to landscape his estate at San Liberato, Italy, the site of a former Roman market town. The town's Romanesque church still stands, near an ancient cypress tree. Page planted climbing roses, rock plants, and valerian, which now cover its walls. Oleanders grow in pots at its base.

build their country home there, only a fourth-century church, restored in the ninth century, remained. Olive trees were growing through its walls and brambles sprawled over its crumbling black-and-white mosaic floors.

When Page first saw San Liberato in 1964 he was immediately captivated by its location and intrigued by the layers of time past. The count had his large, typically Roman house built below the woods on the hillside, slightly higher than the old church, allowing for an unobstructed view of the circular Lago di Bracciano below and the strange, symmetrical mountain beyond, the Rocca Romana. Page felt that this was a sound decision, in keeping with the customs of such

great Renaissance builders as Giacomo da Vignola, who maintained that it was always preferable to situate a house at a lower level rather than a hilltop. The villa at San Liberato was placed just where the hillside gently sloped toward the lake.

Some planting had been done at San Liberato before Page arrived, but he approved of what he saw. A rectangular lawn had been placed in front of the house, bordered by a retaining wall. At Countess Sanminiatelli's request, he installed some long narrow rose beds and a stone fountain below the wall but did not let either interfere with the view.

Page chose to begin his gardening on a medium-size plot next to the church, which he saw as the key to San Liberato's setting. He cross-terraced the ground with low walls and then laid eighteen-inch-wide

paths to break the area into a series of smaller beds, or *giardinetti,* that are appropriately monastic in feeling. Gray-leaved and bluish plants spill onto the paths, roses climb up olive trees, and self-seeding plants, such as valerian, have taken root in walls and between steps. A *Magnolia stellata,* silvery olive trees, and a summer-flowering lagerstroemia add height to the overall composition. Page also used this garden to try out some unusual plants, one or two of each species, which add even more variety to the site's natural haphazardness. The resulting garden is timeless, a mirror to reflect the spirit of the place.

To counterbalance the churchside garden, Page made islands of modern and old-fashioned roses on the other side of the lawn. Nearby he added large beds of flowering shrubs, such as pineapple-scented Moroccan broom (*Cytisus battandieri*) and tall, shiny-leaved *Stranvaesia davidiana,* as well as red-flowering dogwood (*Cornus florida rubra*).

Page decided on a more formal treatment for the circular entrance

LEFT *The circular entrance court to the villa at San Liberato is located above the church. Page added clipped laurel hedges and lemon trees in classical terra-cotta vases.*

ABOVE Page gave the little garden next to San Liberato's church a certain medieval flair. A sunken path separates the church from the adjoining garden, the first one Page did at San Liberato. Shrubs billow into the path from a garden on higher ground.

court. He framed and shaped it with clipped laurel hedges, lemon trees in classical terra-cotta pots, and, on an upper level, a double line of trimmed holm oaks. Equally formal is the separate pool area, which is enclosed within a rectangle of high laurel hedges. A long path bordered by beds of Page's favorite Iceberg roses leads to a pool house with a covered terrace. A splendid allée of *Magnolia grandifloras* follows these white roses just before the path becomes a woodland walk among banks of camellias and blue and mauve azaleas and hydrangeas.

Count Sanminiatelli, an impassioned and knowledgeable tree collector, turned adjacent meadows into an arboretum. Page, who was developing a wide interest in trees during the years he worked at San Liberato, was always willing to enhance a garden with unusual and interesting specimens. He noted at San Liberato, as he had at La Mortella, that something, possibly "radio-active," stimulated incredible

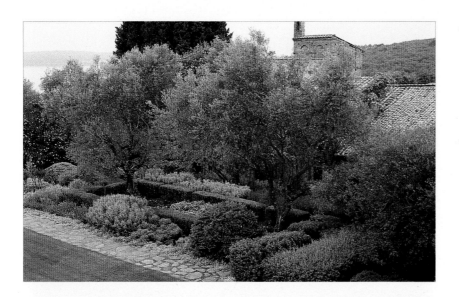

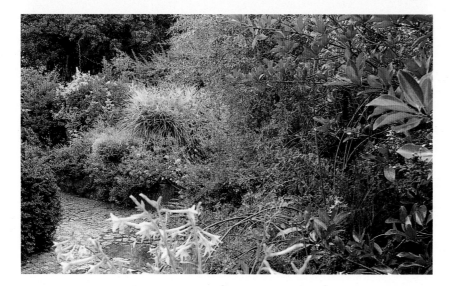

LEFT, ABOVE A patchwork of flowering shrubs, such as caryopteris and Jerusalem sage, surrounds a rectangular hedge of rosemary in the shade of young olive trees at San Liberato's monastic garden.

LEFT, BELOW A different palette prevails later in the season, when fragrant Nicotiana blooms next to a spreading pyracanthus in the foreground.

OPPOSITE A rustic path runs from the little church garden up to San Liberato's entrance court. Page planted Japanese anemones, valerian, and a clump of ornamental grass to provide soft September colors.

FOLLOWING PAGES, LEFT AND RIGHT, ABOVE Countess Sanminiatelli asked Page to plant a collection of hybrid tea roses, which he placed in formal flower beds below a retaining wall, where they would not interfere with the view from the house. The rose beds are edged with a clipped hedge of Teucrium fruticans. A low flight of steps bisects this rose garden, ending at a fountain, in the base of which grow water lilies. RIGHT, BELOW Page planted an island of shrub roses on the side of the lawn opposite from the monastic garden at San Liberato to achieve a balanced design. Rambler roses tumble into the path that ascends to the house.

growth and glistening health in plants there. "Ten foot sapling planes and tulip trees," he remarked, "planted some fifteen years ago have already reached sixty foot or more. Cedars and pines, black walnut, scarlet oak, magnolias and maples, branched to the ground make spires and domes of luxuriant foliage."[2]

The interests of Sanminiatelli and Page coincided in the planting of the arboretum, and together they collaborated and corresponded over the choice and positioning of every tree. Sometime toward the end of his life, Page wrote of his work at San Liberato:

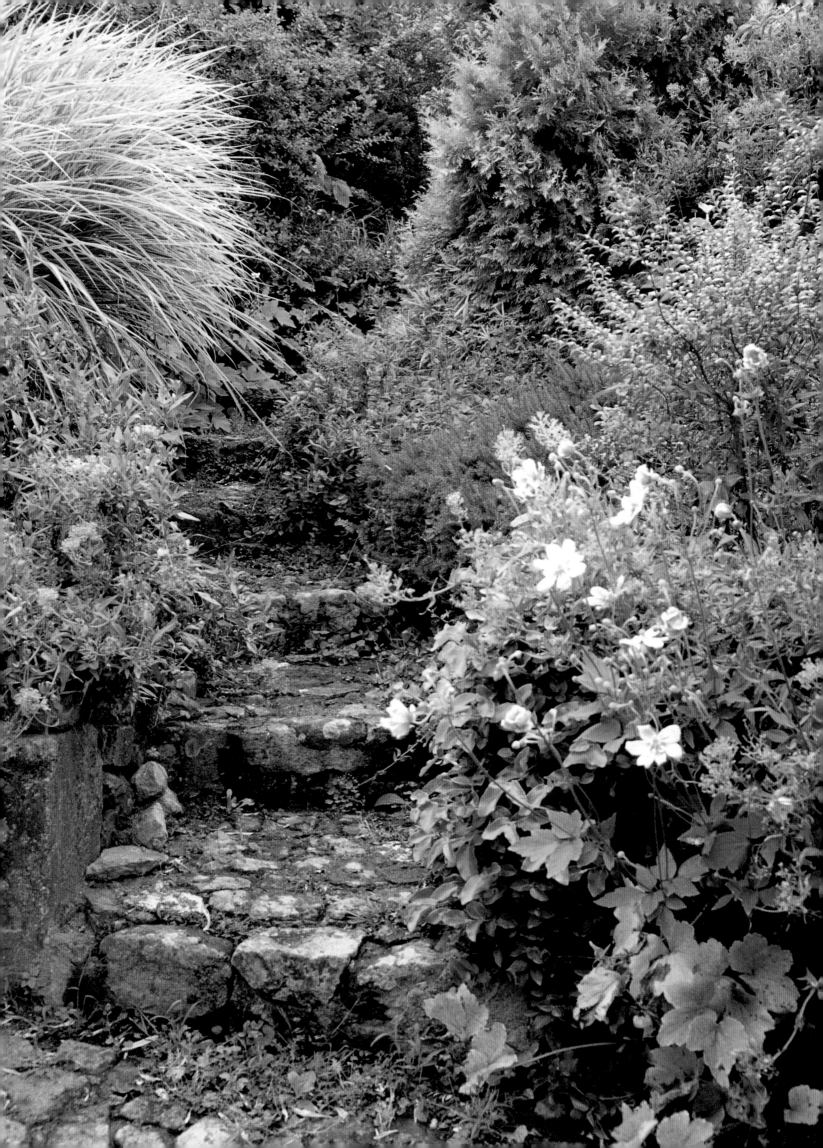

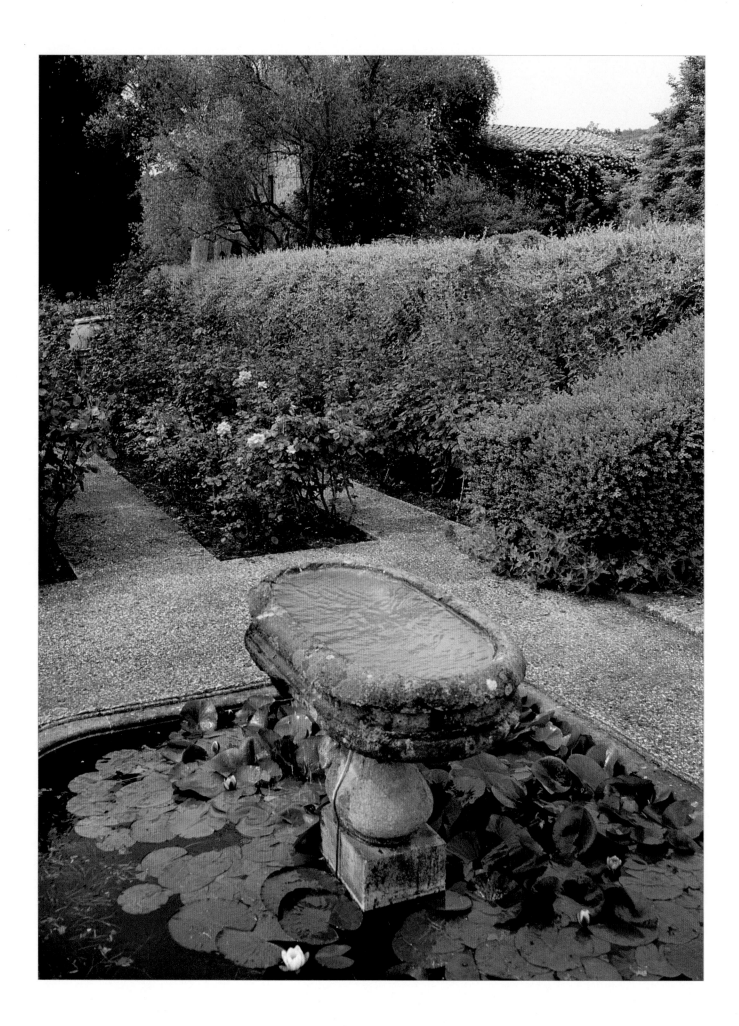

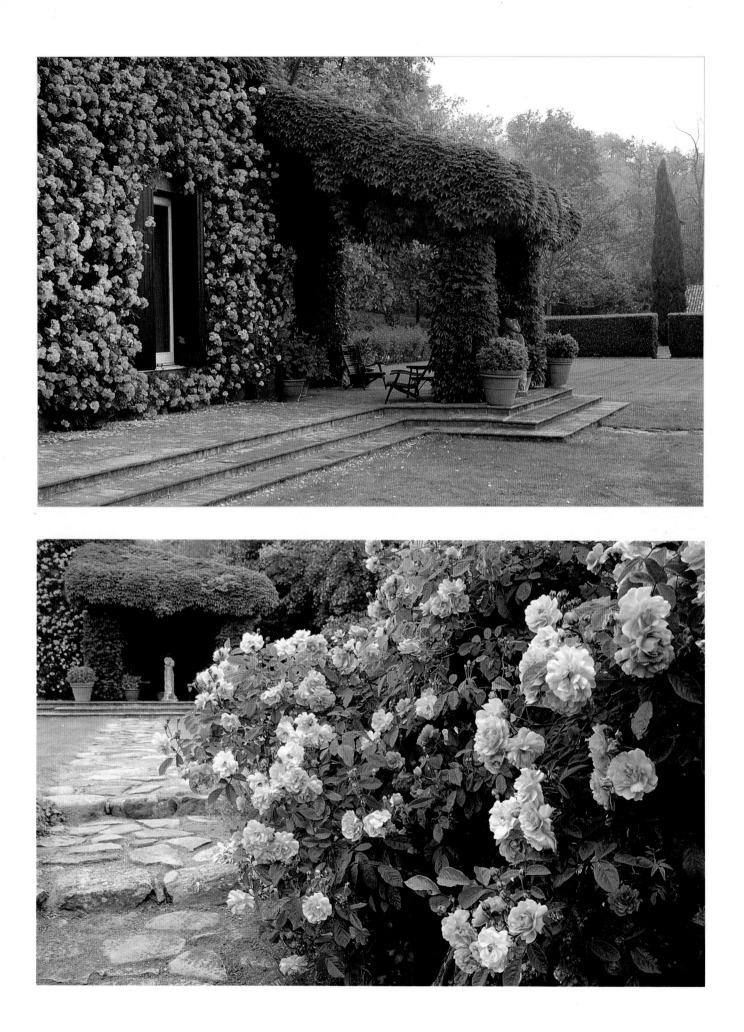

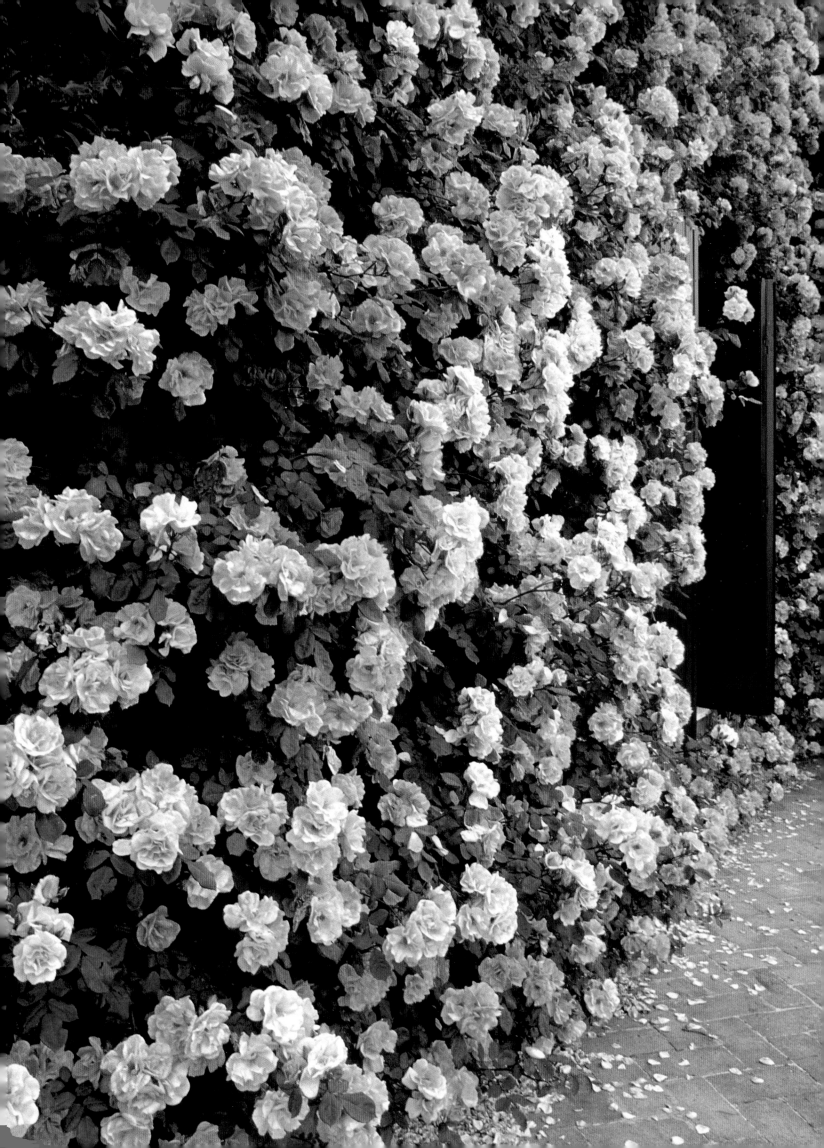

If I consider this garden especially good it is because we, its owner and myself, were always alert to the nature of the place; in placing every plant. We set out paths or lawns or beds to frame or underline or try to accentuate or concentrate around the invisible presence embodied in the physical characteristics of the place.

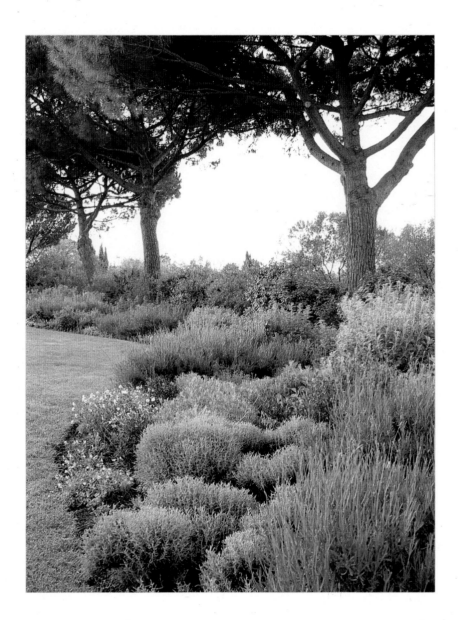

*O*PPOSITE *The Clair Matin roses covering the façade of the villa at San Liberato give the house an exuberant look.*

*R*IGHT *At Tor San Lorenzo, the country house of the Gallarati Scottis near Anzio, Russell Page's first step in structuring the garden was the installation of a border of such gray-leaved plants as lavender, artemisias, and lamb's-ears backed by umbrella pines and willow-leaved pear trees.*

I know of no other garden more magical than this, so strong is the atmosphere of tranquility, the just relationship of trees and woods to lake and mountain and sky—the simple planes of the gardens, the sloping woods and fields where even the details of more gardening sections have come together in silent harmony.[3]

Page faced a completely different landscape at another Italian commission, the Tor San Lorenzo, the property of the Marchese and Marchesa Gallarati Scotti south of Rome near Anzio. It was an

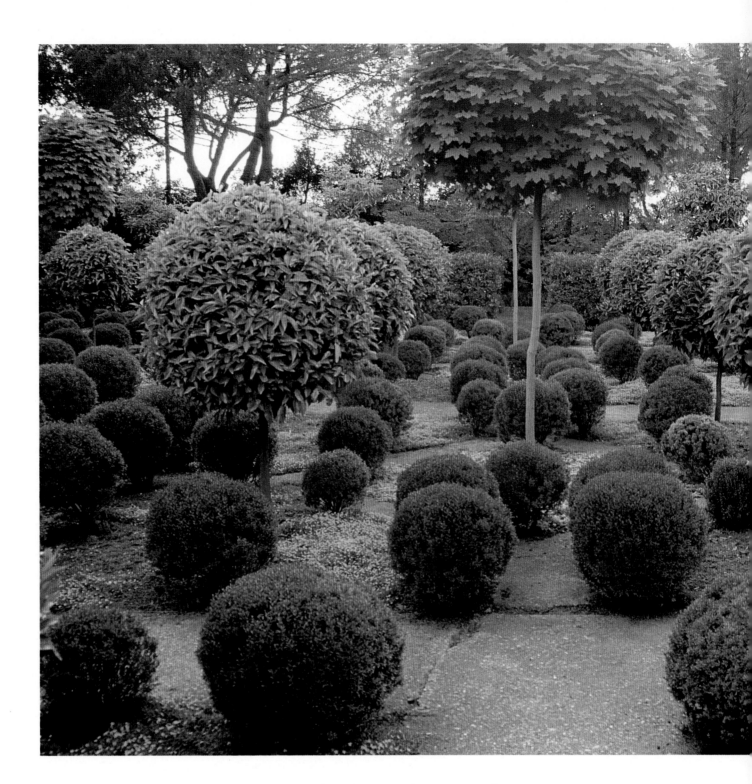

abandoned dairy farm, which the owners had bought on a whim at auction, on an undulating but nondescript and treeless piece of land. By the time Russell Page was introduced to the Marchesa Gallarati Scotti by Count Sanminiatelli in 1967, she had become a voracious plant collector. The modest farm buildings had been turned into a country house, and the grounds around it were overflowing with a haphazard collection of herbaceous plants, European alpines, and roses. The marchesa was initially interested mainly in alpines and other rock plants, then became enthusiastic about plants from Aus-

Above The Marchesa Gallarati Scotti created a myrtle garden within the framework of a rose garden that had been designed by Page. Each of the diamond-shaped beds now contains a round-headed maple surrounded by four bitter-orange trees. Myrtle bushes pruned into spheres complete the geometric pattern.

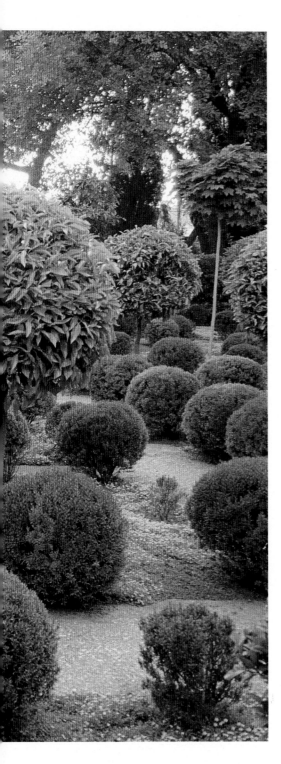

tralia, California, and South Africa, ordering them in ever-increasing varieties and quantities. Page's task was to provide a broad framework for this enthusiastic collection, to bring order and clarity to the marchesa's disparate material. To gain her confidence, first he made her a rock garden on the slope behind the house, before concentrating his efforts on the overall site.

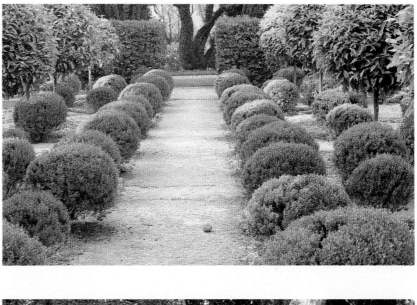

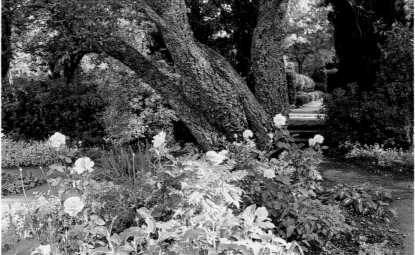

RIGHT, ABOVE *The path in the middle of the myrtle garden leads in a straight line across the central axis to a garden of mauve and yellow flowers.* RIGHT, BELOW *The same view from the opposite end of the path, from the mauve and yellow garden looking toward the myrtle garden, takes in some Freesia roses and a cork oak near the entrance.*

After installing a gray and silver border of eleagnus shrubs, Iceberg roses, lavender, and artemisias near the lawn alongside the house, he planted a background of olive trees, umbrella pines, and willow-leaved pear trees to give it dappled shade. He always paid particular attention to the native trees of a region. "When I started work in the Mediterranean," he explained, "I learned to use cypresses and olives, aleppo and umbrella pines for the basic structures of my tree planting for I have always thought that wherever I was working I must relate any tree planting to the landscape and its indigenous trees so that my garden,

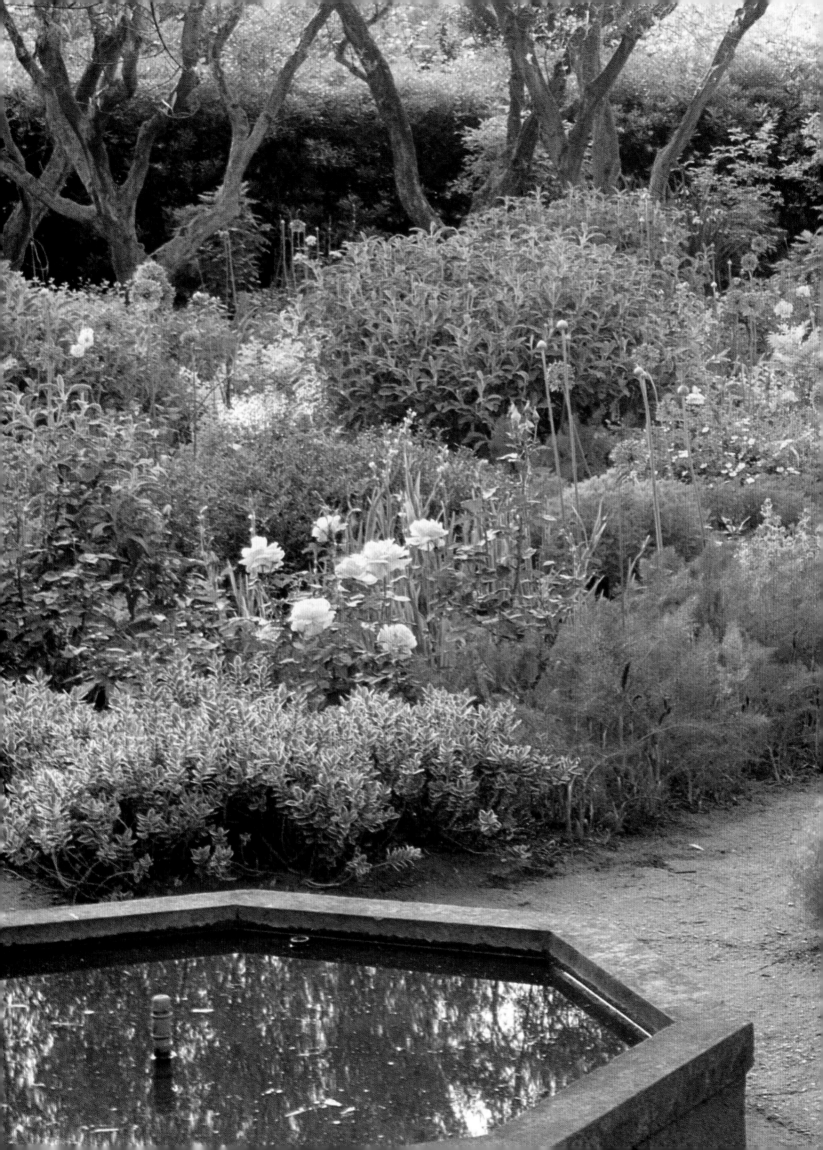

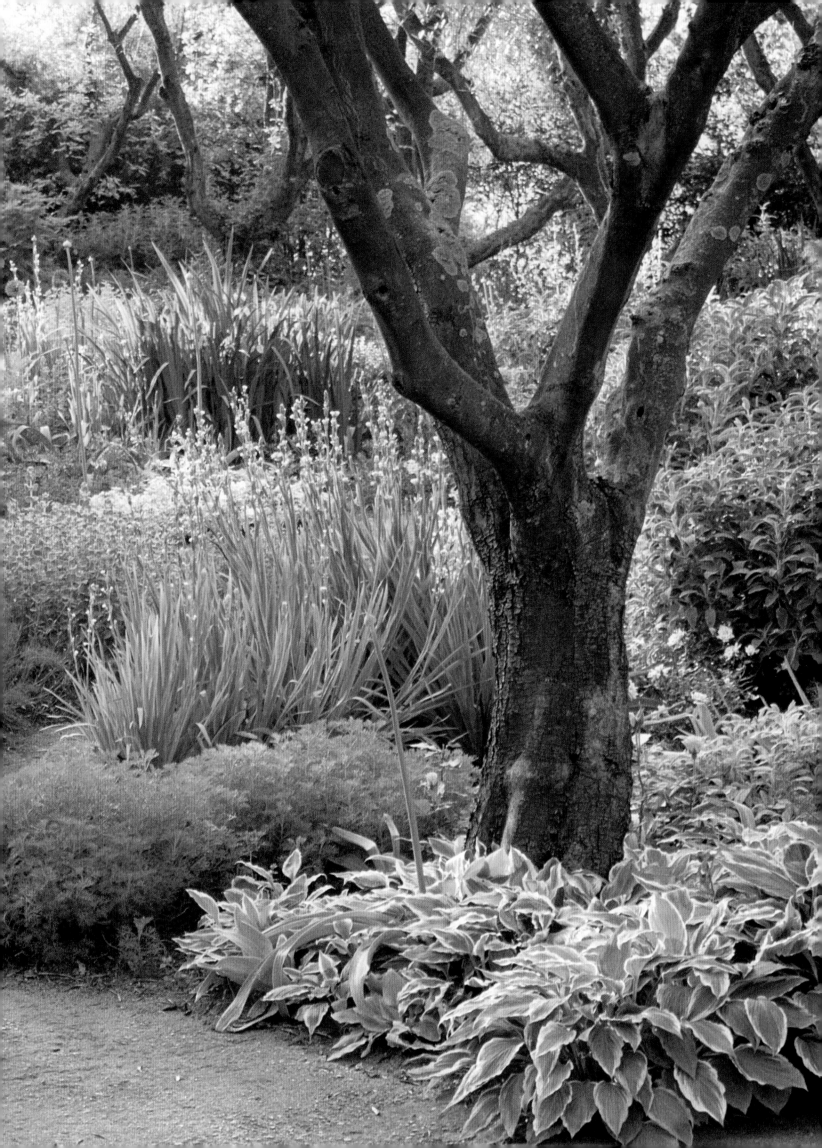

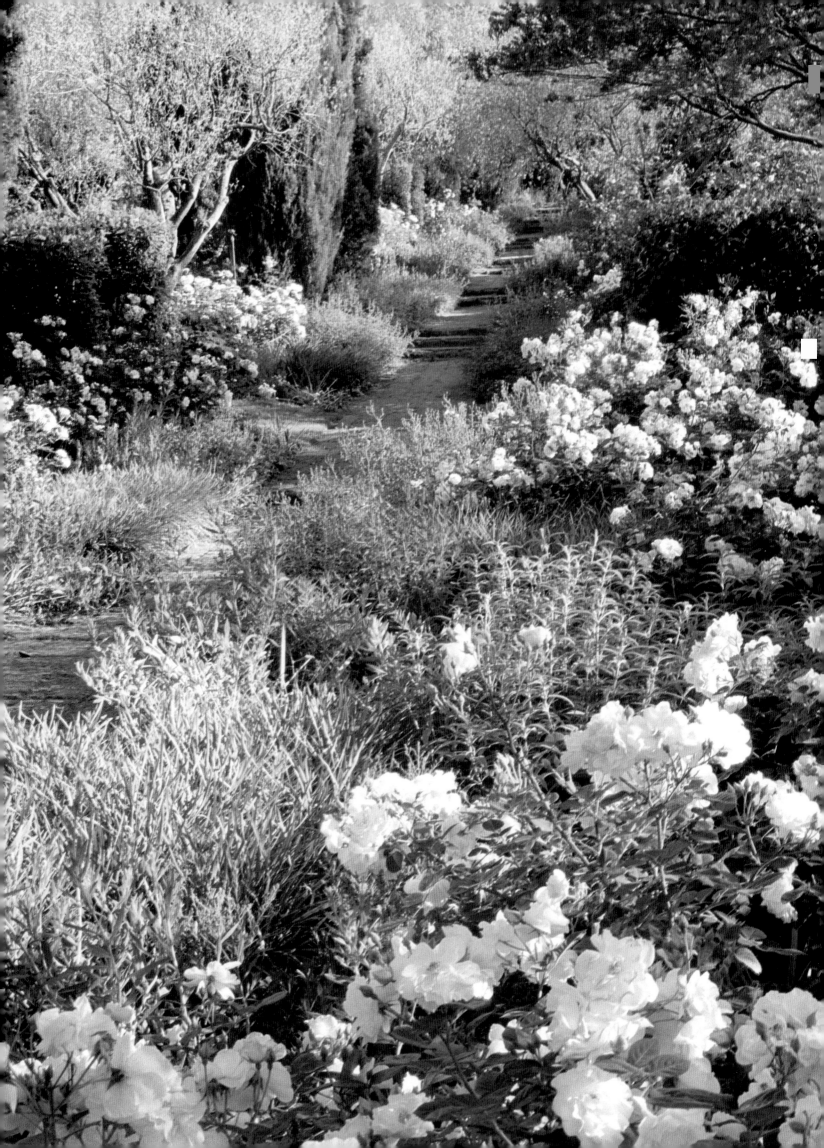

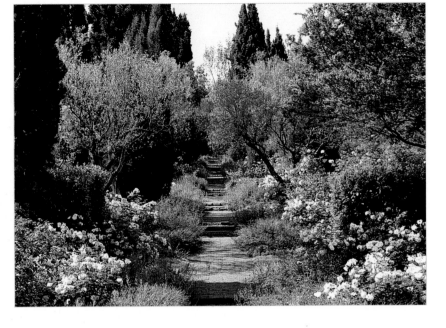

PRECEDING PAGES *Page designed two octagonal pools within an enclosed grove of olive trees for Tor San Lorenzo. The marchesa replanted the garden in shades of mauve and yellow; her planting comprises variegated hostas, bronze fennel, golden helichrysum,* Sisyrinchium striatum, *purple alliums, mauve columbines, and many other plants.*

OPPOSITE *A major feature at Tor San Lorenzo is a main path descending to the lower garden, bordered by two ample beds generously planted with Penelope roses and lilies among whorls of* Salvia leucantha.

ABOVE *Another view of the path, seen from above, reveals Seafoam roses growing near the edge of the path in the middle.* Tulbaghia violacea *bulbs will send up bluish flowers later in the season.*

BELOW *Roses ramble dreamily on one of Tor San Lorenzo's retaining walls, which is covered with erigeron daisies.*

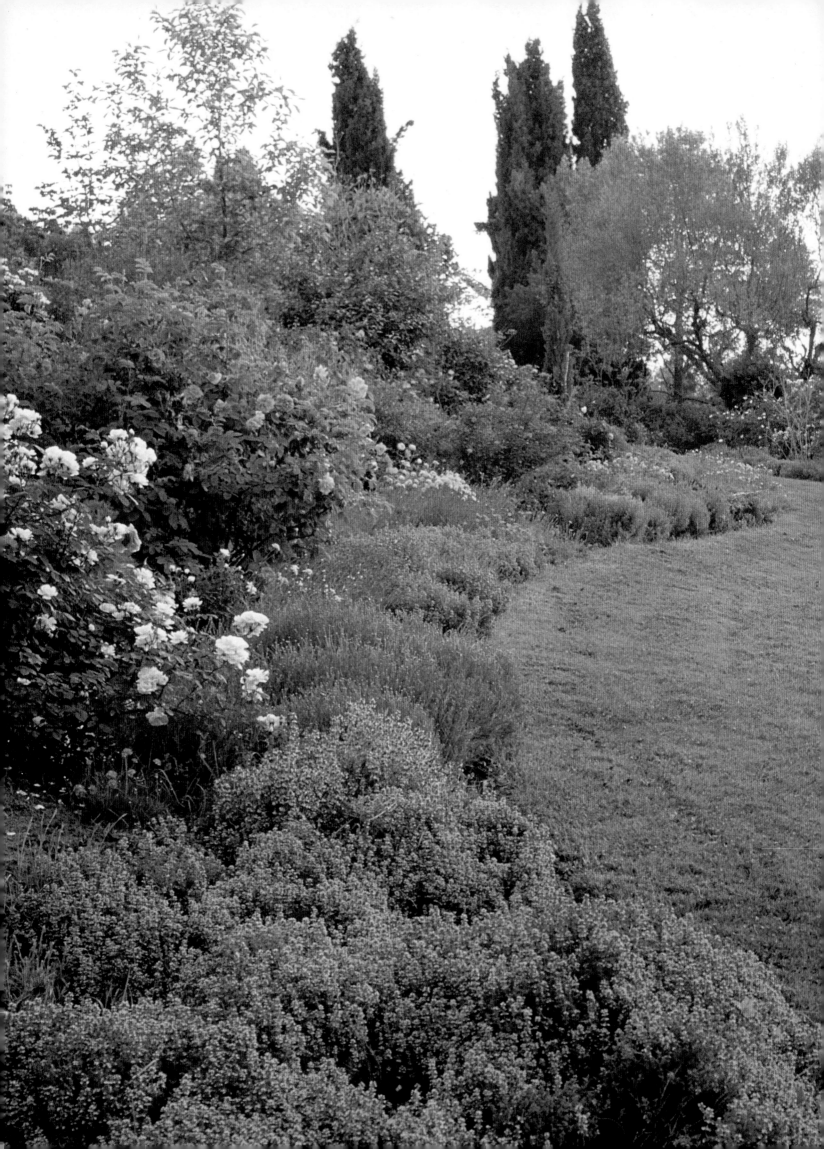

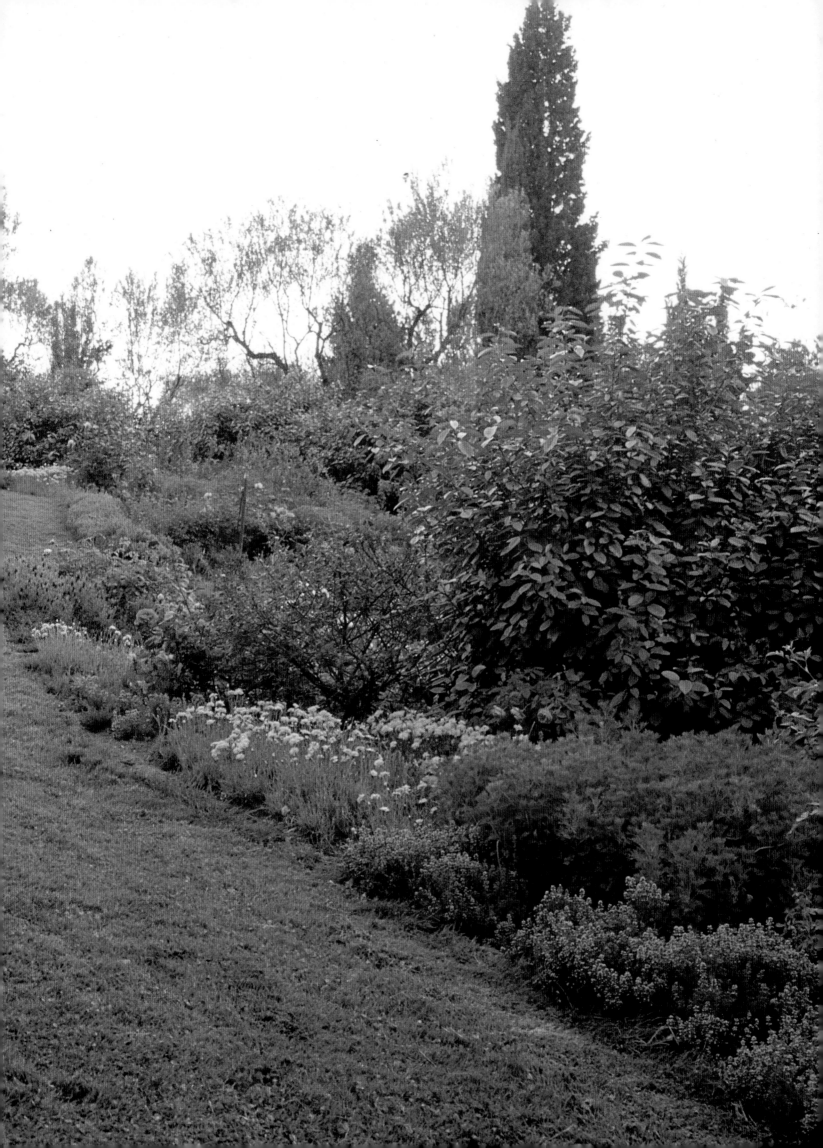

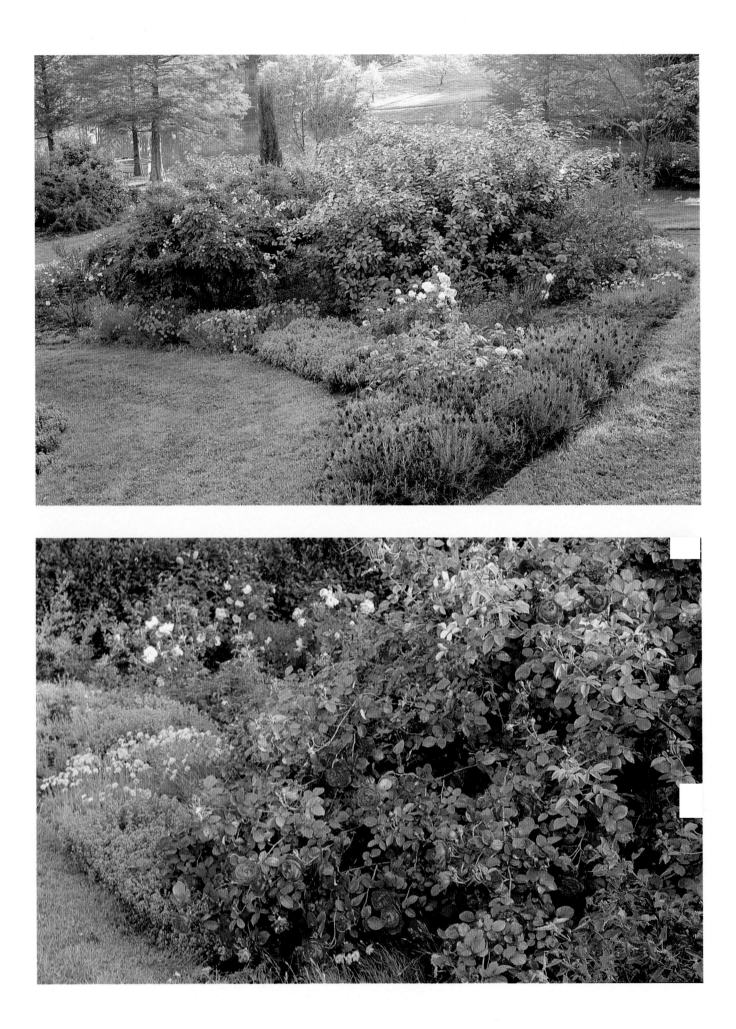

Preceding pages Wide, serpentine grass walks, suggested by Russell Page, meander through the "valley of roses" at the bottom of San Lorenzo's hill. The bluish tints are provided by thyme, lavender, and carnations.

Opposite, above Page indicated the design for the island beds at Tor San Lorenzo; they are now occupied by extensive rose, lavender, and dianthus plantings. Elaeagnus bushes build up the centers of the beds.

however large or small, should be in basic harmony with the landscape."[4]

The main axis of this lawn garden, running downhill from the side of the house, is formed by a long, straight avenue of alternating cypress and kiwi trees, thickly underplanted with agapanthus. Two parallel cobbled tracks run the length of the avenue: an old-fashioned country cart road treated formally. It leads to a series of green garden rooms, each enclosed by hedges and filled with different kinds of plants.

Two of these open-air rooms, situated on either side of the cypress and kiwi allée, attest to the marchesa's painterly imagination and gardening ability. The large formal one on the left was conceived by

Opposite, below Hundreds of modern and old-fashioned rose varieties grow, seemingly with abandon, in Tor San Lorenzo's valley of roses, grouped by the marchesa's painterly instinct rather than by variety.

Above Low flights of steps designed by Page at widely spaced intervals give this curving path at Tor San Lorenzo a particular grace. Its shape is complemented by the huge, showy leaves of a ligularia, growing in the raised border to the right.

Page as a rose garden. Six square beds set at a diagonal could hold as many roses in systematic order as the marchesa cared to grow within the evergreen walls of pittosporum hedges. This room was meant to be her "paintbox, palette and canvas,"[5] in which she could recreate with flowers the abstract color patterns that she paints when not gardening. Years after Page designed the garden, tired of seeing the same roses in the same order, she proceeded to replant this garden. Although she retained the original design, now each bed is dominated by an *Acer globosa,* a mop-headed maple tree, surrounded by four slightly shorter orange trees and a number of myrtle bushes clipped into spheres. The ground is carpeted with golden *Lysimachia nummularia* and an unidentified bluish flowering weed that casts a

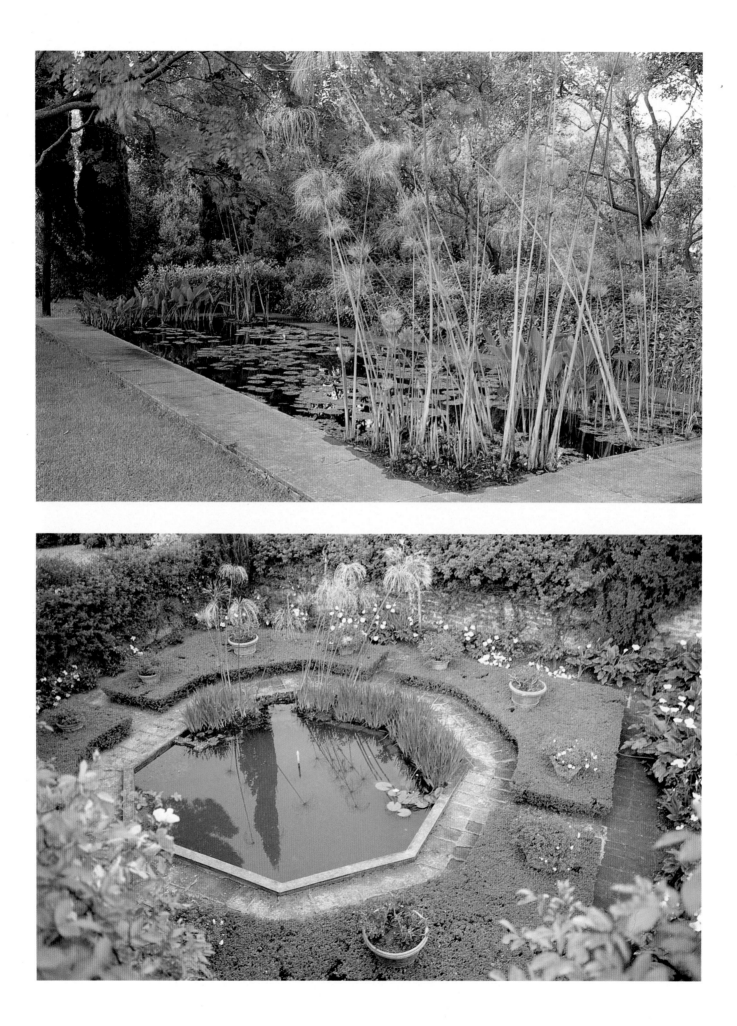

*A*BOVE *A rectangular pool at one end of the rustic villa at Tor San Lorenzo has a wide stone edge. Two of Page's favorite aquatic plants, water lilies and Egyptian papyrus, inhabit the pool.*

*B*ELOW *Near the other end of the Gallarati Scottis' house Page built an octagonal pool and gave it a decidedly formal treatment surrounding it with substantial box hedges.*

magical glow when in bloom. The result is a marvelous green garden of repetitive forms. Page would have understood, approved, and applauded.

The garden on the opposite side of the cypress avenue offers an equally enchanting surprise. Originally designed by Page as a Mediterranean olive grove with two octagonal stone fountains, it is now a garden devoted to the unusual combination of mauve and yellow flowers. Parallel beds of yellow tulips, irises, potentillas, pentstemons, hostas, hebes, yellow roses, and alliums grow here in the midst of silver- and yellow-leaved foliage plants and bronze fennel, shaded by the original olive trees.

A broad stone-paved walk, bordered by the occasional olive tree or cypress and thickly underplanted with white Penelope roses, clumps of lilies, and *Tulbaghia natalensis,* a South African bulb, leads to the lower garden. Here the eye is drawn to a valley of roses and the facing hillside with its meandering grass walks and free-form beds brimming over with shrubs, roses, botanical curiosities, and simple English-garden treasures. Page suggested the design of this open landscape to allow for the marchesa's ever-growing botanical collections. He also approved plans for a lake at the bottom of the valley and gave advice for planting the banks but did not live to see the finished result.

Russell Page not only provided the framework and indicated the way one should move through the gardens at Tor San Lorenzo, he also was instrumental in teaching the marchesa to concentrate her enviable energy and focus her interests. The estate's garden is living proof of his efforts and her continuing creativity.

Chapter 9
The Last Years

In his last years Russell Page was actively involved in many projects all over the world, including a number of jobs in the United States commissioned by corporations, museums, and various government agencies. Toward the end of his long career Page was keenly aware that of the hundreds of gardens he had designed, many had disappeared. He hoped that the ones he was doing in the public sector might find permanence now that foundations and corporations had taken over the role of patronage from the aristocracy and the great industrialists of the nineteenth century.

❧ Page had already shown himself to be a master of the short-term public display: He had designed the colorful but ephemeral Festival Gardens in London in the 1950s and had also composed brilliant temporary floral exhibits in Paris and at the Brussels Exhibition in 1958. Now he was looking for projects that might endure. Stimulated by curiosity as much as by the possibility of permanence, he traveled to western Australia twice in the seventies to plan a new town. The project was aborted, but not before Page had seen the region's unusual flora and fauna and viewed the western desert in blazing flower. Page had many other offers for public projects in this period, although, unfortunately, some of those were also unrealized, among them a townscape for Tehran before the fall of the shah and a public garden to replace Les Halles, the famous fruit and vegetable market in the heart of Paris, on which Page spent four frustrating years. ❧ Mrs. Albert Lasker, the wife of a well-known philanthropist, whose gardens outside of New York City Page had done in the 1960s, brought Page into contact with Mrs. Lyndon Johnson, and he subsequently became involved in her farsighted plans for the beautification of the U.S. capital and the conservation of the American landscape. Sadly, administrative complications slowed and muddled many of these projects. A proposal to create a federal botanical garden, in particular, was put on hold because of a lack of enthusiasm, by both the public and private sectors, insufficient funding, and the country's overwhelming concern with the Vietnam War. ❧ Despite these setbacks Page was meeting a number of prominent society people of the eastern United States and was soon designing gardens for some of them in Saint Louis,

Above A sketch by Russell Page shows the future garden at the Frick Collection in New York City.

Opposite The beds along the back wall of the Frick Collection garden are planted with shrubs, those at the edge of the lawn with bulbs and annuals. The color scheme of the flowers changes from year to year and season to season. Bluish tulips bloomed early one spring.

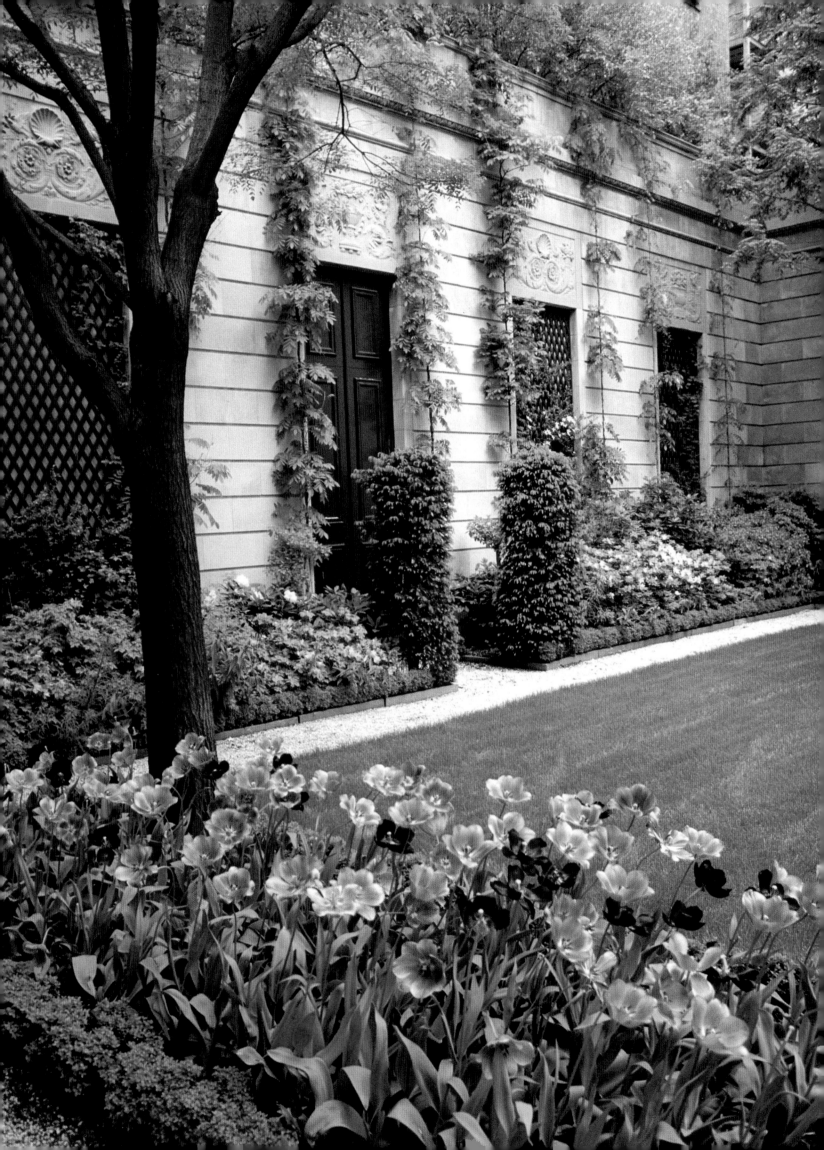

Palm Beach, New York, and Connecticut, and eventually California, Washington state, Texas, Maryland, Ohio, and even Montgomery, Alabama, where he planned a garden and park for a Shakespearean theater. In New York City, at Mrs. Lasker's request, he made a study plan for Central Park, worked on the entrance approach to the Metropolitan Museum of Art, did a project for New York University, and designed a garden for the Brooklyn Botanic Garden. His lasting contribution to the city was the new garden he designed for the Frick Collection, the elegant East Side art museum housed in the old Frick family mansion.

In 1972, when the trustees of the Frick decided to tear down the adjacent Widener house to build a new gallery wing, they were met by neighborhood protests. To calm the atmosphere they agreed to create

Page designed the Frick garden as if it were one big room, with a rectangular pool in the center. He planted four different trees—a crabapple, a sargent cherry, a koelreuteria, and a Japanese pagoda tree—asymmetrically on the lawn.

a temporary courtyard garden in its place for ten or fifteen years, before going ahead with the addition. The garden is now permanent. When the board began to discuss the choice of designer, one of its members, Mrs. Paul Mellon, had her retired Washington gardener flown up to New York to give his advice. The old man immediately recommended Russell Page, saying that Page would look over the situation, make a drawing on the back of an envelope or a bit of paper, and be the right man for the job.

When Page first arrived at the Frick in 1973, he found a small plot of ground set behind iron railings on its southern, street side. The three flanking sides were of classical design: one was eighteenth century in style, the other seventeenth—and the third was formed by the sides of adjoining tall buildings. At first, he thought a formal box-edged parterre surrounding a central fountain would be appropriate for this garden, which would be seen mainly from a distance. But upon

reflection Page decided that the size of the plot would prohibit such a choice. The overpowering tall buildings on the north side were the major problem, but Page devised an ingenious solution to divert the viewer's attention from them. He set a planter filled with Callery pears behind the north wall to suggest a neighboring garden on a higher level. Then, to give a sense of space to this small area, he made a lawn bordered by narrow beds on the northern and eastern sides. Years before, in Holland, Page had noticed how water served to enlarge one's sense of actual distance, and so he employed this optical trick at the Frick, using a third of the lawn to make a rectangular pool flush with the ground and rimmed with flat narrow stone. He filled it with water lilies and American lotus and had a fountain jet installed off center to provide interest in winter.

Although the overall feeling to the garden is classical French, Page chose solutions that were not strictly traditional. Instead of planting rows of pleached lindens, for example, he used four different species of trees—a late-blooming crabapple (*Malus hupehensis*); the Kentucky yellow-wood (*Cladrastis lutea*), with yellow bark and fragrant white wisteria-like panicles; a wide-spreading koelreuteria, and a rounded Japanese pagoda tree (*Sophora japonica*)—in asymmetrical positions to lend depth and mystery to the shallow space.

In his first year's planting plan, two box-edged beds that corner the lawn were filled with tulips, begonias, marigolds, and blue salvias, according to the season. Page insisted, however, that no permanent bedding-out plan be adopted; otherwise the garden would become stale. The only permanent planting he did suggest was that of his favorite white Iceberg roses along the entire length of the eastern wall. He also placed white, cream, and pale yellow azaleas, hydrangeas, and andromedas, underplanted with pale pink lilies and tall summer hyacinths (*Galtonia candicans*), under the north wall. The walls themselves were covered with wisteria, clematis, flowering quince, akebia, and several varieties of climbing roses.

The Frick project took Page ten years. He often stopped in New York on the way to somewhere else to play with the garden. Page once wrote: "A garden striking to a casual visitor is not usually a garden to live with and I try to avoid any trick effects . . . since even a mild shock of surprise is opposed to the idea of tranquility which I consider more than ever essential in a city garden."[1] The Frick garden is that rarity, an oasis of green serenity amidst the bustle and chaos of New York City.

Budd Harris Bishop, the director of the Columbus Museum of Art, was so impressed by Page's courtyard jewel for the Frick Collection that he commissioned the Englishman to make a garden for his

*F*OLLOWING PAGES *The pool in the center of the Frick garden is planted with water lilies and lotus flowers; a luxurious touch in New York City. A mix of climbing vines covers the recessed arches in the wall and Iceberg roses grow at its foundation.*

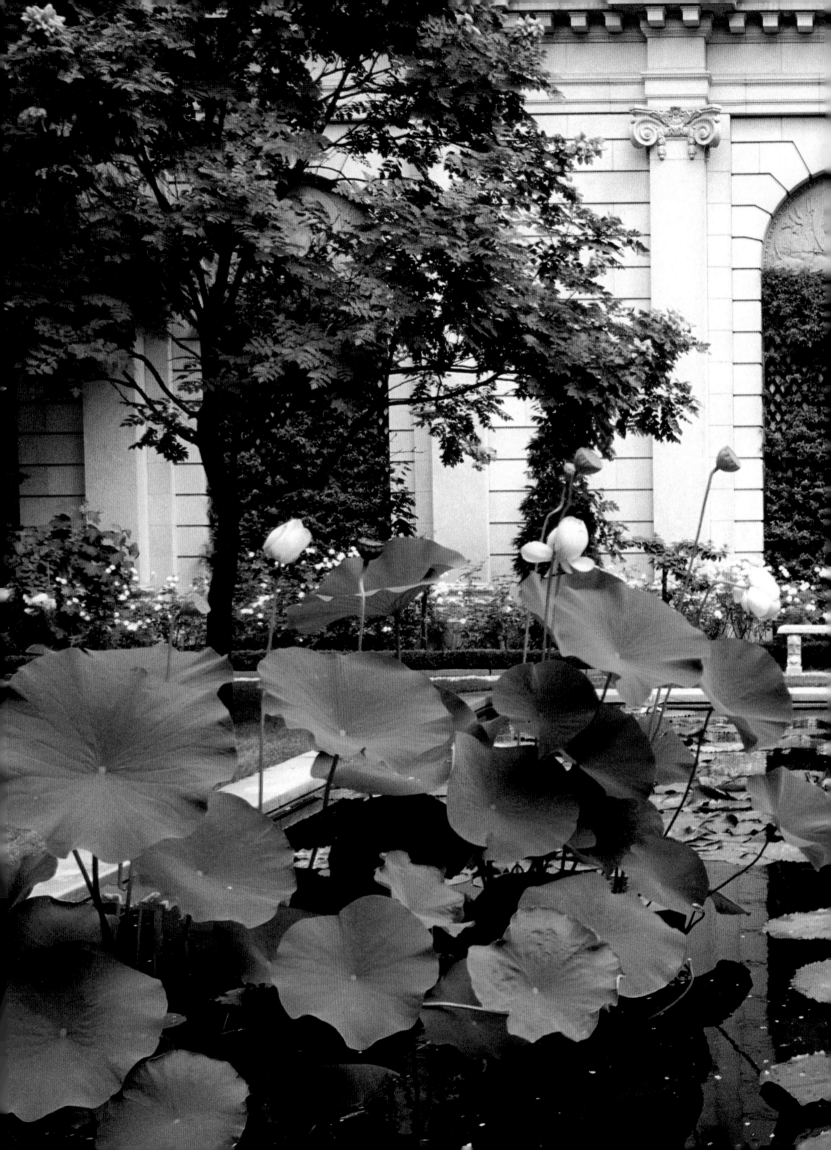

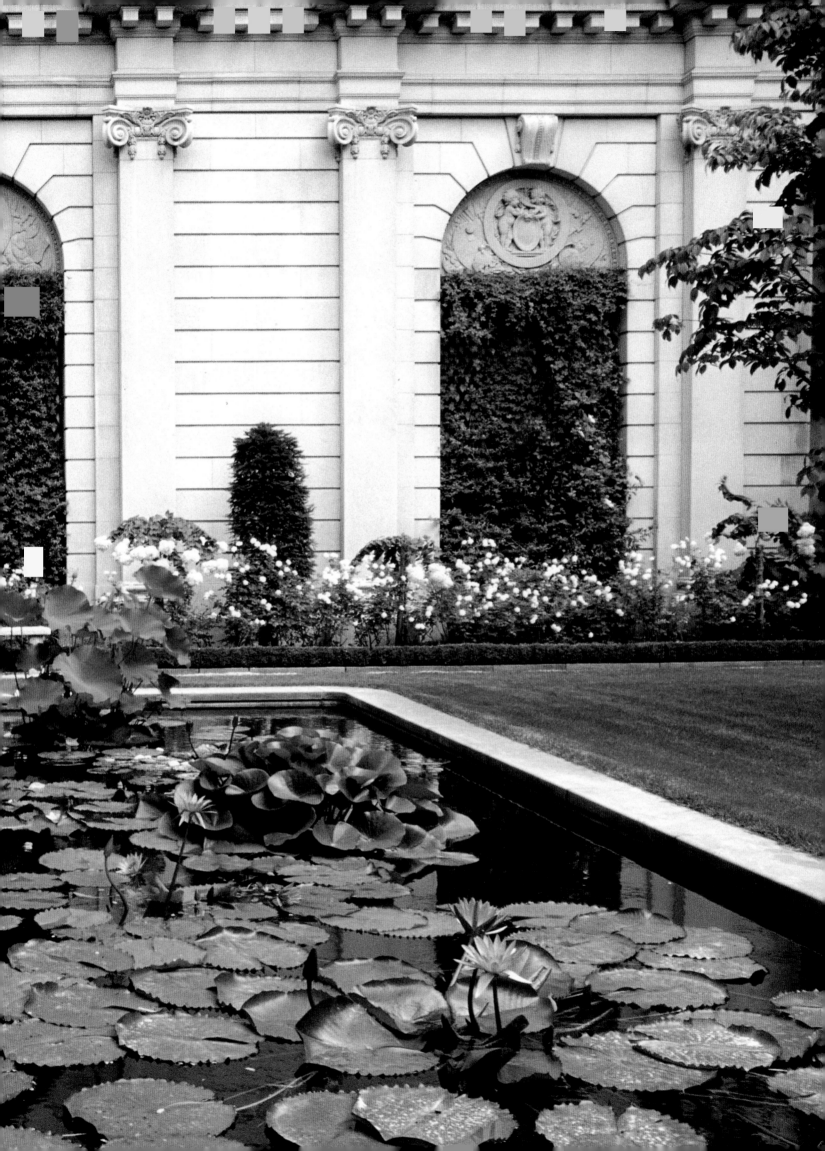

museum in 1977. Aside from quick day trips to Columbus, often stopping off on the way to Saint Louis or New York, Page worked on the design primarily from photographs and plans. By letter he admonished the museum staff not to change the "anomalies and asymettrys" of his carefully calculated plans. The simple, elegant walled garden, with a rectangular pool and a rectangle of grass set in paving stones and gravel, opened to the public in June 1979. It is a fine addition to the museum.

During these busy years Page also spent a great deal of time working for, and staying with, Thomas Vail, the publisher and editor of the *Cleveland Plain Dealer,* and his wife, Iris, at their home, east of Cleveland, Ohio. Page was fascinated by this part of the United States, with its suburbs of rolling countryside that formerly had been

farmland, tree-shaded country lanes, and Georgian-style houses interspersed with modern architecture, all set well back from the roads behind trees. Gardening as it is known in Europe hardly existed there, but Page was stimulated by the variety of native trees and shrubs and the promise of a thousand wildflowers in spring.

Mr. Vail had seen photographs of the British designer's gardens in various magazines. He wrote to Page twice and met him for the first time in 1976 over lunch at the Berkeley Hotel in London. Later that year Page flew to Cleveland to look at the Vails' estate, known as l'Ecurie, and agreed to rework the landscaping and develop a series of gardens for them. Eventually there would be eight gardens in all, each different in character. At least one of them is visible from every room in the house.

Page was generous with his praise for the previous work done by David Engel, wherever he felt it fitted the house and site. But he

*A*BOVE LEFT *At l'Ecurie, the home of the Thomas Vails near Cleveland, Russell Page planted a second row of hawthorn trees next to one in existence, thereby adding volume and putting the garden into a proper scale with its surroundings. He cut a large opening into the woods to extend the vista.*

*A*BOVE *Page created an adaptation of a Spanish courtyard for the south side of l'Ecurie, its main axis defined by an Alhambresque rill with a water jet at the end. Hemlock hedges enclose the garden and pots of flowers provide color variations.*

quickly saw that the property was overplanted and in fact probably spent more time taking things out than actually planting. The front of the house, in particular, needed rethinking and redoing. A wooded mound centered in the entrance court appeared to smother the hilltop house. Page had Mrs. Vail drive him up and down the entrance drive most of his first afternoon at l'Ecurie, as he considered a solution. He thought it a mistake to have an artificial wood directly in front of the house while acres of natural woodland surrounded the property. Page felt that l'Ecurie, which looked like a rustic château, needed an entrance yard that corresponded to its character. He replaced the

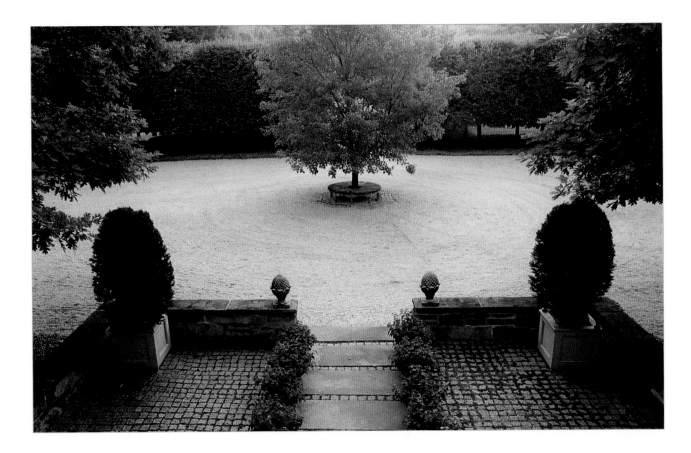

ABOVE One of Russell Page's major contributions to the remodeling of l'Ecurie was the replacement of a wooded mound near the entrance with a classical courtyard enclosed by clipped linden trees. A red maple stands in the center.

FOLLOWING PAGES A geometric planting of linden trees leads to the entrance of l'Ecurie.

mound with a broad graveled courtyard and planted a native red maple, surrounded by a white octagonal bench, in the center, "to bring a nice domestic look"[2] to the composition. He used formal rows of pleached lindens to flank both drive and courtyard, a design as effective in winter snow as in summer green. The same can be said of the various garden rooms Page designed around the house; elegance and "good bones" know no season.

Once the problem of the front of the house was solved Page and the Vails began discussing ways to improve the dull view from their main library window. The Vails happened to mention how impressed they had been with the Moorish gardens they had recently seen in Spain. Page then suggested transforming the area into an Alhambresque

garden, and the Vails readily agreed. First he enclosed the space with tall hemlock hedges, and then considered the area within. Page wrote to the Vails from London: "I think a water jet 5-6 feet maximum is essential to give life to this garden. I would like a water channel straight down the middle. . . . All kinds of arrangements of pots of geraniy or whatever will give us all the colour we might wish."[3]

Soon a fountain and its pool were installed at the far end of the garden, with the water channel carrying the flow to a large Japanese granite bowl set beneath the library window. Page also planted eight crabapple trees in two parallel rows in raised hexagonal beds to provide

BELOW Page, leached evergreen oak allée provides a striking accent alongside the lawn for Anne Bass's house in Fort Worth, Texas.

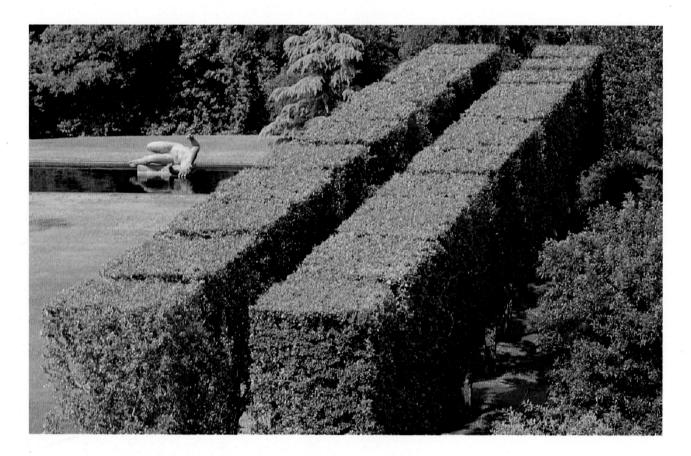

shade for the enclosed space and also to carry out the formal structure he had imposed on the other gardens. Climatic conditions were too harsh for the crabapples, however, and the Vails eventually had to replace them with "Callery" pears. Nonetheless Page's basic design remains unchanged here, as it does throughout the property. Although his work encompassed six years of correspondence and on-site work at l'Ecurie, Page's legacy continues there, as the Vails proceed with many of the projects he suggested before he died.

In 1981 Page traveled to Texas to make a rose garden for Anne Bass on her eight-acre estate outside of Fort Worth. He was as wary of Texas as most Europeans and was equally unenthusiastic about the Bass's modern house, designed by Paul Rudolph. The arch-

OPPOSITE Page designed a formal rose garden in pastel shades for Mrs. Bass. Nearby, on a lower terrace, is a lily pool.

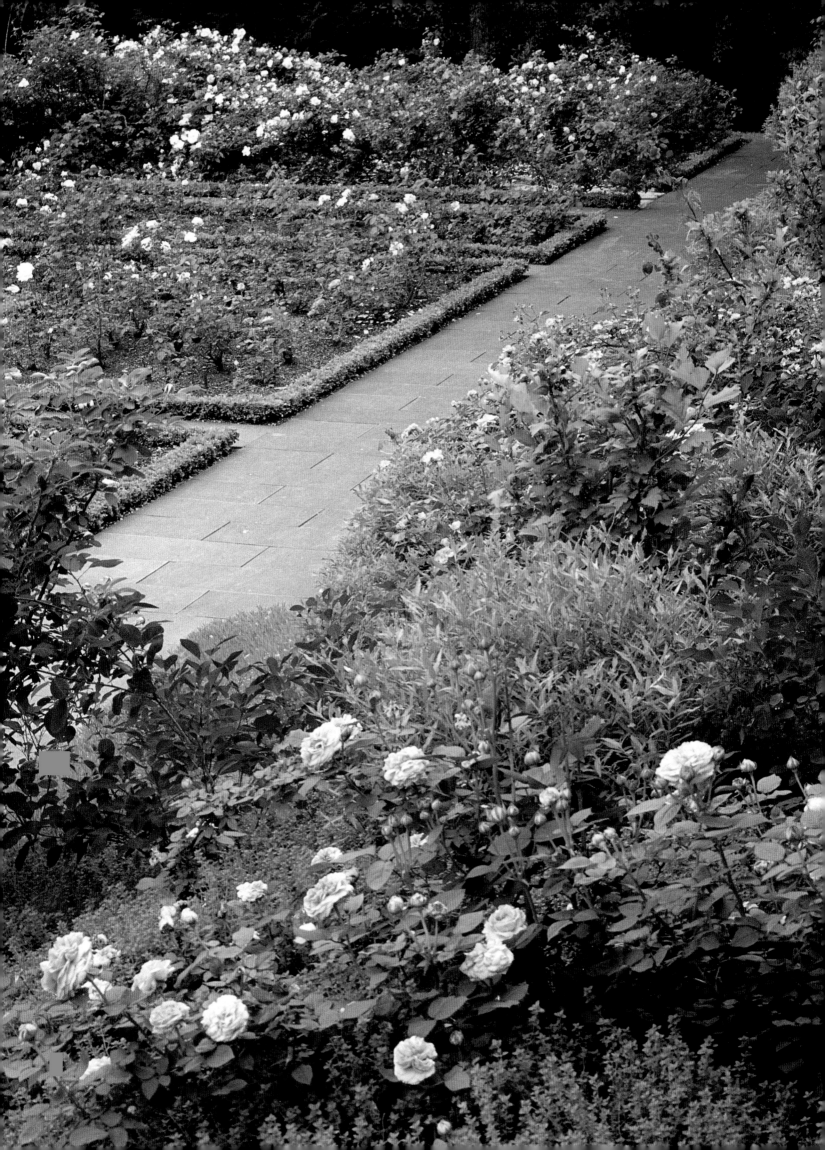

itect, however, having seen the Frick garden, endorsed the choice of Page. The two designers had their squabbles, particularly over the positioning of a new flight of steps into the rose garden, but Page was often stimulated to do his best work under minor tensions. Rudolph realized that Russell Page's great strength was his artist's eye and imagination. Without putting pen to paper, without a

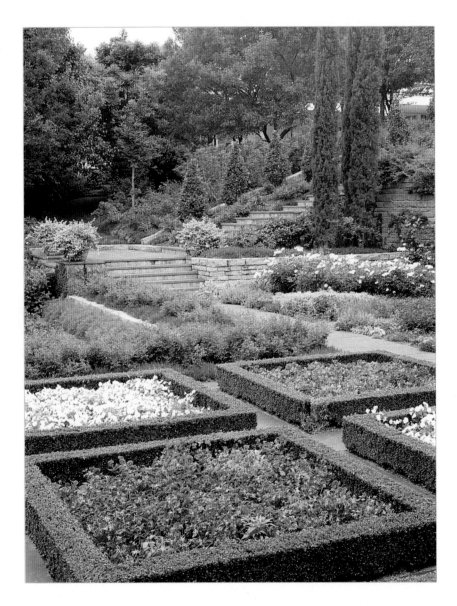

LEFT Page designed box-edged beds filled with changing displays of plants to line the path that descends to a pergola below.

OPPOSITE Page built the pergola adjacent to a greenhouse designed by Paul Rudolph, the architect of the Bass house. Wisteria will soon cover its top and provide cooling shade. Nearby, the rectangular lily pool is backed by a row of Italian cypresses.

drawing, Page could visualize the entire project and every detail with masterful clarity.

Page linked the gardens to the house, extending and reflecting the interior space of the house to the peripheral green base of the property designed by the landscape architect Robert Zion. Page planned grassed steps descending to a central broad lawn, ending at a black reflecting pool, which he never saw completed. On the left of the lawn he planted an allée of pleached oaks. He installed steps leading down a bank planted with miniature white roses to a lower garden of square

box-edged beds that flank a lily pond and a rustic wisteria-covered pergola, which he attached to Paul Rudolph's orchid house.

Page talked Mrs. Bass out of an all-white garden, saying it would be an imitation of Vita Sackville-West's white garden at Sissinghurst. Instead he imposed a quieter palette of pinks, lavenders, greens, and silvers, set off by touches of white, to offset the harshness of the climate and make lavish use of Mrs. Bass's favorite old-fashioned roses.

Page's next job was in Connecticut, at White Birch Farm, an upscaled replica of Mount Vernon. The owners hired Page to provide plans for the stonework and gardens surrounding the house, as well as

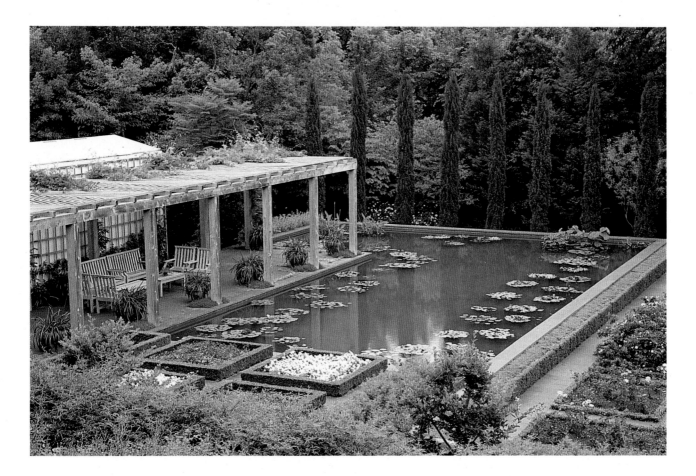

for the entrance courtyard. He did the overall design work, but declined to do the detailed planting. (It was later carried out by Deborah Nevins.) Although his health was starting to fail, he continued to work on several projects, including his last great work, the Donald M. Kendall Sculpture Gardens on the grounds of the Pepsi Corporation in Purchase, New York.

PepsiCo had moved its world headquarters from Manhattan to Purchase, about thirty-five miles north of the city, in 1965. The well-known American architect Edward Durrell Stone had designed a complex of seven three-story buildings for the company's 144-acre site. Starkly symmetrical in style, they form a circle open on the north side.

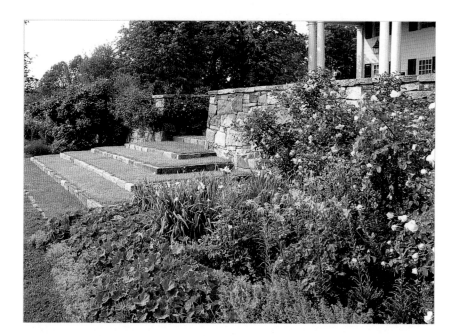

Left While Page lent a classical French touch to some American gardens, his contributions to White Birch Farm in Connecticut are distinctly English. Wide grass steps edged in stone bisect a rose border below the mansion's terrace.

Below Page thought out the proportions and designed the stone-work for White Birch Farm, but did not supervise the actual planting. Deboral Nevins, a landscape architect, oversaw the detailed planting of this massive rose border as well as that of other flower gardens on the property.

Opposite, above Page designed a lawn enclosed by flower borders and hedges near the pool house at White Birch Farm. A pair of beds planted with dianthus on the stone terrace above the lawn is a Jekyllian feature.

Opposite, below A circular staircase between the dianthus beds leads from the stone terrace to the lawn. The retaining wall is covered with White Dawn roses.

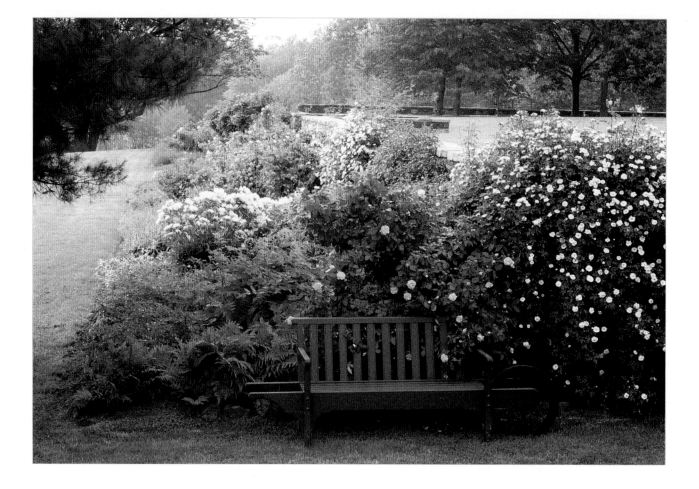

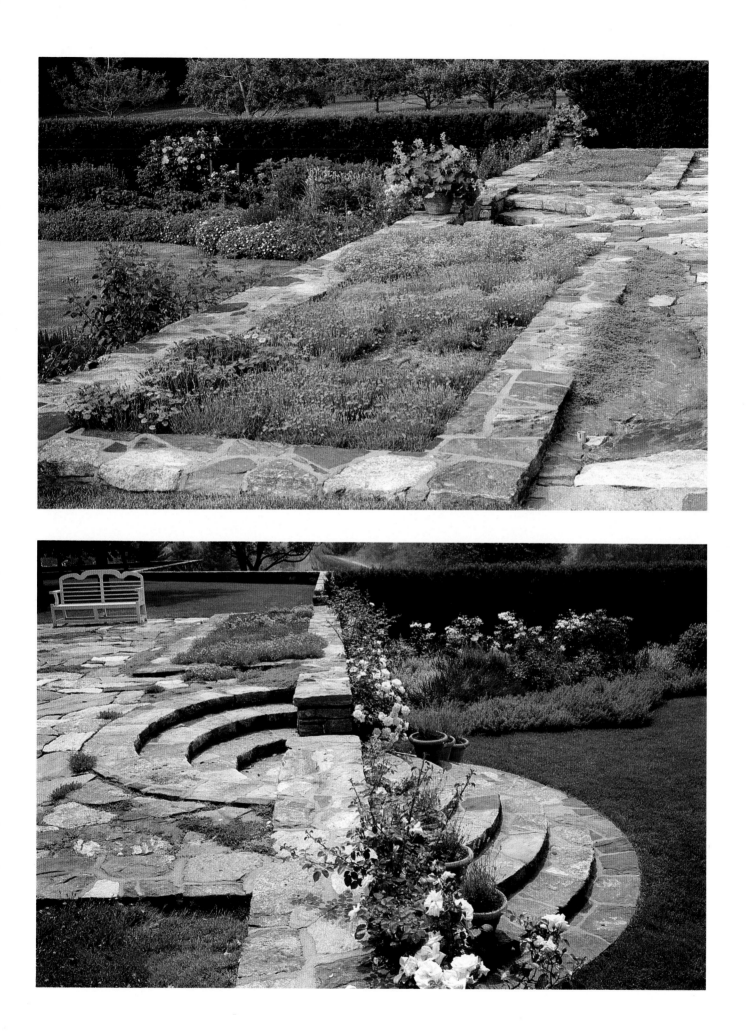

Edward Durrell Stone, Jr., the architect's son, conceived the early landscaping of the grounds.

In 1981 Russell Page was commissioned to transform the corporate estate into a landscaped park and sculpture garden. His first note to Donald M. Kendall, then chairman and chief executive of PepsiCo, and subsequent close friend, collaborator, and admirer of Page, conveyed the designer's general approval of the grounds and the selection of early twentieth-century sculpture that dotted the landscape. His only criticism was that the placing of the larger pieces of sculpture severely affected the fluidity of the original composition. "As things

ABOVE AND OPPOSITE The land-scaping task Page faced at his last major work, the Sculpture Gardens at the headquarters of PepsiCo, in Purchase, New York, was on a gigantic scale, encompassing 112 acres and 40 sculptures. Page planned the "Golden Path" to wind through the park past all the sculptures, including David Wynne's Grizzly Bear; *Alexander Calder's* Hats Off; *Arnaldo Pomodoro's* Grande Disco; *and Robert Davidson's* Totems.

are," he wrote, "the landscape looks too bland and the sculpture too aggressive."[4] The scale of the two elements was so disparate that it spoiled the total visual effect, whether one was standing still or walking through the grounds.

Page had used sculpture before in gardens and had often chosen and commissioned works, such as the black basalt animal figures at

FOLLOWING PAGES Page's major undertaking at PepsiCo was the establishment of spatial relationships between the sculptures and their surroundings. Majestic sugar maples divide this lawn into various areas for the sculptures.

Calaratjada in Majorca more than ten years earlier. He had also made a particularly fine garden around a major work by Alexander Calder for Greek shipowner Alex Goulandris, near Lausanne, Switzerland, but once that villa had been sold and the sculpture removed, the garden became meaningless. Page was against adding sculpture to a garden unless it was to be the main point of the composition.

Working alone and with painter Oskar Kokoschka after the war, Page had struggled to understand the nature and form of an object. He came to realize that in gardening, as in painting, the spatial relation-

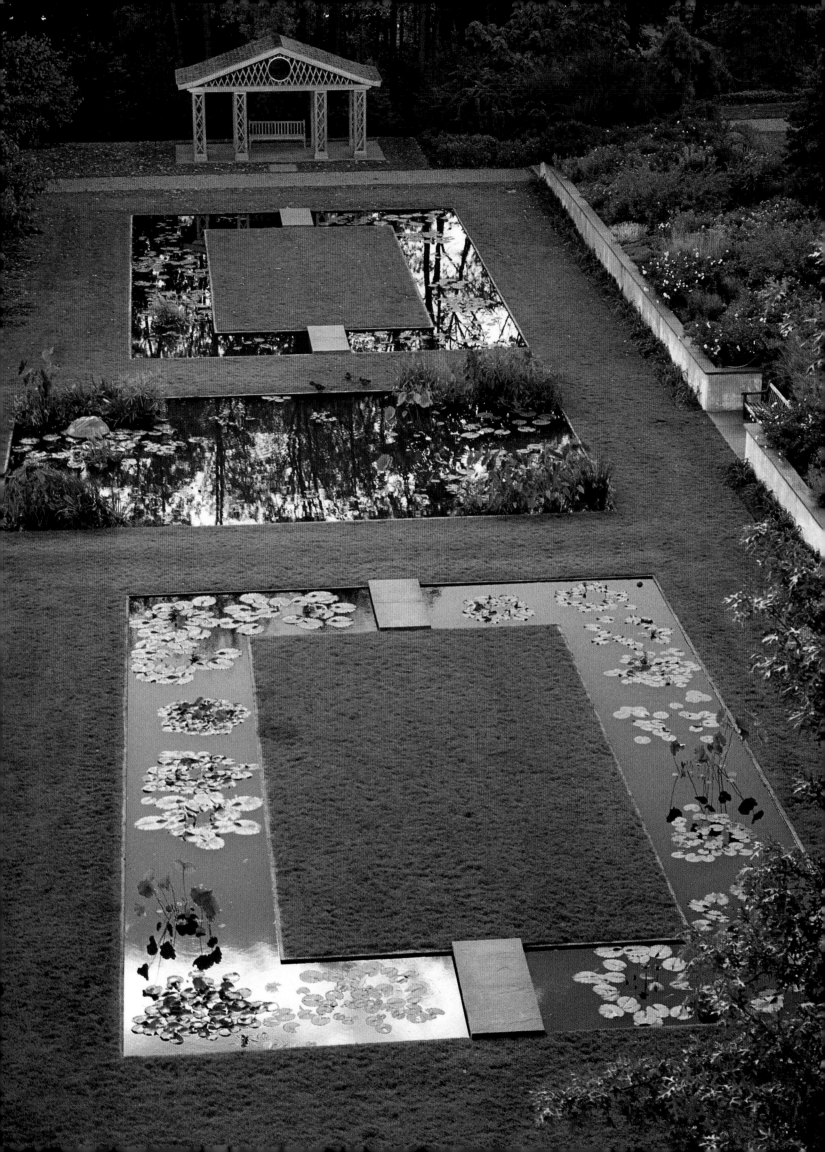

ships between objects—whether buildings, elements in the landscape, or sculptures—can be more important than the objects themselves. He believed that within the space between objects something is always happening. Page further explained: "Whether I am making a landscape or a garden or arranging a window box I first attack my problem as an artist—my preoccupation is with relationships between objects, whether it is a wood or a pond, a rock or a plant, or a group of plants. My understanding is that every object emanates—sends out beyond its physical body vibrations which are specific to itself. These vibrations vary with the nature of the object, the materials it is made of, its

*O*PPOSITE *A wild heron takes advantage of the lush setting of the water-lily pool at PepsiCo.*

*B*ELOW *Art Price's* Birds of Welcome *await the visitor under a group of willows near the entrance to the sculpture gardens.*

*P*RECEDING PAGES, LEFT *Page's geometric water-lily pool and its adjacent perennial border are among the highlights of the PepsiCo park. The pavilion was inspired by a design of Humphrey Repton, an eighteenth-century English garden designer.* RIGHT *Page would sometimes search far and wide for just the right tree, however rare. In these endeavors he was assisted by American nurserymen, for whom he had high regard. Page selected the yew topiary next to the water-lily pools to add intimacy and humor to the water garden.*

colour, its textiles and its form. . . . So with a stone—the tune of marble differs from that of sandstone or granite—the shape and colour dictate the speed and spread of its vibrations."[5] Behind this insight lay the inspiration for Page's manipulation of space in garden design.

Before he began planting at PepsiCo Page designed a walkway of amber-colored gravel that looped through the park, around the seven linked office buildings, and passed within the central Greek cross-shaped courtyard. This "golden-pathway," as Page called it, was the key to circulation through the grounds and helped establish an essential unity that the site had been lacking. Once the path was traced he began to plant, using the plantings to reinforce the ties between the landscape and the sculpture. He enlivened the park by breaking it into

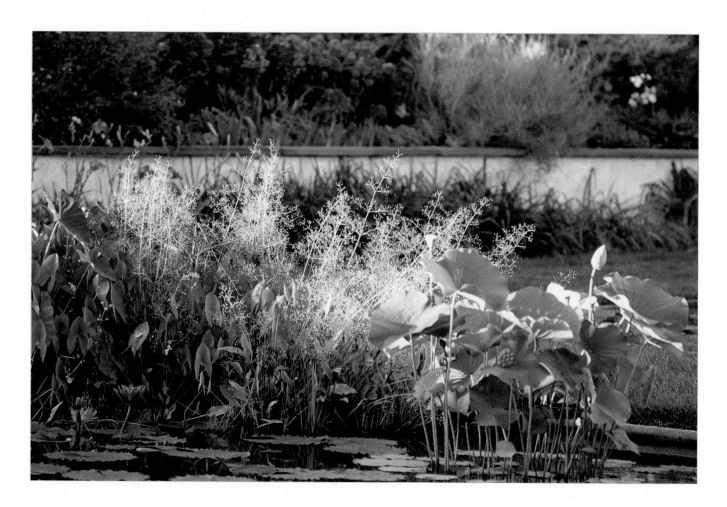

sections; these smaller gardens within the park—an ornamental grass garden, an azalea garden he never saw completed, a fall garden, and a stream and bog garden he began just before his death—are successful in spite of the enormous scope of the grounds. The most elaborate of these smaller compositions is the formal water-lily garden, featuring three pools set in the level green of the lawn reflecting the changing sky. A group of topiary yews and a long herbaceous border on the narrow bank over the pools completed the composition.

Although it was immensely hard work Page enjoyed the commission at Purchase. "I use the trees as sculptures and the sculptures as flowers, and then I take it from there. It's a cross-current thing."[6] For three months each spring and three months in the autumn for nearly five years he lived in an isolated hotel near the corporation headquarters, where he was picked up by car early each morning and returned at nightfall. The first year he planted some 350 trees in one month. Page, ill with cancer, was driven by the consciousness of how much there was to do, and how little time left to do it. But despite his health and advancing age he managed to alter the face of the vast landscape and help Kendall choose and place many of the park's forty sculptures. It was an enormous achievement.

Page used water plants—water lilies, sagittaria, and lotus flowers—as accents in the central lily pool at PepsiCo. Phlox, caryopteris, and perovskia lend color to the perennial border in the back.

Along with landscape settings for the sculptures Page created ten major theme gardens within the precincts of the PepsiCo park. A grass garden is situated near the building, designed by Edward Durrell Stone.

All serious art is a critical act, a reconstruction as well as a criticism of life. It is also an attempt at immortality. Russell Page was as acutely conscious of this as any other creator. The ephemerality of his art, and the sadness he felt for all the gardens made and lost in his lifetime, strengthened his desire to create and to endure. The gardens he designed in the United States, especially those for the Frick Collection, the Columbus Museum of Art, and for the PepsiCo sculpture park were his final wager against the erosion of time.

A Brief Chronology

Many details of Russell Page's life and career are sketchy. His prewar files were destroyed during the London Blitz, and his memory of those days was sometimes vague. Late in life he began to collect his plans and papers (they are now preserved by Robert and Jelena de Belder at the Arboretum in Kalmthout, Belgium, where they can be consulted, with authorization). Whenever possible we have used the first date marked on Page's architectural plans to date a garden and the last to determine the end of the project, although he often continued to visit and work on many of his gardens throughout his life. Only those gardens we consider of major interest and those discussed in the book are listed in this brief chronology and, whenever possible, dated.

{November 1, 1906} Montague Russell Page is born in Lincolnshire, England, second son of three children of Harold Ethelbert Page, a solicitor in the city of Lincoln.

{1918–1924} Student at Charterhouse. Takes Leach Prize for Art at school. Visits garden designer Gertrude Jekyll and her garden.

{1924–1926} Studies art at the Slade School, University College, London, under Professor Tonks.

{1927–1932} Meets lifelong friend André de Vilmorin while art student in Paris. Travels in France, visiting gardens and taking small gardening jobs.

{1928} First professional job; designs a rock garden for one pound a day wages in Rutland, England.

{1930} Helps reorganize garden at Ogden Codman's château near Melun, France.

{1932} Spends summer at Amos Laurence's French château, Boussy Saint-Antoine (now destroyed), re-designing gardens and studying garden architecture. Returns to England. Works in the office of landscape architect Richard Sudell. Meets with Henry Bath and begins work at Longleat House, Bath's estate (work continues after the war and throughout most of Page's life).

{1934–1938} Writes articles for English magazine *Landscape and Gardening.*

{1935} Works at Cheddar Gorge, on the Longleat estate, with landscape architect Geoffrey Jellicoe. Association with Jellicoe (president of the Institute of Landscape Architects from 1939 to 1949) lasts until 1939. Their collaborations include Royal Lodge, Windsor Great Park; Ditchley Park, Oxfordshire; chess-board garden for Holme House, Regent's Park; planting guide for the development of the village of Broadway, in the Cotswolds; Charterhouse School.

{1935} Meets French decorator Stephane Boudin at Ditchley Park; start of lifelong collaboration.

{1936} Begins work at Leeds Castle, England; continues work there throughout his life.

{1937} Begins work at the château Le Vert Bois, in northern France, and at the château de la Hulpe in Belgium.

{1937–1939} Holds post of lecturer in landscape architecture at the University of Reading.

{1938} Begins work at the château de Mivoisin, France, for Marcel Boussac; continues through the 1940s and 1950s.

{1940} Recruited by the Political Warfare Department of the Foreign Service to control broadcasting to France and organize the French Service for the BBC.

{1942} Promoted to the Political Intelligence Department of the Foreign Office. Goes on mission to the United States with Sir David Bowes Lyon and Sir John Wheeler-Bennet to work with U.S. government agencies in setting up foreign-language broadcasting services.

{1943–1944} Engaged at general headquarters in Cairo organizing and executing propaganda for southern Europe and the Balkans.

{1945} Sent as political warfare officer, holding rank of lieutenant colonel, to Ceylon. Demobilized; returns to London. Meets painter Oskar Kokoschka; begins to paint again.

{1946} Resumes collaboration with Stephane Boudin. Works with André de Vilmorin. Becomes a disciple of mystic and philosopher George Gurdjieff.

{1947} Marries Lida Gurdjieff at Saint-Germain-des-Prés, Paris (divorced 1954). Begins first of many projects on the French Riviera, at the Villa Plein Ciel.

{1948} Page's only child, David, is born. Work begun at Frenay le Bouffard, Normandy, and for Mohammed Sultan at Guizeh, Egypt.

{1949} Starts work at the Pavillon Colombe, Edith Wharton's prewar garden in France, for the Duchess of Talleyrand, and at the Creux de Genthod, Switzerland.

{1950s} Works as garden correspondent for *Maisons et Jardins,* France.

{1950} Works for King Leopold of the Belgians at Waterloo and at the Moulin des Dames, Chantilly. Returns to England to direct and design the Festival Gardens, Battersea Park, for which he is created OBE. Designs gardens at the château de Bleneau, France.

{1951} Designs the approach avenue at Longleat House.

{1951–1954} Landscapes Supreme Headquarters Allied Powers, Europe (SHAPE) grounds outside of Paris.

{1952–1953} Designs garden for the Frank de Poorteres in Belgium. Begins project for the Duke of Windsor at Gif-sur-Yvette, France. Landscapes La Loggia, northern Italy.

{1954} Marries Vera Milanova Daumal (she dies in Switzerland in April 1962). Begins work for Giovanni Agnelli at Villar Perosa, Italy; for Sir William Walton on the island of Ischia, Italy; and for Albert Provost, near Grasse, France.

{1956} Landscapes the Villa Silvio Pellico, northern Italy.

{1958} Designs French pavilion at Brussels Exposition.

{1959} Designs Vilmorin exhibit for the Floralies de Paris. Landscapes gardens for Jean de Poortere, Belgium, and at Schloss Freudenberg, Switzerland.

{1960} Continues work at Leeds Castle. Continues work begun at Kiluna Farm, Long Island, New York.

{1962} Leaves France, returns to London to live. *The Education of a Gardener* published. Works at Coppings Farm, home of Lord Bernstein, and at Boisgeloup in France.

{1963} Mother's death. Resumes work at Schloss Freudenberg, Switzerland, and at Walton garden, Ischia, Italy. Begins work in and around Rome at San Vito and Castel Gandolfo, at Peygros, France. Landscapes garden for Jacques Thierry in Brussels.

{1964} Appointed Landscape Consultant by the Societé d'Encouragement for the race track of Longchamps, Paris. First trip to Spain to begin work on sculpture garden for Don Bartolomeo March on Majorca (1964–1979). Returns to La Hulpe, Belgium. Begins work for Don Jaime Ortiz-Patino at Vandouvres, Switzerland; and at San Liberato, Italy, for Count and Countess Sanminiatelli (1964–1977).

{1965} Starts work for the David Somersets at the Cottage, Badminton, England.

{1966} Does plantings for Vanderbilt Hall, New York University, and project for Baron and Baroness Guy de Rothschild, Marbella, Spain. Begins work at Howletts, England, for John Aspinall.

{1967} Designs garden for Don Jaime Ortiz-Patino, Sotogrande, Spain. Begins work at Varaville, Normandy, France; and Tor San Lorenzo, near Rome, for the Marchesa Gallarati Scotti. Designs Agnelli roof garden, Rome. Death of Stephane Boudin.

{1968} Begins projects for Baron and Baroness Guy de Rothschild, at Ferrière, France; for Duchess Salviati, near Rome; for the Chester Beattys, at Owley, in England; and at the château de l'Hermitage, in the South of France.

{1969} Begins projects for Count Brandolini, at Vistorta, Italy; for count de Villegas, Brussels. Meets Robert and Jelena de Belder.

{1970} Begins projects for the De Belders at Kalmthout and Hemelrijk, Belgium. Designs roof garden for Maurice Rheims, Paris.

{1971} Appointed landscape architect for a projected public garden in Paris to replace les Halles (resigns in 1977).

{1972} Designs small garden for Alfonso Zobel, Sotogrande, Spain. Begins a garden near Deauville, France.

{1973} Accepts commission to design a new garden for the Frick Collection, New York City.

{1975} Begins reconstruction of gardens at Port Lympne, England. Travels to Venezuela; asked by government of Venezuela to design parks and advise on conservation. Tries to interest them in building a training school for botanists and park keepers, an arboretum, a botanical garden, etc. Makes a five-year planting plan for the Elbow Beach Hotel, Bermuda; resigns in 1984 after twenty-four visits.

{1976} Begins garden at Little Mynhurst Farm, England. Returns to Venezuela.

{1978} Awarded medal of the Academie d'Architecture, Paris. Travels to Chile; does project for El Mercurio SAP, Santiago de Chile. Designs a sculpture garden for the Columbus Museum of Art and a garden for Thomas Vail, Cleveland, Ohio. Is asked by the Victoria and Albert Museum, London, to redesign the Quadrangle and to participate in organizing a garden exhibition for the museum. Begins lake, duck sanctuary, and the Culpeper garden at Leeds Castle.

{1979} Designs a water garden near Dieppe, France. Resumes work at Schloss Freudenberg, Switzerland.

{1980} Accepts commission to landscape the PepsiCo headquarters, Purchase, New York. Begins garden for Mr. and Mrs. Peter Brant, Connecticut.

{1981} Plans garden for Ann Bass, Fort Worth, Texas.

{1982} Begins project for the Cleveland Clinic Foundation, Cleveland, Ohio; plans park and Shakespeare Theater for Montgomery, Alabama.

{1983} Begins Temple of Flora project for the United States National Arboretum, Washington, D.C.

{1985} Death in London, January 4.

Notes

Preface

1. David Pryce-Jones, "An Architect of Gardens that Delight," *Town & Country* December, 1976.
2. Russell Page, *The Education of a Gardener,* (England: Penguin Books, Ltd., 1985), p. 47.
3. *Education of a Gardener,* p. 46.

Chapter 1

1. Unpublished papers. Russell Page's unpublished papers are held by his niece, Vanessa Stourton, in London.
2. Undated letter from Mrs. Bey Corbally Stourton.
3. *Education of a Gardener,* pp. 16-17.
4. *Education of a Gardener,* p. 35.
5. *Education of a Gardener,* p. 51.
6. Told to Gabrielle van Zuylen by Regnault.
7. *Education of a Gardener,* plate 7 between pp. 48 and 49.
8. *Education of a Gardener,* plate 6 between pp. 48-49.

Chapter 2

1. *Education of a Gardener,* p. 33.
2. *Education of a Gardener,* p. 40.
3. *Education of a Gardener,* p. 226.
4. *Education of a Gardener,* p. 186.

Chapter 3

1. *Education of a Gardener,* p. 295.
2. *Education of a Gardener,* p. 248.
3. Unpublished papers.
4. Unpublished papers.
5. *Education of a Gardener,* p. 228.
6. *Education of a Gardener,* p. 229.
7. Unpublished papers.
8. *Education of a Gardener,* p. 242.

Chapter 4

1. *Education of a Gardener,* p. 283.
2. *Education of a Gardener,* p. 252.
3. Eyewitness account of M. Prevosteau as told to Gabrielle van Zuylen.
4. Unpublished papers.
5. *Education of a Gardener,* p. 257.
6. *Education of a Gardener,* p. 327.

Chapter 5

1. Unpublished papers.
2. *Education of a Gardener,* plate 5 between pp. 216 and 217.
3. Unpublished papers.
4. Unpublished papers.
5. Letter from Russell Page to Gabrielle van Zuylen, 1967.
6. Unpublished papers.
7. Unpublished papers.
8. Letter from Russell Page to Gabrielle van Zuylen, 1968.
9. Undated letter from Russell Page to John Aspinall.

Chapter 6

1. Unpublished papers.
2. Notes for a lecture Page gave on the Alhambra; unpublished papers.
3. Unpublished papers.
4. Unpublished papers.
5. Unpublished papers.
6. Unpublished papers.
7. Unpublished papers.

Chapter 7

1. Unpublished papers.
2. Unpublished papers.
3. Unpublished papers.
4. Unpublished papers.
5. Unpublished papers.
6. Written description of Russell Page's childhood by his sister, Mrs. Bey Corbally Stourton; unpublished papers.
7. Unpublished papers.
8. Unpublished papers.
9. Russell Page, "House and Garden" in *20th Century Decorating, Architecture and Gardens,* ed. Mary Jane Pool (London: Weidenfeld and Nicolson, 1980), p. 14.

Chapter 8

1. Unpublished papers.
2. Unpublished papers.
3. Unpublished papers.
4. Unpublished papers.

Chapter 9

1. *Education of a Gardener,* p. 262.
2. Ogden Tanner, "Russell Page Remembered," *Horticulture,* July 1988.
3. Tanner, "Russell Page Remembered."
4. John Russell, "Persons One Is Glad to Have Known," *New York Times,* June 23, 1983, sec. 3.
5. Letter to André de Vilmorin, May 26, 1982; unpublished papers.
6. Unpublished papers.

Acknowledgments

We would like to thank everybody at Stewart, Tabori & Chang who helped us put this book together. In particular we would like to express our gratitude to Andrew Stewart for his interest in our project, Leslie Stoker for her invaluable guidance and great patience, and Jim Wageman for his excellent design. We are most appreciative of the help of Lynn Pieroni, Andrea Danese, Sarah Longacre, Jose Pouso, Kathy Rosenbloom, Mary Albi, Amy Hughes, and Marsha Lloyd.

The debt we owe to Russell Page's son, David Page; to his niece, Vanessa Stourton; to his sister, Bey Corbally Stourton, and his brother, A. D. Page, is immeasurable. Thanks to their confidence and encouragement, we have been given the use of Russell Page's private files and unpublished writings. I have quoted from all this material, as well as from *The Education of a Gardener,* with the kind permission of the publisher.

The idea of this book came from Russell Page's great friends Robert and Jelena de Belder, the world-renowned Belgian botanists and dendrologists, to whom he left the body of his architectural plans, drawings, and related papers. My affection and debt to them and to their daughter, Diane, is vast.

Memory has helped me recover some of his spoken comments and descriptions of gardens. Many other friends and acquaintances, from gardeners to corporation presidents, have shared their recollections. We are thankful to André de Vilmorin, Page's closest friend, who died in 1988.

Index

Numbers in *italics* indicate photographs.

Designed by Jim Wageman,
with Lynn Pieroni

Composed in Adobe Garamond
by Graphic Arts Composition
Philadelphia, Pennsylvania

Printed and bound by
Toppan Printing Company, Ltd.
Tokyo, Japan